THE PRAKTICA WAY

THE
PRAKTICA
WAY

The Praktica Photographer's Companion

LEONARD GAUNT

FOCAL PRESS LONDON — NEW YORK

ISBN 0 240 50743 6

First edition 1972
Second edition 1972
Reprinted 1974
Third edition 1975

ALL ENQUIRIES

relating to this book or to any photographic problem are answered by post by the Focal Press without charge if a stamped addressed envelope is enclosed for reply.

Printed and bound in Great Britain by
A. Wheaton & Co., Exeter

CONTENTS

INTRODUCTION

The Prakticas are reflex cameras—the so-called single-lens reflexes (SLR)—with eye-level viewing facilities. The reflex principle is simple: it means that a mirror inclined at 45° behind the lens reflects an image of the scene in front of the lens on to a ground-glass screen in the top of the camera. The mirror is in such a position in front of the film that the distances from its centre to the ground-glass screen and to the film are the same. Thus, when the image is sharply focused on the screen, you can be sure that, when you move the mirror out of the way to take the picture, the image will be equally sharp on the film.

Eye-level viewing of the reflected image is provided by a specially shaped prism and a magnifying eyepiece. The prism, which is a rather truncated pentaprism (or five-sided prism), has its reflecting surfaces so placed that they turn the light rays forming the image through 90° again, so that they continue parallel to their original path, and at the same time turn the image right way up and right way round. The eyepiece is effectively focused, via the pentaprism, on to the screen and presents what appears to be a nearly life-size image.

Because of this arrangement, it is commonly said that, with the SLR camera, you view and focus *through* the camera lens. This is not strictly true, in that the eye does not look through the camera lens. It does not see the original scene at all. It sees a reflected image on the screen. Failure to appreciate this fact leads to the misconception that, in looking through the camera lens, the imperfect eye may adapt itself to focus an image sharply when, in fact, the image is not correctly focused by the lens. The image the eye sees, however, is that on the focusing screen, and if that image is not sharp, no amount of adaptation by the eye can make it so. If your sight is so imperfect that the image *never* looks sharp (i.e., your eye will not focus on the screen), nevertheless, when the image is at its least unsharp, it is correctly focused by the lens. If this situation

arises, however, you should have an eyepiece correction lens (see page 180) fitted to your camera.

Advantages of reflex principle

The advantage of the reflex principle of viewing and focusing the image is obvious. No matter what lens or attachment you put on the camera (and there are very many lenses and attachments available for the Prakticas) your viewpoint when looking through the eyepiece is effectively the same as that of the lens. With cameras not using the reflex principle, the viewfinder is a separate optical system. Inevitably, its viewpoint is different from that of the lens and it views a slightly different field. At close range, indeed, it views a *considerably* different field. This is known as parallax error. Moreover, when you change the lens of this type of camera, you also have to change the viewfinder, except in a few cases where elaborate systems of masks or optical compensation are provided. Nor can this type of viewfinder focus the image. A rangefinder system has to be provided and all such systems are limited as to the range of lenses with which they can work.

There are many who claim that the best rangefinder cameras are less bulky and quicker in use than the SLR. For much photography this may well be true, although, as with so many things, a lot depends on what you get used to. There are none, however, who can deny the overwhelming advantages of the SLR in close-range and long-range work and in conditions where it is vital to obtain a parallax-free image.

Like most SLR's, the Prakticas are interchangeable-lens cameras. This means that the basic camera consists essentially of two completely separable parts—the body and the lens. The lens is attached to the body simply by screwing it into a flange carefully engineered on to the camera body at exactly the right distance from the film. When the lens is screwed in, it comes to a positive stop (not simply a tightening of the screw) so that every lens designed for the Prakticas will work perfectly on every Praktica body.

The thread of the Praktica lenses is also used by many other cameras and there are innumerable independent manufacturers who make lenses and other items of equipment to fit these cameras. The choice of lenses and accessories for the Prakticas is therefore enormous. It is a wise precaution, however, to make careful enquiries before attempting to fit to the

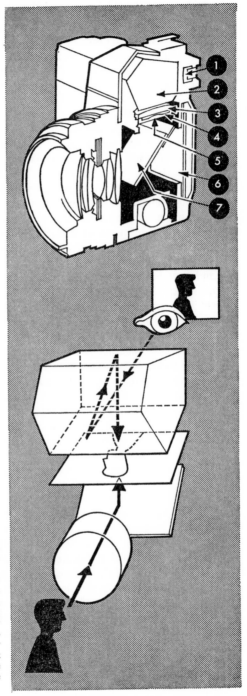

Top: Features of the single-lens reflex:

1. Magnifying eyepiece
2. Pentaprism
3. Condenser lens
4. Fresnel surface
5. Ground glass
6. Film plane
7. Mirror

Nos. 3, 4 and 5 comprise the Jena focusing system introduced in the first Praktica Nova cameras.

Bottom: The viewing and focusing principle of the single-lens reflex. The subject is projected by the lens, via the mirror placed at 45° behind it, on to the ground glass surface. The user views this image through the magnifying eyepiece via the specially shaped prism which presents him with a correctly oriented image. Note that the user does not view the image directly through the lens.

Praktica lenses or equipment made specifically for other cameras. The thread may be the same but other features, such as automatic diaphragm operation (see page 40) or the protrusion of the lens into the camera body (see page 59), may raise difficulties and even cause damage.

The Praktica shutters

Every interchangeable lens camera has to have some means of protecting the film from the effect of light when the lens is removed. Many cameras have between-lens shutters, i.e., the camera shutter is an integral part of the lens itself. Such lenses cannot normally be wholly removed from the camera without allowing light to reach the film. The Prakticas, however, use a focal plane shutter. On the older cameras, this is a shutter in the form of two cloth blinds which expose the film by moving across it at varying separations (see page 116). It is placed immediately in front of the film, behind the mirror and, both before and after the exposure is made, the two blinds are securely locked together so that no light can pass. Thus, the lens can be removed at any time with no risk of inadvertently exposing the film. The recent models have a more elaborate steel shutter of a multi-bladed construction which moves vertically across the image format.

The focal plane shutter is more efficient than the between-lens shutter and can give higher speeds. The range of speeds provided by the Praktica shutters varies according to model: none but the very earliest have fewer than eight speeds ranging from $\frac{1}{2}$ sec to 1/500 sec while all current models give the full range of 11 speeds from 1 sec to 1/1000 sec.

All Praktica shutters are synchronised for use with electronic flash and expendable flashbulbs (see page 121).

Other Praktica features

The Praktica cameras use 35mm perforated film in the standard packings of 20 or 36 exposures. The perforations enable the film to be wound on by the correct amount for each exposure so that an automatic stop can be provided. On all except the very early models, winding on is very swiftly accomplished by a single movement of a lever. This single movement advances the film the correct distance, tensions the shutter ready for release, and locks the lever so that the film cannot be wound on again before the shutter is released. The

Because the viewfinder image is provided directly by the lens on the camera a wide variety of accessories can be used without the need for viewfinder adjustment or replacement. The focal plane shutter and the ease of focusing impose virtually no limit on the range of lenses that can be used (*top right*). Naturally, bulb or electronic flash can be fitted to the accessory shoe, either fixed or attachable (*top left*). One great advantage of the SLR system is the ease with which it can be used or close range work. Bellows, extension tubes, close-up lenses (together with filters if necessary), microscope attachments and special copying equipment are all in the standard range of Pentacon equipment.

lever on the Novas, Prakticamat and Super TL can be operated again after shutter tensioning but it does not move the film. Once the shutter is released, it cannot be released again until the film has been advanced. Thus, you cannot inadvertently expose the same frame twice (but you can get round this safety device on some models for special effects, see page 258).

The choice of films, black-and-white or colour, is wide (see page 110) because of the popularity of the 35mm format, and there are no very great problems involved in developing your own films (see page 231).

In the long history of the Praktica cameras, there have been many models with built-in exposure meters. They have ranged from models in which the meter is virtually an independent instrument to the most advanced devices measuring the light passing through the camera lens. The latter TTL meters naturally have enormous advantages when ancillary equipment is used on the camera. For close-range work, for example, you might use extension tubes or bellows (see page 182). Without a TTL meter, you have to make allowances for the extended light path. With the TTL meter you simply take a direct reading. Similarly, you do not have to allow for the density of any filter placed over the lens.

These, then, are the basic features of the Praktica cameras. There have been many models since the marriage of the original Praktiflex of 1948 and the Pentacon of 1949 produced the Praktica of 1952. In the rest of this book we trace the development of the range, examine the individual models and detail the innumerable uses to which they can be put. This book does not, however, deal with the Pentacon Super, an expensive 35mm model from the same manufacturers, nor the Pentacon Six, which uses 6 × 6cm roll film.

PRAKTICA MODELS

There have been more than 20 models of the Praktica camera in the past 20 years and the latest are far removed indeed from the Praktiflex that started the series in 1948. They fall roughly into four groups:

1. The early Praktica and Praktica FX models, which were waist-level viewing cameras with no pentaprism and a variety of non-standard flash contacts.

2. The Praktica IV and V models, with built-in pentaprism for eye-level viewing, rapid wind lever, and automatic diaphragm operation, which was first introduced in the latest FX models. Built-in exposure meters also first appeared in the IV and V.

3. The Praktica Novas, Prakticamat and Praktica Super TL introduced many new features, including the instant return mirror, lever wind on the top plate, single shutter speed knob (except on the first Novas), automatic zeroing of the exposure counter and other minor improvements.

4. The Praktica L series departs radically from the previous designs, which all bore a close family resemblance. The body is smaller and squarer, the shutter is a vertically moving metal type and the LLC introduced an electrical connection between the lens aperture and exposure meter needle to provide full-aperture metering. The LTL uses the stopped-down metering system of the Super TL. The LB has a built-in uncoupled selenium meter. Both VLC and LLC have self-timers as have some versions of the LTL.

The individual models within these groups are detailed in the following pages but identification of some of the earlier models is clouded by the facts that minor alterations were frequently made while a particular model was in production and that some models were sold under different names in

different countries. With these provisos, the chronological history is as follows:

Praktiflex, 1948. This was the forerunner of all the Praktica cameras but is not strictly in the range. It used a different lens thread in a smaller (40mm) mount and cannot be fitted with any of the lenses subsequently made. It had no slow shutter speeds, the slowest being 1/25 sec.

Praktica, 1952. The Praktiflex design was modified in 1952 to incorporate the lens mounting of the Pentacon camera, previously the Contax S, the reflex version of Zeiss's well-known Contax rangefinder camera. This simple screw mounting (42mm in dia.) has remained unchanged throughout all the later models and has been adopted by many other manufacturers, notably the Japanese Asahi company, producers of the Asahi Pentax cameras. This first Praktica was, like its predecessor, a reflex camera, but the ground-glass screen in the top plate was a condenser type to improve edge illumination. It was protected by a fold-flat hood. The shutter was a cloth focal plane type giving speeds from ½ second to 1/500 sec in the old progression of ½, 1/5, 1/10, 1/25, 1/50, 1/100, 1/200, 1/500. There was a B setting for brief time exposures. The slow speeds were obtained by means of a separate knob operating a delay mechanism. The shutter was not flash synchronized. The carrier lugs on early models were on the sides of the camera. In some later models they were moved slightly forward. The rewind button was in the camera top plate next to the film transport knob.

Praktica FX, 1955. There were several versions of the Praktica FX and some of them were sold under the name Praktiflex FX. The first versions were the same as the 1952 Praktica but had non-standard flash contacts in the base for F and X synchronization. The F synchronization, however, gave a 10 msec delay for flashbulbs then available. Later versions had three non-standard flash contacts on the camera front, X synchronization at top, F at the bottom and a central neutral or "earth" contact. Another version adopted the standard 3mm coaxial contact and had one socket for X synchronization only.

Praktica FX2, 1956. The pentaprism for eve-level viewing made its first appearance with this model. It was an attach-

able extra and the viewfinder hood was modified to a slightly rounder shape. Other variations from the previous model were the return of the F synchronization socket (coaxial this time) and the inclusion of a device in the camera for automatic stopping down of the lens diaphragm. The F synchronization was the new standard type for M-class flashbulbs (not focal plane bulbs) and the versions with this feature were sometimes sold as Praktica F.X2. There was also an FX3 version which was an FX2 with an automatic diaphragm lens.

Praktica IV, 1959. The pentaprism became a permanently attached part of the camera for the first time with the Praktica IV. This model also introduced the lever wind for rapid film transport and shutter tensioning but placed it on the base plate, leaving the winding knob on top as an alternative. The rewind knob was modified, the top half lifting up and swinging out to form a crank. It also incorporated a film type reminder disc. The rewind button no longer had to be held depressed but stayed in, once pressed, until the shutter release was operated.

Variations of the Praktica IV were the IVB, IVM, IVBM, IVF and IVFB, the B indicating exposure meter, the M indicating rangefinder and the F models incorporating a fresnel screen viewfinder for the first time.

The inclusion of an exposure meter in the Praktica IVB (see page 79) brought a modification of the rewind knob, which was not split to form a crank as in the IV but had a small crank built into the rim. The knob pulled up to reveal the film speed scale. The meter window was in the front of the pentaprism and two pointers were shown in a window next to the rewind knob. The exposure meter was the selenium type, which needs no batteries, and had no coupling to the camera controls (see page 77 for operating details).

The Praktica IVM introduced the rangefinder spot in the centre of the focusing screen. This was a split-image type showing a discontinuous line in the centre of the screen image until the lens was correctly focused. The rest of the screen was the normal ground-glass/condenser type, so there was no fine focusing collar around the rangefinder spot.

The Praktica IVBM was a IVB with the rangefinder screen.

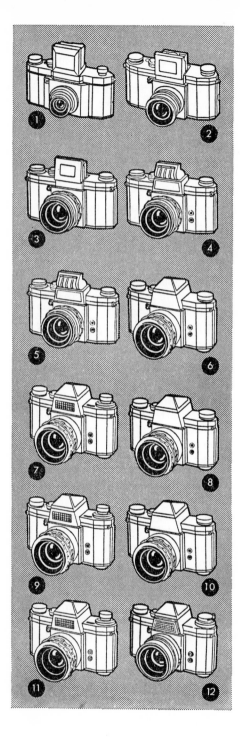

PRAKTICA HISTORY

1. The original Praktiflex had a smaller lens mount and no slow speeds.

2. The 1952 Praktica introduced the condenser screen and slow shutter speeds.

3. The Praktica FX was flash synchronized. In early models the contacts were in the base.

4. The Praktica FX2 had a modified viewfinder which was redesigned to allow a pentaprism to be fitted. The automatic diaphragm mechanism made its first appearance in this model.

5. The Praktica FX3 was an FX2 supplied with an automatic iris lens.

6. The Praktica IV was the first with a permanent pentaprism. It also introduced the lever wind, but it was on the baseplate.

7. The Praktica IVB was a IV with a built-in exposure meter.

8. The Praktica IVM was a IV with a rangefinder screen.

9. The Praktica IVBM was a IV with both rangefinder and exposure meter.

10. The Praktica IVF was a IVM with a fresnel screen.

11. The Praktica IVFB was a IVF with an exposure meter.

12. The Praktica VF introduced the instant-return mirror and the standard shutter speed range. The Praktica VFB was a VF with an exposure meter.

13. The Praktica Nova of 1965 began a style change.
The lever wind was moved to the top plate. The shutter release button was angled.

14. The Praktica Nova B was a Nova with exposure meter.

15. The Prakticamat introduced through-the-lens metering and increased the shutter speed range from 1 sec. to 1/1000 sec.

16. The Praktica Nova I was the first with an orthodox shutter speed knob.
It also introduced the quick-load system.

17. The Praktica Nova IB was a Nova I with exposure meter.

18. The Praktica Super TL of 1968 is similar to the Nova I but has a TTL metering system and a micro-prism rangefinder.

19. The Praktica L is the first of a new breed with a squarer shape, metal shutter, improved automatic diaphragm mechanism, hot shoe flash contact, etc.

20. The Praktica LLC is similar to the L but has a TTL meter reading at full aperture and self-timer.

21. The Praktica LTL has all the features of the LLC but uses the stopped-down metering system of the Super TL.

22. The Praktica LB is a replacement for the Nova IB, using the styling of the L range with a built-in selenium meter.

23. The Praktica VLC is an LLC with interchangeable viewfinder and screens.

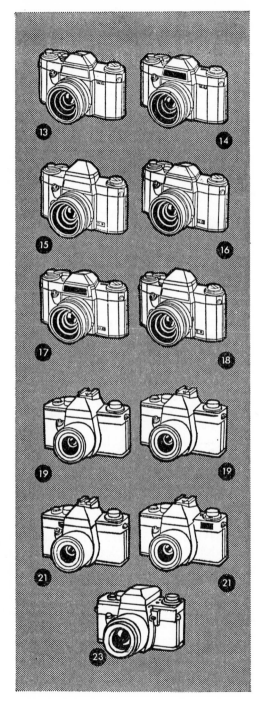

The Praktica IVF introduced the fresnel lens over the viewing screen. This is a special design of condenser lens that can be made thin and flat while spreading the illumination evenly to the corners of the screen. In this model, the fresnel lines were quite prominent, partly because there was no ground glass surface beneath them. Consequently the part of the screen showing the fresnel lines could not be used for focusing. The focusing effect it appears to give depends on the accommodation of the eye, because it is an aerial image. To supplement the rangefinder, however, there was a fine ground-glass collar around the central spot to allow screen focusing of part of the image.

The Praktica IVFB was a IVF with built-in exposure meter.

Praktica VF, 1964. Before this model, the Praktica cameras lagged behind most other 35mm reflexes because, when the shutter was released, the mirror moved up to cover the viewfinder screen and stayed there until the film was wound on for the next exposure. The Praktica VF, however, introduced the instant return mirror—a mechanism which allowed the mirror to return to the viewing position as soon as the shutter had run down. So that the user would know whether the film had been transported or not, a signal appeared in the top left-hand corner of the screen when the shutter was not tensioned.

The VF was also the first model to use the now standardised progression of shutter speeds but for technical reasons the 1/15 sec speed had to be omitted. The range was, therefore, $\frac{1}{2}$, $\frac{1}{4}$, $\frac{1}{8}$, 1/30, 1/60, 1/125, 1/250 and 1/500. The slow speeds were still obtained by the separate operation of a delay mechanism (see page 116).

The Praktica VFB was the same as the VF but with a built-in exposure meter.

Praktica Nova, 1965. The Nova models followed the VF in bringing the Praktica range up to date. The styling of the camera was improved, giving a lower line to the pentaprism, moving the rapid wind lever to the conventional top of the camera position and setting the shutter release button at an angle to the camera front. The rewind knob incorporated the conventional fold out crank. The back was hinged instead of being detachable. The exposure counter was made conveniently

PRAKTICA VLC

The main features of the Praktica VLC are as follows:

1. Frame counter
2. Transport and shutter tensioning lever
3. Film speed setting
4. Shutter speed knob
5. Pentaprism (interchangeable)
6, 7. Meter changeover switch symbols
8. Rewind knob
9. Flash socket
10. Self timer release
11. Self timer lever
12. Electrical contact
13. Automatic diaphragm mechanism
14. Mirror
15. Pentaprism release button

16. Cassette chamber
17. Metal bladed shutter
18. Tripod socket
19. Battery compartment
20. Easy load guide
21. Rewind button
22. Take-up spool
23. Viewfinder eyepiece
24. Pressure plate

25. Shutter release
26. Stop-down button
27. Distance scale
28. Aperture control
29. Depth of field scale
30. Focusing ring
31. Meter changeover switch
32. Carrying strap lug

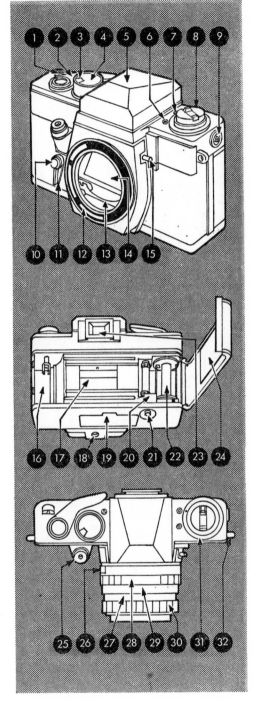

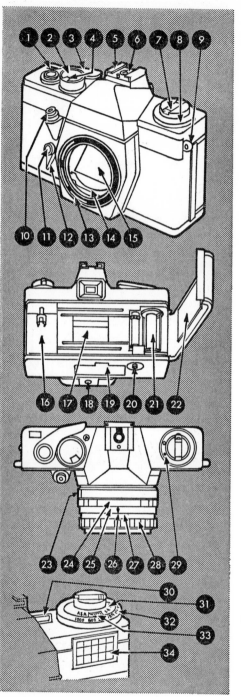

PRAKTICA L, LLC AND LB

The main features of the Praktica L and LLC are as follows:

1. Exposure counter
2. Shutter speed knob
3. Transport and shutter tensioning lever
4. Film speed setting
5. Accessory shoe
6. Flash contact
7. Rewind crank
8. Meter changeover switch (on LLC)
9. Carrying lug
10. Shutter release with lock
11. Self timer release button (on LLC)
12. Self timer lever (on LLC)
13. Electrical contacts for full aperture metering (on LLC)
14. Automatic diaphragm mechanism
15. Mirror

16. Cassette chamber
17. Metal-bladed shutter
18. Tripod bush
19. Battery compartment (on LLC)
20. Rewind button
21. Take-up spool with quick load device
22. Pressure plate

23. Stop-down switch
24. Aperture control
25. Depth of field scale
26. Focusing mark
27. Distance scale
28. Focusing control
29. Meter changeover switch symbols LLC)

Additional features of LB:

30. Meter indicator
31. Aperture indicator
32. Shutter speed indicator
33. Film speed setting
34. Meter window

PRAKTICA LTL

The main features of the Praktica LTL are as follows:

1. Exposure counter
2. Shutter speed knob
3. Transport and shutter tensioning lever
4. Film speed setting
5. Accessory shoe
6. Flash contact
7. Rewind crank
8. Rewind knob
9. Carrying lug
10. Shutter release with lock
11. Delayed action release (optional)
12. Delayed action lever
13. Meter switch
14. Automatic diaphragm mechanism
15. Reflex mirror

16. Cassette chamber
17. Metal focal plane shutter
18. Tripod bush
19. Battery compartment
20. Rewind button
21. Easy-load guide
22. Take up spool with easy-load frame
23. Pressure plate

24. Aperture ring
25. Depth of field scale
26. Focusing mark
27. Distance scale
28. Focusing ring

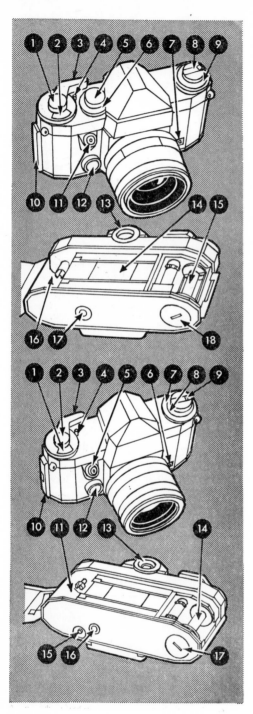

PRAKTICA SUPER TL AND PRAKTICAMAT

The main features of the Praktica Super TL are as follows:

1. Film type reminder
2. Exposure counter
3. Transport and shutter tensioning lever
4. Rewind button
5. Shutter speed knob
6. Film speed setting
7. Flash contacts
8. Rewind crank
9. Film load indicator
10. Back latch
11. Shutter release with lock
12. Meter switch
13. Viewfinder eyepiece
14. Focal plane shutter
15. Take-up spool with quick load device
16. Cassette chamber
17. Tripod bush
18. Battery compartment

The main features of the Prakticamat are as follows:

1. Exposure counter
2. Film type reminder
3. Transport and shutter tensioning lever
4. Rewind button
5. Shutter release with lock
6. Flash contacts
7. Shutter speed control
8. Film speed setting
9. Rewind crank
10. Back latch
11. Cassette chamber
13. Viewfinder eyepiece
14. Take-up spool
15. Rewind button
16. Tripod bush
17. Battery compartment

THE PRAKTICA NOVAS

The main features of the Praktica Novas are as follows:

On Nova and Nova I

1. Exposure counter
2. Film type reminder
3. Transport and shutter tensioning lever
4. Rewind button
5. Shutter speed knob
6. Shutter release with lock
7. Pentaprism
8. Rewind crank
9. Film speed and film load reminders

On Nova B and IB

10. Exposure counter
11. Transport and shutter tensioning lever
12. Rewind button
13. Shutter speed knob
14. Exposure meter needles
15. ASA film speed setting
16. DIN film speed setting
17. Meter shutter speed scale
18. Meter aperture scale

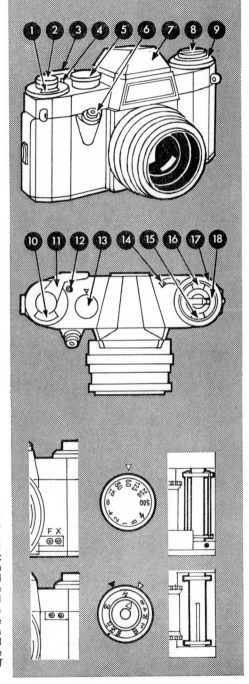

The main difference between the original Novas and the Nova I models is in the shutter speed knob. The Nova I models (*top*) introduced the orthodox control with all speeds on one knob. The original Novas (*bottom*) used the old Praktica double control with a delay mechanism for the slower speeds. The Nova I models also had a quick load mechanism and the flash contacts were moved toward the base of the camera.

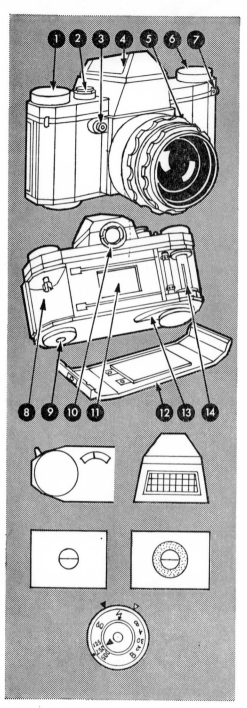

There were many versions of the Praktica IV and V. The main features were as follows:

1. Transport and shutter tensioning knob which, in the Praktica IV, also wound the mirror down to the taking position.
2. Shutter speed knob
3. Shutter release
4. Pentaprism
5. Flash contacts, vertically aligned beside lens mount
6. Rewind knob
7. Carrying lug
8. Cassette chamber
9. Tripod bush
10. Viewfinder eyepiece
11. Focal plane shutter
12. Removable back
13. Transport and shutter tensioning lever
14. Take-up spool

The main external differences between the various models were that the IVB had an exposure meter window in the front of the pentaprism housing with needles visible in a window next to the rewind knob.

The Praktica IVM introduced the split-image rangefinder (*left*).

The Praktica IVF added a fresnel screen and, because that was not a focusing area a ground-glass ring around the rangefinder centre (*right*).

The Praktica VF introduced the new standard shutter speed range but omitted the 1/15sec. setting.

EARLY PRAKTICAS

All models before the Praktica IV were the so-called waist-level types. The main features of the Praktica FX2 were as follows:

1. Transport and shutter tensioning knob, which also returned the mirror to the taking position
2. Rewind button
3. Shutter speed setting
4. Slow speed control
5. Shutter release
6. Focusing hood, redesigned to take an attachable pentaprism
7. Flash contacts
8. Rewind knob
9. Back latch

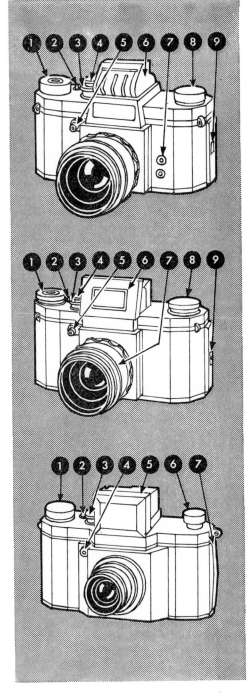

The 1952 Praktica is the true forerunner of the modern range. It took over the 42 mm. lens mounting of the old Pentacon or Contax S and introduced the delay mechanism for slow speeds that all Prakticas used until 1965.

1. Transport, shutter tensioning and mirror returning knob
2. Rewind button
3. Shutter speed setting
4. Slow speed control
5. Shutter release
6. Focusing and viewing hood
7. Lens
8. Rewind knob
9. Back latch

The original Praktiflex is easily distinguishable by its smaller lens mount to which none of the current lenses can be fitted.

1. Transport, shutter tensioning and mirror return knob
2. Rewind button
3. Shutter speed knob (no slow speeds)
4. Shutter release
5. Focusing and viewing hood
6. Rewind knob

self zeroing. The focusing system was improved by putting a ground glass surface under the fresnel lens so that the whole screen image could be used for focusing. The fresnel lines were not so prominent. A lock was incorporated in the release button.

The Praktica Nova B was a Nova with built-in exposure meter similar to that in the previous models.

Prakticamat, 1965. This model took a further long stride forward with the introduction of through-the-lens metering, using a beam splitter to divert part of the light entering the lens to a CdS photoresistor connected to a needle visible in the viewfinder (see page 78). The shutter speed range was increased to 1 sec to 1/1000 sec, unusually set on a disc surrounding the rewind knob.

Praktica Nova 1, 1967. The one remaining difference from most other 35mm reflexes was eliminated in the Nova 1, with the incorporation of an orthodox click-stop shutter speed knob next to the transport lever giving all speeds from 1 to 1/500 sec. This model also introduced the quick-load system (see page 30) which eliminates the need for threading the film into the take-up spool.

The Praktica Nova IB is a Nova 1 with a built-in exposure meter.

Praktica Super TL, 1968. This model uses a newer and more economical TTL metering system than the Prakticamat and is otherwise similar to the Nova 1 with the shutter speed knob next to the transport lever giving speeds from 1 to 1/500 sec. The split-image rangefinder is replaced by a microprism type (see page 87). The quick-load system is incorporated.

Praktica L, 1970. The old Praktica shape disappeared completely with the introduction of the Praktica L. The camera body is compact, with straight lines and squared corners. There are many other changes. The cloth, horizontally moving shutter has given way to a vertically moving metal construction shutter speeded from 1 to 1/1000 sec and B, with a separate, marked setting for electronic flash. Coaxial flash contacts are eliminated in favour of a single, X-synchronised contact in the fixed accessory shoe. The rewind button is moved to the base of the camera. The film transport lever is slimmer and sits closer to the top of the camera. The auto-

matic diaphragm mechanism is of a different design. It stays in the forward position until the shutter closes, regardless of whether you let go of the shutter-release button. The mechanism cannot be disconnected and can therefore be jammed by some older lenses. The Praktica L has no meter.

Praktica LLC, 1970. Retaining the same lines and other features as the L model, the Praktica LLC has a TTL metering system reading at full aperture with the lenses designed for this model but usable with other lenses to give stopped down reading. The special lenses have electrical contacts transmitting the aperture setting to the meter. The meter switch is in the shutter release. There is no separate switch. The battery is a relatively large alkaline type housed in the base of the camera. A delayed-action release is introduced for the first time in Praktica cameras.

Praktica LTL, 1972. Using the stopped-down metering system of the Super TL, which it supersedes, the Praktica LTL has all the other features of the L range including a delayed action (self-timer) mechanism as an optional extra. The meter uses the popular PX 625 battery and is controlled by a switch beside the lens mounting above the shutter release.

Praktica LB, 1973. With a built-in uncoupled selenium meter at the rewind end of the camera, this is a replacement of the Nova 1B with the styling and other improvements of the Praktica L. It has no delayed-action mechanism.

Praktica VLC, 1975. Using the full-aperture metering system of the LLC, the Praktica VLC also has a choice of viewfinders and screens. It is supplied with pentaprism or waistlevel finder and a 5× magnifying finder is also available. There is a choice of seven viewing screens. The meter beam splitter is in the mirror, so that full metering facilities are available with all finders. The flash contact is a 3mm coaxial socket in the camera side wall. Other features are the same as the LLC, but there is no shutter release lock.

LOADING AND UNLOADING
THE PRAKTICAS

All Praktica cameras use standard 35mm perforated film, which is generally supplied in cassettes containing sufficient film for 20 or 36 exposures. Films are available for black-and-white and colour in a range of speeds or sensitivities (see page 106).

Before you can load film into the Praktica cameras you have to open the back. This is effected in all cameras except the Praktica L models by pushing the latch on the side of the camera. The back of the Praktica L models is opened by pulling the rewind knob upwards. The back of all models up to and including the VF is completely removable. The Novas and later models have hinged backs.

The film is inserted into the chamber under the rewind knob with the protruding end of the cassette spool at the bottom of the camera and the mouth of the cassette facing the take-up spool. To insert the film the rewind knob has to be pulled up. It is then pushed back and twisted to and fro to ensure that its pronged end engages the bar in the end of the cassette spool.

Automatic and non-automatic loading

Loading film into the Praktica cameras is simple enough in the earlier models, but in the Nova 1 models, the Super TL and the Praktica L series, it is made even easier. These models have an ingenious quick-load take-up spool with a wire bracket which guides the film around the take-up spool. All you do is to put the film leader across the back of the camera, slip its bottom edge under the support piece below the bottom sprocket wheel and lay it on the take-up spool so that the end of the film lines up with the mark below the spool. Close the camera back and the film winds automatically on to the spool when you operate the film transport lever. If you load your own cassettes from bulk film (see page 110), it is best not to cut the end to the conventional leader shape.

The earlier models have a slotted take-up spool. In these the film is pulled across the camera back in the same way and the take-up spool rotated by its flange until the film leader can be inserted into the slot and out the other side. It will then generally be found best to crease the film with the thumbnail on the exit side so that it will not slip out as the film is wound on. You may, in fact, prefer to make this crease about a quarter of an inch from the end of the leader before inserting it into the slot. The spool is then further rotated by its flange so that the leader passes over the spool (emulsion inwards) on early models and under the spool (emulsion outwards) on Praktica IV, V and the first Novas. It is advisable to continue winding the leader on to the take-up spool until both sprocket wheels engage the film perforations.

The final step after loading the film is to make sure that the pressure plate is perfectly clean and to close the back of the camera by pressing it together. The removable backs of the earlier models are first fitted to the body at the opposite end to the catch. The camera is made ready for the first exposure by operating the transport knob or lever twice, releasing the shutter each time. This winds off the first three inches or so of film that has been exposed to light during the loading operation. Winding the film on once more brings the first unexposed frame of film into position.

At this stage the exposure counter is set automatically on the Nova and later models but has to be set manually on the film-transport knob of earlier models.

Setting the film speed

An extra step—setting the film speed—is necessary on the models with built-in meter. On the LLC and VLC, the film-speed figures appear in a cut-out on the shutter-speed knob as you lift and turn its rim. On the Super TL the film speeds are on a dial under the shutter-speed knob. Pull the knob upwards and rotate it in either direction until the mark on its side wall is opposite the required figure. The knob clicks into position when lowered. Sometimes the shutter-speed knob has to be turned while you carry out this operation because some film-speed figures are hidden between the knob and the side of the pentaprism.

The Prakticamat has a white arrow on the shutter-speed

dial (around the rewind knob), to which the appropriate figure on the film-speed dial above it is set. On the Novas and LB the film-speed ring on the rewind knob has a protruding stud allowing it to be turned until the required figure shows in a cut-out window. The Prakticas IVB and VFB have a similar arrangement but the rewind knob has to be pulled up to reveal the figures.

On the models without exposure meter, there is generally a speed-setting facility on the rewind knob but this is merely a reminder. It has no operational function.

Rewinding and unloading

The exposure counter tells you when you have reached the end of the film. Then, before you can take the film out of the camera, you have to wind it back into the light-tight cassette. You must not open the camera before rewinding, because the film is unprotected and exposure to light will "fog" it, i.e. the light acts on the sensitised emulsion so that it will blacken all over on development.

If you do accidentally open the camera back before re-winding you may be lucky enough to save part of the film if you close the back again immediately and then rewind. The beginning of the film, i.e. the part on the inner coils on the take-up spool, is partially protected by the later coils and light may take a few seconds to reach it.

Before rewinding, you must depress the rewind button which is in the base plate of the L series cameras and in the top plate next to the transport lever of the earlier models. The rewind button of the Praktica IV and later models remains depressed until you operate the film-transport lever. In the older models it has to be held in the depressed position while the film is rewound.

The film is rewound by turning the knob at the opposite end of the camera top plate to the film-transport knob or lever. The Praktica IV and V models (except the built-in meter versions) have a two-part knob, the top part swivelling to make rewinding easier. Later models have a fold-out crank for the same purpose. Nevertheless, the film should not be rewound too quickly. Should any obstruction occur, the leverage on the crank is quite sufficient to tear the film and perhaps make it necessary to take the camera into a darkroom to complete the unloading. Turn the knob or crank steadily

LOADING
PRAKTICA L SERIES

To load the Praktica L models you first open the camera back by pulling the rewind knob up as far as it will go. This releases the latch and the back springs open.

Insert the loaded cassette and push the rewind knob back to engage the bar across the spool end.

Pull the film leader across the camera back and pass it under the guide below the transport sprockets as far as the green mark below the take up spool. Make sure that the wire bracket does not point upward.

Close camera back by pressure. It locks automatically.

Operate transport lever and shutter release alternately until the exposure counter shows No. 1. This generally needs three strokes of the lever and two operations of the shutter release, leaving the shutter tensioned ready for the first exposure.

Set the speed of the film in use by pulling the rim of the shutter speed knob upward and rotating it until the appropriate figure shows in the cut-out.

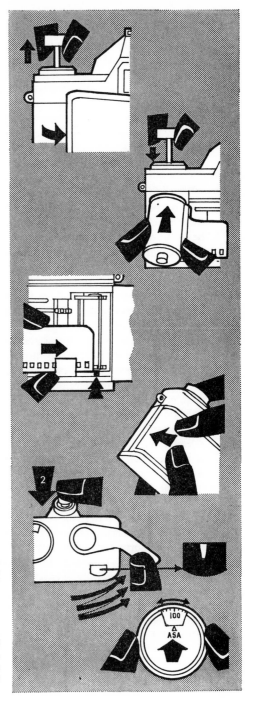

and smoothly until you feel the film pull away from the take-up spool. Two or three more turns will then wind the film fully into the cassette. If you prefer to leave the leader protruding, however, you can stop turning as soon as the film leaves the spool. You can then open the back of the camera and remove the exposed film. If you have left the leader protruding, you would be well advised to tear part of it off or mark it to indicate that the film has been exposed. It is only too easy to make a mistake and put the film back into the camera later under the impression that it has not been exposed.

Unloading partly-exposed film

The occasion may arise when you want to take a film out of the camera before you have exposed all of it. Your idea may be to process the exposed part and keep the rest for later use or to change the film for one of another speed or type.

If you want to cut off the exposed film for processing, take the camera into a darkroom or other completely dark place. Open the camera back, pull up the rewind knob and lift the cassette from its chamber. Pull about an inch of film out of the cassette and then cut the film close to the cassette opening. Put the cassette aside, depress the rewind button (holding it down on earlier models) and gently pull the exposed film from the take-up spool. The best procedure is then to insert the exposed film in the developing tank (see page 231) immediately, but you can, if necessary, store it temporarily in a light-tight container. The lights can then be switched on and a length of film pulled from the cassette and trimmed to make a leader ready for reloading. Remember to mark this leader to indicate that the film is now a short length. Generally, you will lose four or five exposures by this procedure.

If you do not wish to cut the film for immediate processing but merely to replace it by a film of a different type, the procedure is simpler. Look at the exposure counter and take a note of the number of exposures so far made. Unload the film in the normal way but do not wind the leader completely into the cassette. Take the film out of the camera and mark on the leader the number of exposures made.

When you wish to use the film again, load the camera in the usual way but put the lens cap on as soon as you close the camera back. Make the usual two "blind" exposures followed by the number of exposures noted from the film

LOADING
OLDER MODELS

Models previous to the L series have a back latch at the rewind end of the camera when the back is removable and at the transport end when the back is hinged. Press the latch downward or upward as indicated, to open the camera back.

Pull the rewind knob up and insert the cassette. Push back the rewind knob.

Pull the film leader across the back of the camera and, on Prakticamat, the first Novas and all previous models, push it through the slot in the take up spool and rotate the spool so that the film winds emulsion-in on early models and emulsion-out on Praktica IV and later.

The Praktica Nova I and later models have a quick loading device which merely needs the leader to be pushed under a guide and laid on the take-up spool to a green mark.

Close the camera back by pressing the hinged models together and by fitting the opposite end to the lock to the camera first on the removable-back models.

Make two blind exposures to wind off fogged film. On the Nova and later models this sets the exposure counter.

On earlier models, set the exposure counter to No. I by turning the disc in the transport knob.

Set the film speed and type reminder on models without exposure meter.

On Prakticas IVB and VFB pull up rewind knob to reveal film speed scale.

Set film speed on Nova B models,

Set film speed on Prakticamat.

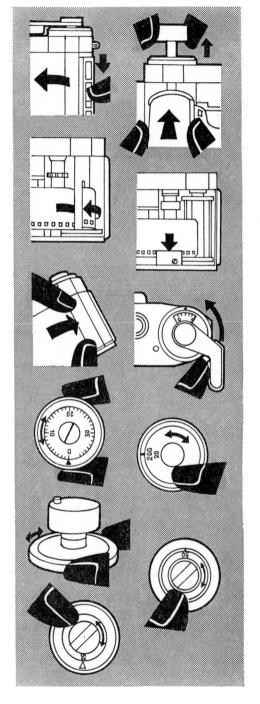

leader and one more for safety. You can then expose the rest of the film.

Protecting the film from light

The cassettes in which films are supplied are light-tight in normal use but it is possible for strong light to penetrate the opening through which the film passes. It is therefore advisable to avoid loading or unloading the camera in bright sunlight. If there is no shade or darker place available, turn your back to the sun and hold the camera close to your body while loading or unloading. This precaution is particularly necessary if you load cassettes repeatedly from bulk film supplies (see page 110).

LENSES FOR THE PRAKTICAS

The supreme advantage of an interchangeable lens camera is that you can adapt the camera to a variety of subjects that you could not consider taking with the standard lens. You can, for example, use a wide-angle lens to shoot at relatively close range and yet still take in a broad view of the scene in front of you; or you can use a long-focus lens to obtain a large image on the film of a distant detail.

The terms "wide-angle" and "long-focus" are relative. They relate to the normal or standard lens of any particular type of camera. The wide-angle lens has a broader angle of view than the standard lens. From a given viewpoint, it takes in more of the scene in front of it but on a reduced scale. The long-focus lens has a narrower angle of view. It takes in less of the scene but reproduces those details it does accept on a larger scale.

Lenses are specially made for the Prakticas by the Carl Zeiss organisation of Jena, the Meyer Optik division of Pentacon VEB, and by the Japanese Sigma company, who produce the Prakticar range. They range in focal length from 20mm to 1000mm (see page 289). There are, however, many hundreds of lenses made by various manufacturers at all prices with the same thread as the Praktica lenses and many others can be fitted to the Prakticas by means of adaptors.

Focal length and angle of view

The angle of view of standard lenses on any camera is about 45°. The average wide-angle lens provides about a 60–75° view, but special models can even give more than 180°. The long-focus lens is similarly almost limitless. On 35mm cameras such as the Prakticas, the most popular angle is about 18° but there are extremely long-focus lenses that take in no more than about 1° of arc of the scene in front of the camera.

Lenses are differentiated by focal length. When you know the focal length of a lens and the type of camera on which it is to be used, you have a good idea of the nature of the lens and the type of image it will produce. The focal length of

the standard lens of a 35mm camera is generally between 50 and 58mm. What this means in practice is that, when the lens is focused on infinity, the distance between the lens and the plane in which it forms an image (the position of the film in the camera) is equal to the focal length of the lens. As most photographic lenses are complex constructions, this may not always appear to be true because the distance is actually measured from the optical centre of the lens and the position of the optical centre can vary. It can sometimes even be outside the lens. That is the secret of the telephoto and retrofocus constructions (see page 58).

The scale of the image a lens reproduces is strictly proportionate to its focal length. Thus, the 50mm standard lens produces an image one quarter the size of that produced by the 200mm long-focus lens and more than twice the size of the image from the 21mm wide-angle. This, of course, remains true no matter what the size of the film in the camera. Thus, on 35mm film, a lens of about 50mm focal length takes in just about the angle that seems natural to the human eye and is therefore regarded as normal. If the film were larger, however, say 6 × 6cm, the image would still be on the same scale but more of the scene in front of the camera would be reproduced on the film. In other words, on a 6 × 6cm film, the 50mm lens would be a wide-angle lens.

This is generally of little importance to Praktica owners because they are concerned only with 35mm film, but it is a point worth remembering if you like to experiment with other cameras. Your lenses will have different characteristics as regards their angle of view if you fit them to larger format cameras and, moreover, they are unlikely to provide a sharp or evenly illuminated image all over the larger film. They are specifically designed to work with 35mm film.

The angle of view of a lens is, in fact, normally expressed on the diagonal of the image format. It can be measured quite simply, as in the diagram on page 41, by drawing a line of the length of that diagonal (*AB*) and erecting a perpendicular from its centre of a length equal to the focal length of the lens (*CD*). Then the angle contained by *ADB* is the angle of view of the lens. This is, in fact, the angle of view when the lens is focused on infinity. When it is focused closer, the lens is farther from the film, as represented by *E* in the diagram and the angle is smaller. Thus, in close-ups,

38

the lens has a narrower angle of view than that generally quoted for it.

Lens diaphragm and f-numbers

All Praktica lenses are fitted with an internal diaphragm to control the amount of light passing through the lens and so acting on the film. A film of a given sensitivity or speed (see page 106) needs just so much light to form an image and no more. The Praktica lenses generally pass far more light than the film requires when the diaphragm is fully open, so, in most cases the diaphragm opening, or aperture, has to be reduced to take the picture.

To facilitate calculation of the exposure (see page 63), and therefore the aperture required, all lenses carry a series of markings which indicate the proportion of the light allowed to pass through them. These markings have numbers in the series 1, 1.4, 2, 2.8, 4, 5.6, 8, 11, 16, 22, which are known as f-numbers. The smaller the number, the more the light passed. At each larger number, the amount of light passed is exactly half of that passed at the previous number. Moreover, the markings are standard for every lens. The numbers do not indicate a particular physical size of the aperture; they indicate light-transmitting power. Thus, at a given f-number, the same amount of light reaches the film, whatever the focal length of the lens.

In practice, this means that the size of the aperture at any given f-number is greater for a long-focus lens than it is for a short-focus or wide-angle lens. The size is, in fact, roughly the focal length of the lens divided by the f-number, so that a 50mm lens set to f2 has a diaphragm opening about 25mm in diameter, whereas a 300mm lens with a 25mm aperture would in fact be set to f12. This is because the light from the longer focus lens has to travel about six times as far from the lens to the film as the light from the shorter-focus lens. By the inverse square law (see page 129) its strength on the film surface is reduced to 1/36th of that from the 50mm lens and the aperture of f12 as opposed to f2 reflects that fact.

If the 300mm lens were required to have an aperture of f2, it would need a diaphragm opening of 150mm. Such a lens would be impracticably large and expensive to manufacture. Thus, longer-focus lenses tend to have smaller maximum apertures than short-focus lenses.

39

Automatic diaphragm lenses

Lenses for single-lens reflexes are rather more complicated than those for other cameras. It is essential with this type of camera that the lens pass as much light as possible to the screen for focusing purposes. A brighter image is much easier to focus and, because it is projected at a large lens aperture, the image moves more positively into and out of focus. Thus, the lens diaphragm needs to be wide open to view and focus the image but, more often than not, has to be closed down to take the picture.

In the early days of the SLR, this caused the camera to be rather slow in operation, because the opening and closing of the diaphragm had to be carried out manually before and after each exposure. It was only too easy to forget to close down after focusing, with the result that the shot was severely overexposed. Now, most lenses have fully automatic diaphragms, which means that the closing of the diaphragm is effected automatically as the shutter release is depressed. The reopening is effected by spring pressure. Thus, the photographer rarely sees his lens diaphragm stopped down. It closes only for the actual exposure and, during that time of course, the miror swings up and obscures his view.

In Praktica cameras from the FX2 to the Super TL (earlier models than the FX2 have no facility for the use of automatic diaphragm lenses) you can see the mechanism that operates the lens diaphragm when you remove the lens from the camera. Just below the mirror, there is a device that moves forward as the shutter release is pressed and pushes in the pin in the rear of the lens mount. The pin operates the diaphragm and causes the lens to close down to the aperture set on the aperture scale of the lens. As you let go of the shutter-release button the pin springs out again and the diaphragm re-opens. This action is, in fact, a little too fast for the longer shutter speeds because, unless you keep the shutter release depressed, the diaphragm re-opens to full aperture while the shutter is still open—leading to overexposure and possibly insufficient depth of field. So you have to keep the shutter button depressed until the shutter closes.

The mechanism in the Praktica L models is slightly different in design and does not have this drawback. It remains in the forward position and thus holds the lens diaphragm

The reflex principle of the Prakticas allows them to use any lens that can be mounted on the camera body. As the Pentacon screw thread of the Praktica has been adopted by many other camera manufacturers, the range of lenses available is tremendous. Those made specifically for the Prakticas range from 20 mm. to 1000 mm. but lenses of even shorter focal length down to the 8 mm. or so of special "fish-eye" lenses are also made with the same thread. The upper diagram gives an indication of the angles of view associated with each focal length.

The calculation of the angle of view is shown in the lower diagram. AB is the diagonal of the image area. CD, perpendicular from the centre of AB, is the focal length of the lens. The angle ADB is then the angle of view of the lens, expressed on the diagonal when the lens is focused at infinity. When the lens is focused closer, it is further from the film, as at E. The angle of view is then narrower.

at its pre-set position until the shutter closes—regardless of whether or not you keep the shutter release depressed.

The Praktica Super TL and L series mechanisms have no provision for disconnection whereas, on the earlier models, if you gently lift the mirror you will see a little red button that can be slid left or right. When it is slid to the right the automatic iris facility is disconnected. This was originally introduced to allow the mechanism to be disconnected when lenses without automatic diaphragms were used, because such lenses often protruded farther into the camera body. If they protruded far enough to foul the automatic diaphragm mechanism the shutter could not be released until the mechanism was disconnected. There are not many such lenses now in use but if you do use an older lens (probably more than 10 years old) check it against the diagram on page 59. The rear element of some wide-angle lenses may protrude much further than the recommended 5.6mm into the camera, but they are still usable. It is the length of the lens at the threaded perimeter that is important. If that is longer than 5.6mm the lens cannot be used at all on the Praktica L models and can be used on other models only if the automatic mechanism is disconnected.

Practically all wide-angle and standard lenses now have fully automatic diaphragms (FAD), but there are still many long-focus lenses that are only partly automatic or not automatic at all. The semi-automatic types are generally described as PD, which means pre-set diaphragm. In this type, there are either two rings controlling the diaphragm or one spring-loaded ring that can be moved fractionally against the spring along the barrel. In operation, one of the rings, or the single ring in one of its positions, is set to the f-number required but, as in the automatic lenses, this does not actually stop the lens down. After focusing, the other ring, or the single ring in its normal position, is turned as far as it will go and the lens stops down to the pre-set aperture. After the exposure, the diaphragm has to be reopened manually.

Some very-long-focus lenses and some inexpensive lenses do not even have this refinement. They are generally known as manual and sometimes as CS (click-stop) lenses, meaning that the opening and closing of the diaphragm has to be carried out manually. Most lenses nowadays have click stops, which simply means that at each f-number setting, and some-

42

200 **100** **50** mm

200	100	50
		16
	22	11
	16	8
22	11	5·6
16	8	4
11	5·6	2·8
8	4	2
5·6	2·8	1·4
4	2	

The f-number is a numerical description of the effective aperture, obtained by dividing the focal length by the diameter of the effective aperture. Thus, the aperture size varies with focal length, even though it carries the same f-number. The upper diagram shows the relationship between apertures and focal lengths. The aperture size is the same for example, on a 200 mm. lens set to f11, a 100 mm. at f5.6 and a 50 mm. at f2.8. Naturally, more light reaches the film from the 50 mm. lens with this size of aperture because it has a shorter distance to travel.

The effective aperture is the diameter of the light beam entering the lens and passing through the diaphragm opening. As the front element of a lens is usually a positive (converging) lens, the effective aperture is generally larger than the actual diaphragm opening.

times at intermediate settings, a ball bearing clicks into a niche. This gives a quicker and more positive location of the setting required and also facilitates working in the dark, because it is a simple matter to count the "clicks" from either end of the scale.

Electric lenses

A unique range of lenses is supplied for the Praktica LLC and VLC cameras. With fully automatic diaphragms operated in the same way as on the other L-range Prakticas, these electric lenses are designed for full-aperture metering. Any full-aperture metering method requires a means of transmitting to the meter circuit the setting of the aperture control ring. The meter circuit can then convert the full-aperture reading to the appropriate reading for the pre-selected shooting aperture. Other systems generally use physical movement of cams and levers to transmit this information, but the Praktica system is all-electric. Powered by the large battery in the camera base, it uses electrical contacts on lens and camera body to send signals through electrical resistances to the meter circuit, the signal strength varying with the setting of the aperture control ring.

The special electric lenses are easily recognised by the three point contacts in the rear of the lens mount. Although designed specifically for the Praktica LLC and VLC, they can be used on other Praktica cameras, with or without meter. On the Prakticamat, Super TL and LTL, they can be used only for stopped-down metering. The diaphragm stops down automatically when the meter is switched on.

Uses of wide-angle lens

A wide-angle lens is a useful addition to anybody's range of equipment. There are many occasions when it actually creates picture possibilities—occasions when the standard lens could not be used at all. The obvious applications are in the photography of tall buildings or other large objects. In such cases it is frequently not possible to get far enough back for the standard lens to include all of the subject. Similarly, in enclosed spaces or cramped surroundings, the standard lens may take too narrow a view to give the picture required.

The advantages of the wide-angle lens are not confined to its angle of view. The shorter its focal length, the greater the

SLR OPERATION

From the VF onwards, the Praktica cameras have instant-return mirrors as well as automatic diaphragm lenses. This means that the camera is ready to view and focus the next picture immediately after the shutter has closed.

Top: The picture is composed and focused at full aperture with the mirror in the down position. Aperture and shutter speed are set but the diaphragm remains fully open.

Middle: When the shutter release is pressed, the diaphragm closes to the pre-set aperture, the mirror swings up to obscure the viewfinder, and the shutter opens to allow the exposure to be made.

Bottom: As soon as the shutter closes, the diaphragm returns to full aperture, the mirror swings back to the viewing position and the camera is ready to view the next picture.

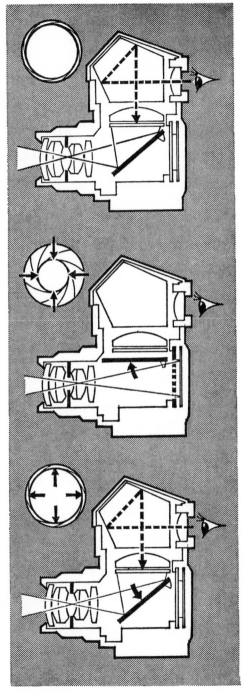

depth of field it gives and that, in practice, means that focusing need not always be absolutely precise. In a way, that is just as well, because it is often not very easy to distinguish between sharp and slightly unsharp images thrown on to the focusing screen by a wide-angle lens. Focusing by scale is quite practicable and, in many cases, the lens can be set to a distance such as 2–3m or 7–10ft to provide a sharp image from close range to the middle distance (see page 92).

A further advantage is that many wide-angle lenses can focus objects at 15cm (6in) or less, which makes hand-held photography of a whole range of close-up subjects possible. Such lenses are useful for photographers specialising in wild flower photography and similar pursuits.

The very close approach that the wide-angle lens makes possible is also frequently used to produce striking effects of exaggerated perspective. Even a very small object placed close to the lens can be made to dominate the foreground and miniaturise the background by comparison. Lines can be made to converge with exaggerated strength to provide powerful compositions. A small aperture can enable the whole scene to be rendered sharply. A larger aperture can throw more or less of the background out of focus.

Naturally, exaggerated or distorted perspective does not suit every subject and the facility of moving in close that the wide-angle lens offers must not be misused. Too close an approach to the subject with any lens makes objects nearer to the lens look disproportionately large, which can be at least displeasing in portraiture and is often totally unacceptable in pictures of machinery, buildings, animals and many other subjects.

This type of distortion can be encountered with any lens. It is not caused by the lens but by the close viewpoint. There is another type of distortion that is typical of the wide-angle lens and is caused purely by the acute angle at which the light rays forming the image are projected from the back of the lens on to the film. The result is to spread the image of any three-dimensional object at the edges of the picture. Thus, a row of equal-sized pillars is reproduced with the outer pillars thicker than those in the middle. People at the edge of the picture look fatter than they should. Spheres in the same position come out as ellipses.

Other troubles may arise with inexpensive wide-angle

DIAPHRAGM MECHANISMS

This simple form of pre-set diaphragm (PD) has a sprung ring with a marker which disengages the aperture ring when pulled upwards and can be turned to the required shooting aperture while leaving the diaphragm fully open. After focusing, the ring is turned to its limit, which is the pre-set aperture.

The automatic diaphragm mechanism of the Prakticas before the Super TL had a small button which could be moved to the right to disengage the mechanism and to the left to engage it. It was advisable to disengage the mechanism when some older non-automatic lenses were used because they projected too far into the camera body and could prevent the shutter release being depressed.

The LLC and VLC have electrical contacts on the camera body and on the rear of the special lenses. These transmit information to the meter regarding the aperture pre-selected on the lens to allow the meter reading to be made at full aperture.

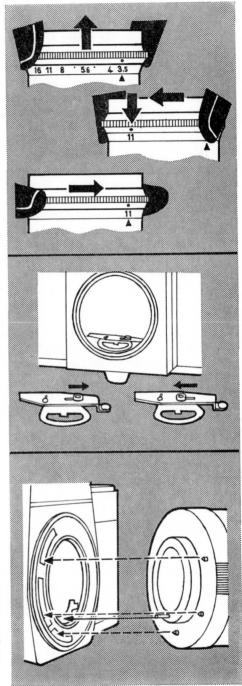

lenses or those from the less-well-known manufacturers. All lenses illuminate the centre of the image area more strongly than the corners, but the difference is generally marginal except in extremely wide-angle lenses such as the so-called fish-eye, which inevitably produces a circular image and therefore fails to illuminate the corners at all. The reputable wide-angle lens of less extreme characteristics illuminates the whole image area reasonably evenly, but there are some lenses that do not measure up to these high standards. By failing to expose the corners of the picture sufficiently they produce prints and transparencies with dark corners. In transparencies this type of fault is frequently evident in the deeper blue of the sky in the corners of the picture.

It is also difficult, and expensive, to produce a wide-angle lens that does not suffer from barrel distortion, which causes straight lines at the picture edges to bow outwards.

These faults become more difficult to eliminate as the focal length gets shorter and a faultless 20mm lens, for example, is very expensive. A 28 or 35mm lens can be relatively fault-free at a much lower price. One or other of these focal lengths could, in fact, provide the most useful all-round lens for the photographer who feels the need for a broader view than that provided by the standard lens but does not intend to use the extreme effect possible with very-short-focus lenses.

Characteristics and uses of long-focus lenses

Long-focus lenses for the Prakticas range from about 75mm to 1000mm. Lenses of 75–100mm are particularly useful for portraiture. Although perfectly good portraits can be taken with the standard lens, there is often a temptation to approach the subject closely to fill the frame. Then the camera may become rather obtrusive and unnerve the sitter, or the close viewpoint may cause some distortion. A shoulder turned towards the camera, for example, can look unnaturally large, while a *very* close viewpoint can actually make the face look an entirely different shape.

These lenses, and the popular 135mm are the medium long-focus lenses. Apart from their value for portraiture, they enable a larger image to be obtained of subjects just out of reach of the standard lens. The 135mm gives an image more than $2\frac{1}{2}$ times the size of that from the 50mm lens, making it possible to photograph people from across the street, for

48

LIGHT MAKES THE PICTURE
(*Above*). Pick out a detail and make a picture out of nothing. Strong side lighting, a 135mm lens and the bright viewfinder of the Praktica can present such striking pictures to the truly observant. Photo: *Raymond Lea*, Marlow, England.

Page 50 (*top*). The brilliantly lit background afforded an opportunity for true indoor silhouette treatment. Photo: *Wolfgang Strunz*, Aachen, Germany.

Page 50 (*bottom*). High-contrast processing can produce the pure black and white effect in a suitable outdoor setting. Photo: *Raymond Lea*, Marlow, England.

Page 51. Reflecting surfaces, such as water, subdue the silhouette effect of backlighting and allow some detail to appear in the figure. Photo: *Vladimir David*, Pardubice, Czechoslovakia.

Page 52. A fallen (or carefully placed) twig, late afternoon sun and, again, the light makes the picture, highlighting texture and adding shadows that are stronger than the subject itself. Photo: *B. C. Wignall*, Colwyn Bay, Wales.

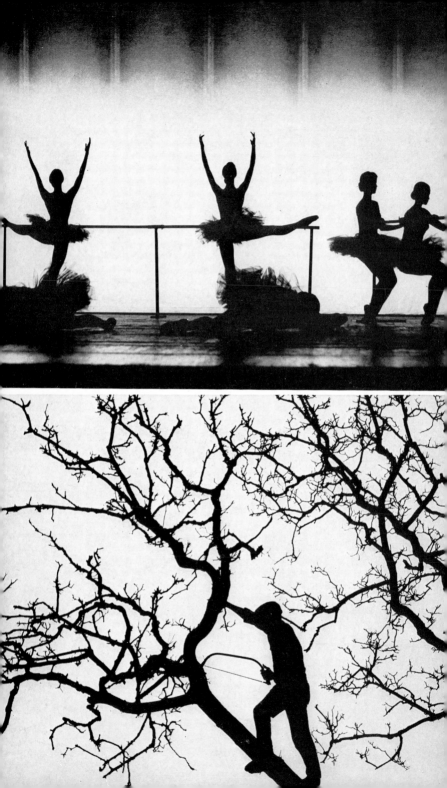

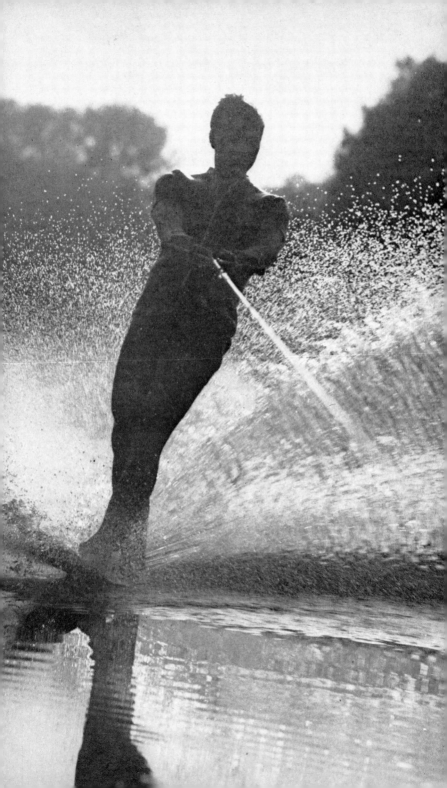

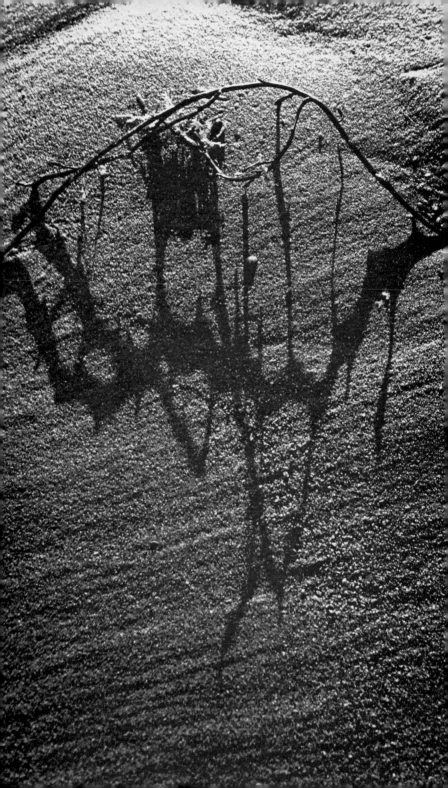

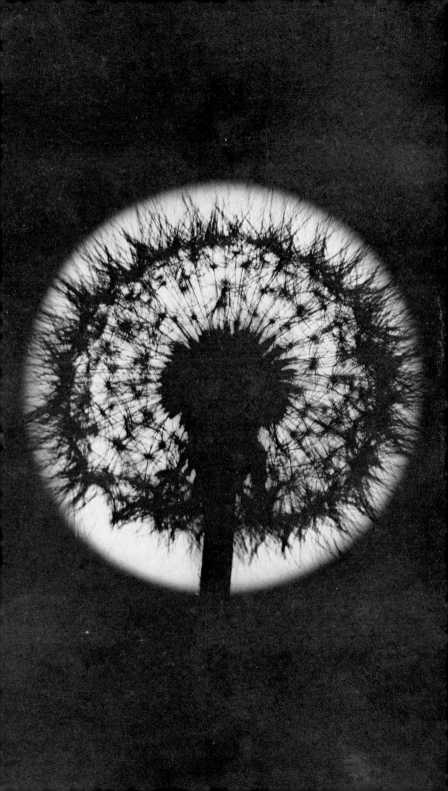

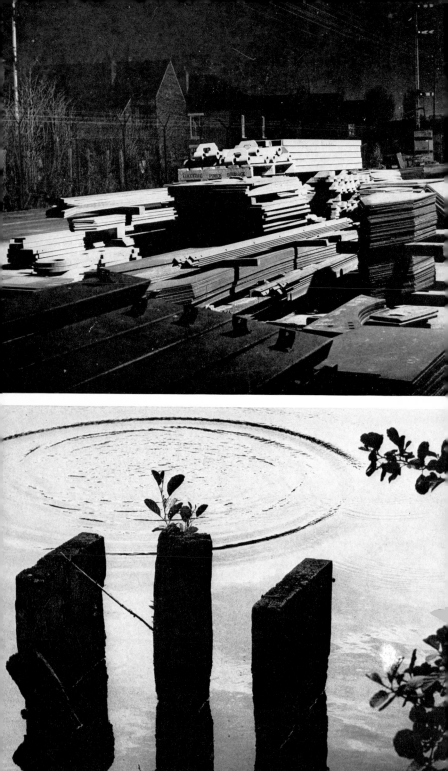

Above. Just an old cart but when the sun strikes it at a steep angle the lines are emphasised and a part can be selected to form an interesting composition of lines and shapes. Photo: *Raymond Lea*, Marlow, England.

Page 53. A strongly back-lit dandelion clock, vignette-style printing and you have a novel way of presenting a simple subject. Photo: *Pentacon VEB.*

Page 54. (*top*). The most inanimate of objects can be given life by strong directional lighting. Here the powerful floodlights of a railway yard at night provided ideal conditions. Photo: *T. Smith*, Lincoln, England.

Page 54. (*bottom*). A successfully contrived picture using backlighting to set the dark bulk of the posts against the contrasting shape of ripples in smooth water. Photo: *Raymond Lea*. Marlow, England.

Cats are furry and cuddly and thoroughly domesticated animals—unless you happen to fire a flash straight into the face of one of them when he is in a less than playful mood. Note how frontal flash in this case brings out the texture of the fur and tongue. Photo: *R. F. Miles, Edgware, England.*

example. It can be useful at sports meetings and other events where the public enclosure is a little removed from the action. The 135mm lens is also a convenient lens for photographing many types of animal, either where a close approach is inadvisable or where it would introduce distortion.

Part of the popularity of the medium long-focus lenses is due to their compactness and the fact that their angle of view remains reasonable in relation to the distance at which they are normally used. Each of these factors is of importance in obtaining a sharp image. An unduly long or heavy lens unbalances the camera and makes it difficult to hold it steadily enough for perfect sharpness of the image. Further, when the object photographed is at some distance from the camera and is subsequently enlarged considerably on the print, it needs only the slightest movement of camera or lens to introduce considerable blur. The long-focus lens magnifies not only the image but also the effect of the movement.

When the focal length of the lens exceeds 135mm, these factors begin to give real trouble and most such lenses either need very great care in handling or must be used on a tripod.

The longer focal-length lenses of normal construction made for the Praktica are in the range 180–500mm. These lenses have a great many uses for photographers who specialise in such subjects as sport, architectural detail, animals, birds, and others that call for a fairly distant viewpoint. Their use is only possible on the reflex camera and the view that they provide on the screen of subjects that are often not easily discernible by the human eye can be quite startling. The restricted depth of field associated with the large aperture and long focal length also make focusing swift and positive.

This ease of focusing points, however, to the type of result that may be achieved. Even at long range, the exceptionally long-focus lens, such as the 500mm, has to be stopped well down if a significant depth of field is required. If a 200mm lens is used at about, say, 8m or 20ft to take a so-called candid shot, it may not even be possible to obtain the depth required. On the other hand, of course, a long-focus lens used at such close range or even closer, can give an abrupt separation of planes that might be just what the photographer requires.

Similarly, the apparent compression of perspective in a long shot can be an unfortunate by-product or it can be used

deliberately to create a picture that does not exist in reality. This compression is the opposite of the exaggerated perspective often obtained with the wide-angle lens (see page 46). There, the close viewpoint exaggerates the size of foreground objects and, by inference, the distance between them and objects farther from the camera. With the long-focus lens, the foreground imaged is actually fairly distant from the camera and the difference in sizes of objects at different distances is not so marked. In extreme cases, objects quite widely separated are reproduced as more or less the same size and therefore look as if they are much closer together.

Telephoto and retrofocus constructions

There is a tendency to call all long-focus lenses telephoto lenses. In fact, the true telephoto lens is a special construction. It is made in such a way that the optical centre, from which the focal length measurement is made (see page 37) is shifted forward and is often outside the actual lens. The effect, therefore, is that the overall length of the lens is reduced and the true telephoto lens can be recognised from the fact that its physical length is less than its focal length. This makes it easier to handle and, in the shorter focal lengths, may make it possible to hand hold a lens that would otherwise need to be used on a tripod.

The telephoto construction is widely used for lenses between about 100 and 200mm focal length. Longer lenses are more likely to be of normal long-focus construction with considerably fewer (perhaps two or three) components.

A similar principle is used for wide-angle and standard lenses. In reflex cameras such as the Praktica, there has to be room between the lens and the shutter for the mirror to swing up and cover the ground-glass screen. On the other hand, very short-focus lenses of normal construction have to be placed extremely close to the film and the mirror could foul the back of the lens as it swings upwards. The solution was to make inverted telephoto lenses, commonly known as retrofocus lenses. The effect in this case is not to reduce (as in the telephoto) but to increase the separation between lens and film (the back focus). The retrofocus lens has a back focus longer than its focal length, thus providing the additional space required by the mirror. The principle is now widely used in both wide-angle and standard lenses.

LENSES

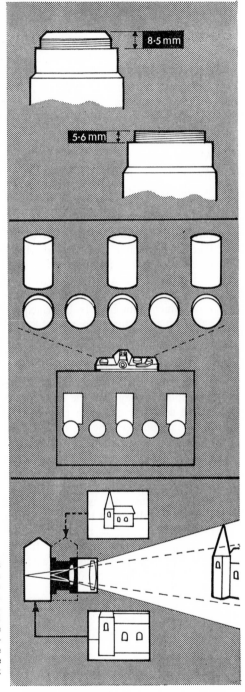

Some older lens threads project farther into the camera body than the present 5.6 mm. If they do so, they cannot be used on the Praktica Super TL, or L range. They foul the automatic diaphragm mechanism, which is pushed forward by the shutter button action, and so prevent the shutter from being released.

An in-built distortion of any wide-angle lenses is that of spreading the image of three dimensional objects at the picture edges. Pillars, tubes, spheres, etc. look fatter than those in the centre. This effect is not obtained with two dimensional subjects, such as discs, provided they are in a plane parallel to that of the film.

The tele-converter works on a simple principle. It is a negative (diverging) lens which when placed behind a normal converging lens, lessens its convergence and causes it to focus its image further back. The converter, in effect, moves the camera back into this plane to receive an enlarged part of the original image.

The retrofocus lens can often be recognised by its very large front glass, which is a requirement of this type of construction and which makes some standard lenses look much more impressive than their normally constructed counterparts.

Whether a lens is of telephoto, retrofocus or normal construction makes no difference to its general handling and performance. It acts in exactly the same manner in each case.

Mirror lenses

Another special type of lens is peculiar to the longer focal lengths from 500mm upwards. At these focal lengths, the telephoto construction becomes expensive and impracticable. Consequently, a 500mm or 1000mm lens, for example, is a physically long lens that is not at all easy to handle. The ingenious principle devised to shorten the light path in these cases was to fold it up by using mirrors instead of lenses. This is known as a catoptric lens as opposed to the dioptric type normally used in photography. There is also a catadioptric type which combines both principles. Mirror lenses from various manufacturers are available for Praktica cameras. The folded light path principle used by these lenses makes them considerably shorter (but of greater circumference) than the normal lenses of these focal lengths.

The performance of the best of these lenses is quite remarkable but they have the drawback that they cannot incorporate a diaphragm. The only method of controlling their light transmission is by the use of filters. Coloured filters can sometimes be used with black-and-white film, but neutral-density filters are essential for colour film.

If you decide to buy a mirror lens, it is preferable to choose one of modest aperture, say $f8$ or $f11$. Faster lenses are made, but pause to consider the effect of a larger aperture on a 500mm or 1000mm lens. The depth of field, even in long-range shooting, can be rather shallow and you have no means of stopping down to increase it. It is generally better in this type of photography to have more depth of field than you really require than to have too little.

Tele converter attachments

You do not have to buy another complete lens to obtain longer focal lengths. Any lens can be converted to a form

of telephoto construction by placing a suitably designed negative lens or group of lenses behind it. Such lenses are available as tele converters. The principle is quite simple. The negative lens intercepts the converging light rays from the positive camera lens and lessens their convergence sufficiently to bring them to a focus at a greater distance from the camera lens. This has the effect of spreading the image so that only the central portion appears on the film in a magnified form. The rays forming the outer edges of the original picture no longer converge sufficiently to fall on the film.

Tele converters are supplied as 2×, 3× or variable 2–3×, meaning, respectively, that they double the focal length (and therefore the size of the image) triple it, or can be adjusted to double or triple.

There are several models, some relatively expensive and some not so expensive. Unless you are lucky, the most expensive is the best. It can give remarkably good results, generally better than the results from the cheaper long-focus lenses, provided it is used on a good-quality camera lens. Naturally, it cannot, except in image size and the benefits associated with it, improve on the results given by the lens with which it is used, but the good-quality converter will not noticeably impair the performance of the prime lens.

You have to pay a penalty for the convenience of the tele converter. It *is* convenient because it is smaller than any lens but effectively doubles the number of lenses you own. The penalty is in maximum aperture. Your focal length is doubled (or trebled) but your diaphragm openings remain the same. As the *f*-number of the diaphragm opening is directly related to the focal length of the lens (see page 39), doubling the focal length also doubles the *f*-number, and the marked *f*-numbers no longer apply. Your *f*8 becomes *f*16, *f*11 is *f*22 and so on. The effect, of course, is that the maximum aperture of your lens is reduced by two stops. Your 50mm *f*2 lens becomes a 100mm *f*4 (or, with a 3× converter, about *f*6.3).

On the other hand, there is an advantage. The tele converter has no effect on the focusing scale of a camera lens. If you focus on 10m and then place the converter behind the lens, you are still focused on 10m. This is a distinct advantage with long-focus lenses. If you have a 135mm lens that focuses to 2m, for example, you can convert it to a 270

or 405mm lens focusing to 2m. No orthodox lens will do that.

At the other end of the scale, your 28mm lens focusing at, say, 15cm, can be converted to a 56 or 84mm lens focusing at that range.

In theory you can put two or more converters behind your camera lens and increase your focal length indefinitely but quality will inevitably suffer and the light loss becomes considerable.

It is sometimes said that tele converters should be used only with long-focus lenses, not with wide-angle or standard types. Some say the opposite. In fact, they work with any lens but may give better results with one specific lens than with another, regardless of focal length. You can ascertain only by practical experiment with which of your lenses the converter works best.

EXPOSURE METERS
AND THEIR USE

Some Prakticas have exposure meters built in. On the older models the suffix B to the model number, i.e. Praktica IVB, indicated that a meter was built in. If your model has no meter, you will probably find that a separate meter helps you to get your exposures right.

Exposure is exposure to light. When a film is exposed to light, the silver halide grains suspended in its emulsion are so affected that they can subsequently be reduced to black metallic silver when acted upon by a developing solution (see page 236). When the light reaching the film is in varying degrees of intensity, as in the image thrown by a lens, it is possible to gauge the exposure so that subsequent development will reproduce those intensities reasonably faithfully in terms of blackening of the emulsion. The exposure has to be within certain limits. Heavy overexposure produces almost total blackness on the film. Severe underexposure fails to reproduce the darker or even middle tones.

Exposure of the film is effected by opening the camera shutter. Most Praktica shutters can be opened to give a range of exposure times from at least $\frac{1}{2}$–1/500 sec, while all current models run from 1–1/1000 sec (see page 118). A further control over the amount of light allowed to fall on the film is provided by the lens aperture (see page 39) which can be varied in diameter so as to increase or decrease the intensity of the light. Thus, exposure is the product of time (shutter speed) and intensity (aperture) and can evidently be varied between very wide limits.

The function of an exposure meter is to indicate the combinations of shutter speed and aperture that allow the correct amount of light to act on the film. Naturally, there can be more than one combination—1/30 sec at $f11$ has the same effect as 1/250 sec at $f4$—and the meter cannot make the

choice for you. That depends on the degree of movement in the subject (see page 100) and/or the depth of field required (see page 80).

Types of exposure meter

There are two types of exposure meter—those using selenium photocells and those using cadmium sulphide (CdS) photo resistors. There are arguments for and against each but only two are of any real importance. First, the photo resistor has to be powered by a battery. The batteries used are very small and generally last for at least twelve months, but if you do not want to be bothered with batteries, you have to use the selenium meter. Secondly, the photo resistor can be made much smaller for a given sensitivity. The selenium cell cannot be made sensitive enough *and* small enough to form part of a meter measuring the light passing through the camera lens. If you want a TTL meter (as in the Prakticamat, the Super TL and the Praktica VLC, LLC and LTL) you have to use battery power.

However, if you are buying a separate meter, the choice of CdS or selenium type is purely a matter of personal preference. Although, size for size, the photo resistor is more sensitive than the selenium cell, good meters have virtually the same sensitivity, whichever type they are. Similarly, although the photo resistor can be made smaller for a given sensitivity, its circuitry is a little more complicated and there is generally little difference in the sizes of the two types.

How the exposure meter works

Most people understand that an exposure meter measures the strength of the light but many do not fully understand the answers it gives. It does not indicate the intensity of the light in any kind of standard unit as a measuring instrument might normally be expected to do. It generally moves a pointer across a scale but the scale is so marked as to indicate, either directly or indirectly, combinations of shutter speed and aperture that will admit sufficient light to the film to have a certain effect on that film. It is the relationship between the light falling on the meter cell and the effect that amount of light has on the film that is often not fully understood.

The meter cell can receive the same amount of light from

USING
AN EXPOSURE METER

There are various methods of using an exposure meter—some right, some wrong, some rather pointless. It is often said that you should tilt the meter downward to avoid too much influence from the sky. This applies only if the sky is very bright and occupies a major part of the picture.

Taking the mean of two separate readings — one from light areas, one from shadows—may work in practice but is unnecessarily complicated. A reading from a mid-tone (*below*) makes more sense.

For backlit subjects in which full detail is required in the shadow parts, a close-up reading from those parts will generally prove adequate.

For almost all subjects, the most accurate reading is that taken from a mid-tone, because that is what the meter is calibrated to. A good approximation to a mid-tone is often the hand but official "grey cards" can be purchased which reflect 18 per cent of the light falling on them. This is, in fact, the average reflection of most photographic subjects.

The metering method that solves most problems is the incident-light method not generally available with built-in meters. It measures the light falling on the subject. The meter has a diffuser fitted over its cell and is pointed from the subject position toward the camera. Thus, the reading is in no way affected by the nature of the subject.

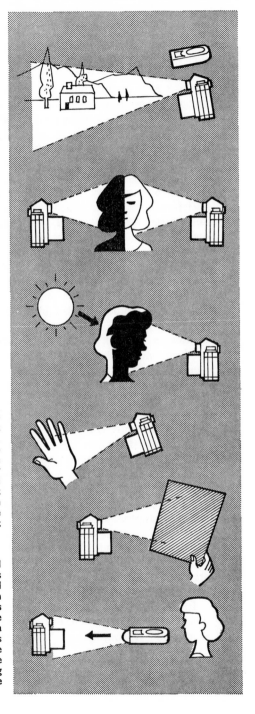

a variety of subjects. It may, for instance, receive the same amount of light from an even grey subject, a subject with equal areas of black and white and a subject of varying depths of grey. The same applies, of course, to colours. Yet again it may receive the same amount of light from a dark colour or tone brilliantly lit as from a light tone or colour dimly lit. In each case, the meter simply measures the total, integrated light. It takes no account of variations of light intensity in various parts of the subject.

Just as the meter can take only a simplified, single-minded view of the subject, so it can only be made to interpret that view in a single way and can give only one answer. It is therefore calibrated to accept each reading as coming from a subject the various tones of which integrate to a mid-tone and to recommend combinations of aperture and shutter speed to produce tones on the film that will similarly integrate to a mid-tone. Thus, if the meter reads a single tone, whether that tone be light or dark, it always recommends an exposure to reproduce that tone as a mid-tone. It will recommend an exposure to reproduce either black or white as mid-grey.

Similarly, if the meter reads a subject containing a predominance of dark tones, it recommends an exposure to produce tones on the film that integrate to a mid-tone and so causes overexposure. If light tones predominate in the subject, the straight meter reading gives an exposure recommendation that leads to underexposure.

These basic facts apply to all types of exposure meter (whether separate, built-in or TTL) and are vitally important. It is a dangerous fallacy that the close-up reading is the answer to all exposure problems. With the TTL meter, for example, you can put a long-focus lens on the camera and perhaps read a small area of the subject. But reading a particular area does not lead to correct exposure of that area unless it happens to be a mid-tone. If you read a light-toned area, such as sand, sky, light clothing, etc., and give the exposure recommended by the meter, that tone will be underexposed and will reproduce darker. If you read a dark-toned area, it will be reproduced lighter. The meter interprets everything it sees as a mid-tone.

In practice, the meter does not work exactly as it should do according to theory, but you can test this particular theory very easily if you have a Praktica with through-the-lens

66

metering facilities. On black-and-white film, take one shot of an evenly illuminated light tone that fills the viewfinder. A whitewashed wall is admirable. Take another shot of a dark tone that also fills the viewfinder. In each case, give the exposure recommended by a straight meter reading. When the film is processed you will find that the densities on these two frames are not very different. In theory, they should be exactly the same. According to popular misconception, they should be very different.

On colour film, the effect is even more marked. If you take a shot of a whitewashed wall, an expanse of snow or even brilliantly lit sand, you will find that the exposure recommended by the meter produces quite noticeable colour distortion.

Choosing the mid-tone

Thus, for most subjects, you should take your meter reading from a mid-tone, not, as is so often said, from the tone you wish to reproduce correctly. The mid-tone generally agreed to be most suitable is that which reflects 18% of the light falling on it. An average good white surface, for comparison, reflects about 90% of the light falling on it. If you take your reading from a mid-tone, your exposure ensures that that tone will be reproduced correctly. Consequently, all other tones are also reproduced correctly, provided the film can handle the brightness range involved. No film can reproduce accurately all tones from brilliant white to velvety black in the same subject—but there are virtually no subjects in which detail is required in such extremes of tones. When part of the subject is rather dark and you particularly want to bring out the detail in those parts, you have to give them extra exposure. That is when the exposure based on the mid-tone is not enough. Depending on the depth of tone in the darker parts you need a stop or perhaps two stops more exposure. With black-and-white film that is no problem. With colour film, however, the mid-tone exposure is the only one that gives a reasonable certainty of correct colour rendering. If you exceed it to obtain detail in the shadows or give rather less to prevent the highlights blocking up you will probably also lose colour fidelity. Under-exposure of colour film leads to deep over-saturated colour and overexposure gives pale, even pastel tones and can burn delicate colours right out to white. Additionally, parts of the

picture may show a disturbing colour cast. Skies, for example, can look faintly green or purple.

Thus, in practically all cases, the best way of using any type of exposure meter is to pick out a mid-tone in the subject (or in the surroundings, providing the selected tone is lit in the same way as the subject) and base the exposure on a reading from that tone. For most people, the back of the hand is a convenient and reasonably accurate approximation of a mid-tone.

Most subjects, however, do integrate to a mid-tone and a straightforward reading of the whole subject area is reasonably accurate. The art of correct exposure is to recognise the abnormal subject and to use the meter or adjust its reading accordingly.

Prakticamat TTL meter

The idea of taking light measurements through the camera lens seems to be an obvious and simple solution to exposure problems. With hindsight and the advent of the cadmium sulphide (CdS) photo resistor, it is, indeed, obvious—but not so simple. The description "TTL metering" covers a variety of methods, each claiming its own particular advantages.

The Pentacon company considered various methods before introducing its own first system in the Prakticamat in 1965. It rejected all existing or projected methods in favour of an ingenious beam-splitter device which gave remarkably accurate, integrated readings.

It rejected the method that placed the CdS cell on the back of the mirror with fine slits in the mirror allowing light to pass. The great disadvantage here is that the light receptor is placed in front of the image plane. Consequently, it is illuminated to a varying extent, depending on both focal length and aperture of the lens in use. Similar considerations apply where two CdS cells are located between the pentaprism and the eyepiece.

The so-called spot metering systems were rejected largely because most subjects contain an even distribution of tones and only a reading that fully integrates all those tones can lead to correct exposure. The individual brightnesses of the tones in a picture can, moreover, vary in the ratio of 120:1, or between 6 and 7 lens stops, even discounting very deep shadows and small extra-brilliant highlights. It is not easy to

choose a suitable mid-tone or to make the mental calculation required when reading from some other tone in the picture area.

For the Prakticamat, therefore, a large (1¾in long) CdS cell was placed as close to the image plane as possible. The ideal, of course, would be a 24 × 36mm cell actually *in* the image plane. That is impracticable but the Prakticamat cell is next best thing. Its position ensures that readings are not influenced by different focal-length lenses nor by changes of aperture. Together with the size of the cell, it has the additional advantage that a much more finely-matted focusing screen can be used than on cameras with smaller cells.

In the Prakticamat a beam-splitting prism is placed just above the focusing screen. It bleeds off a small, constant percentage of the light reaching the whole screen and redirects it to the CdS cell just below the eyepiece. The beam splitter works in one direction only so that light passing through the eyepiece cannot reach the cell and cause false readings.

Praktica Super TL and LTL meters

At first sight the system used in the Super TL and LTL seems to contradict the requirements laid down for the Prakticamat. At the stage of development then reached, it was considered that a large cell was necessary in order to collect a sufficiently large proportion of the light falling on the subject. The later models use a smaller cell but the beam splitter is combined with a light concentrator which allows the small cell to accept light from a much larger area of the image. The beam splitter is on the image-erecting surface of the pentaprism, i.e. its forward face, thus ensuring again that the proportion of light bled off is not influenced by focal length or aperture. Such a system is, in theory, more prone to be affected by light entering the viewfinder eyepiece but, in practice, no significant effects have been noticed.

A further difference in the Super TL and LTL system is that readings are taken from the whole screen but are "centre weighted". This appears to mean that more weight is attached to the reading from the centre of the screen than from the surrounding areas, leading to fractionally less exposure than would be given by a normally integrated reading. The theoretical reasons advanced for such an arrangement leads to confused statements and counter statements, but its signifi-

cance is really marginal. What matters is the performance of the meters in practice and that is, in fact, quite remarkably good.

Operation of Prakticamat, Super TL and LTL meters

Although the arrangement of the CdS cells is different in the Prakticamat and the later models the mode of operation is exactly the same. A needle visible in the viewfinder moves as either aperture or shutter speed is altered. When it is lined up with a mark, the exposure is correct for the subject on which the camera is focused—provided it is a subject of normal tone distribution (see page 66). Provision is made for films of different speed by altering the setting of the shutter-speed knob (see page 76). The meters read at the taking aperture, i.e. the meter switch also disconnects the automatic diaphragm mechanism.

The meters have limits of operation. That of the Prakticamat can be used at all shutter speeds only with films of up to 25 ASA. For a 50 ASA film, the one-second setting cannot be used. At 100 ASA, neither the one-second nor the $\frac{1}{2}$-sec speed can be used. At 400 ASA, only speeds of 1/15 sec and faster can be used. The full range of each meter is given on page 297. Naturally, the fact that the meter cannot be used at those shutter speeds does not preclude their use in taking the photograph. If the meter indicates, say, 1/15 sec at $f4$, you can shoot at 1 sec at $f16$ if you wish—but you will not be able to check that reading if the film you use is faster than 25 ASA on the Prakticamat or 100 ASA on the Super TL.

You can make a last-minute check on the suitability of your aperture- and shutter-speed settings on the Prakticamat by taking up only the first pressure on the shutter release. If the needle lines up with the indicator marked, release the shutter; if not, alter your aperture or shutter speed accordingly.

The meters use a PX 625 (Mallory) mercury-button battery housed in the camera base plate. The life of the battery is about two years and users of the Super TL and LTL should watch for signs of wrong exposures after about 18 months. Prakticamat users can check the state of their batteries by setting the shutter to 1/1000 sec at a film speed of 17 DIN. If they then depress the button next to the tripod bush, the meter needle should jump at least to the centre

mark. If it does not, the battery needs replacing. The aperture of the lens while carrying out this test is immaterial.

The battery is changed by unscrewing the cover, turning the camera over to allow the battery to drop out and replacing it with a new battery with plus sign visible.

Praktica LLC meter

The meter of the Praktica LLC is yet another different version. The other Praktica TTL models have to be stopped down to the taking aperture to obtain a reading. This has the disadvantage that the screen is sometimes too dimly illuminated to allow the needle to be seen clearly. The LLC, however, takes its readings at full aperture—provided you use the special lenses made for this camera. A modified version of the same system is used in the Praktica VLC (see page 76).

Metering at full aperture with automatic diaphragm lenses is not unusual, but the Praktica LLC system is unique. Whereas mechanical methods are normally used in other cameras, the LLC transmits the actual aperture setting to the metering system electrically. There are three point contacts on the lens mount which engage with three strip contacts on the camera body when the lens is screwed in. As the aperture ring is turned, these contacts transmit the information to the meter through variable resistances that the lens is set to, say, $f8$ although the actual diaphragm opening is at its widest.

Full-aperture metering can be effected only with the special "electric" lenses, available in a wide range of focal lengths, but the meter can be used with other lenses. This is effected simply by switching the meter to permit stopped-down measurement. The CdS cell is then affected in the normal way by the reduced light transmission as the diaphragm aperture is reduced.

A further unusual point about the LLC meter is that it has no separate switch. The meter is switched on when you take up the first pressure on the shutter release. The power source, too, is much larger than usual—a Mallory PX21 4.5V alkaline battery housed in a large compartment with plastic clip-on cover in the camera base. The life of the battery is said to be about one year but, in certain circumstances, it can exhaust very rapidly. The average drain on the battery of a CdS meter is only in the region of $300\mu a$ but the battery of the LLC has to drive the aperture information circuit as well and this entails

PRAKTICAMAT METER

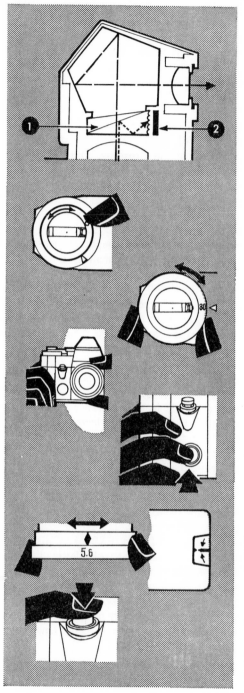

The TTL meter of the Prakticamat has a large photo-resistor (2) in an equivalent focal plane below the viewfinder eyepiece to which light is directed by a beam splitter (1) below the pentaprism.

To operate the meter, the film speed must first be set on the inner ring of the rewind knob.

The shutter speed is set on the outer ring of the rewind knob.

The picture is composed and focused.

The meter is switched on by pressing the large button switch below the shutter release.

The aperture control is adjusted until the meter needle visible in the viewfinder lines up with the central mark.

The shutter is released to take the picture.

The procedure can be reversed, if necessary. The aperture can be set first and the shutter speed varied to line up the needle.

SUPER TL, LLC AND LTL METERS

The Praktica Super TL (right) and the LLC and LTL (left) use the same type of meter but the LLC has electrical contacts between camera body and lens to allow it to measure at full aperture.

The light-sensitive photo-resistor (2) is located at the front of the pentaprism and light is directed to it by a beam splitter and light concentrator (1).

To operate the meter, the film speed is set in the cut-out on the shutter speed knob on the LLC and LTL and on the disc under the shutter speed knob on the Super TL.

The LLC selector switch is then set to the sign appropriate to the type of lens in use—the special LLC lenses or any other Praktica-fitting lens. The pre-selected shutter speed is set on the shutter speed knob.

The picture is composed and focused.

On the LLC, the shutter release is partially depressed to switch on the meter. The Super TL has a large button switch on the camera front and the LTL has a flat switch above the shutter speed knob.

The aperture control is adjusted until the meter needle in the viewfinder cuts the small circle.

The shutter is released to take the picture.

The procedure can be reversed if necessary. The aperture can be set first and the shutter speed adjusted to line up the meter needle.

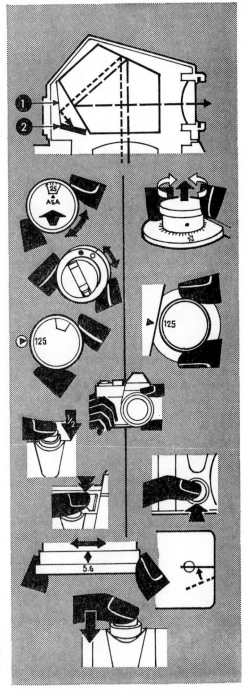

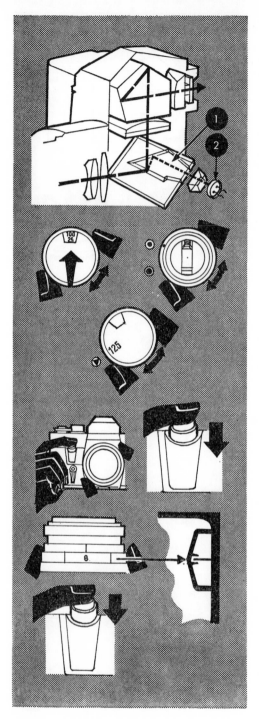

PRAKTICA VLC METER

As the Praktica VLC has a removable pentaprism, the meter had to be redesigned. The beam splitter (1) of this model is a two-part type in the mirror and sidewall of the mirror box, providing a complicated pattern of light diversion from the mirror to the CdS cell (2). The meter can thus be used normally with the Focusing Magnifier or the Waist-level Finder.

Operation of the meter is the same as with the Praktica LLC. First set the film speed in the cut-out on the shutter speed dial and then turn the selector switch to the full aperture or stopped-down metering symbol, as appropriate. Non-electric lenses must be used in the stopped-down mode.

Set a shutter speed suitable for the subject.

Compose and focus the picture in the viewfinder.

Switch on the meter by taking up the first pressure on the shutter release. Adjust the lens aperture until the meter needle visible in the viewfinder is between the two lines in the centre of the meter needle frame. Shutter speed and aperture are then set for correct exposure.

Check the framing of the image and release the shutter. The meter switches off when you take your finger off the shutter release.

The procedure can be reversed if necessary. Set the aperture at which you wish to shoot and adjust the shutter speed to centre the meter needle.

a drain of 35 ma. Moreover, this circuit is switched on by the shutter release being depressed only 1/20 in. It is evident that if you are at all careless in the carrying or packing away of your camera, something may press only very slightly on the shutter release button and switch on the circuit. In those circumstances a fully charged battery will totally exhaust in 16 hours—even in total darkness.

There is only one solution to this problem and that is to *lock the shutter button* (see page 103) whenever the camera is not in use. With the shutter button locked, the meter cannot be switched on.

It is important to observe polarity when changing the battery. The plus and minus signs are not very conspicuously marked on the bottom of the battery compartment.

Using the LLC meter

To use the meter of the Praktica LLC, you first set the speed of the film in the camera by pulling the rim of the shutter-speed knob upwards and turning it to bring the required speed into the cut-out on the top of the knob. ASA figures are in orange and DIN speeds in black. The remaining procedure depends on the type of lens you use.

When using one of the special LLC lenses with electrical contacts in the back of the mount, set the selector switch around the rewind knob to the solid circle by turning the black ring anti-clockwise (viewed from the back of the camera). You can then set either the aperture or shutter speed you wish to use and determine the factor you have not pre-set by centering the needle in the small circle in the viewfinder. This you do by focusing and composing the picture in the viewfinder and switching on the meter by taking up the first pressure on the shutter-release button. There is a reasonable amount of resistance after this first pressure to obviate the danger of releasing the shutter inadvertently, but you still need to take care not to press too hard. With the meter switched on, you turn the shutter-speed knob or the aperture-control ring until the needle is centred. As you turn the aperture-control ring, the diaphragm does not close, as is normal with automatic iris-control lenses, but the setting to which you have turned the ring is transmitted to the meter through the electrical contacts and the needle moves accordingly.

Other types of lens can also be used if the selector switch is set to the open circle mark. This allows stopped-down readings to be taken. Matters become a little complicated, however, if the lens is an automatic iris type, because such lenses do not, in fact, stop down when the iris control is turned and the LLC switch does not disconnect the automatic mechanism inside the camera. Thus, to use an automatic lens with the LLC meter you have to carry out three operations simultaneously:

1. Depress shutter-release button to switch on meter.
2. Operate stop-down switch or depth-of-field preview on lens barrel to allow lens to stop down.
3. Operate aperture control or shutter speed to centre the needle visible in the viewfinder.

Some lenses, however, have an A/M (automatic/manual) switch on the lens barrel and you can switch to manual to avoid (2) above. The "three-handed" difficulty does not arise with non-automatic lenses either. They can be used in the normal manner with the selector switch turned to the open circle.

Praktica VLC meter

The principle of the meter in the Praktica VLC is exactly the same as that in the LLC. An important difference in its construction is that the beam splitter feeding light to the meter is placed in the mirror so that light is transmitted through the edge of the mirror and through an opening in the wall of the mirror box to the light-sensitive CdS element. The meter needle and index project into the mirror box just below the viewing screen and are therefore visible as you view the image through any of the finders.

Operation of the meter is exactly the same as with the LLC, except that you centre the needle between the two marks on the line enclosing the needle travel. The power source is the same, too, and is subject to the same heavy drain, but the VLC shutter button has no lock. You must, therefore, be very careful when putting the camera away that nothing is allowed to rest on or press against the shutter release button. Quite light pressure switches on the meter and aperture-teller circuits and the battery could drain

BUILT-IN METERS

The built-in selenium meters of the Nova B and 1B, the Praktica IVB and VFB are similar in operation. The main features of the Nova meter and controls are as follows:

1. Meter
2. Meter needle
3. Follow pointer
4. Film speed setting
5. Shutter speed indicator
6. Aperture indicator

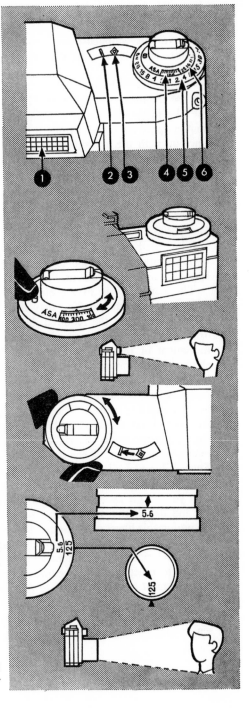

The LB uses the same system as the Novas but the meter window is in a different position.

To operate the meter, first set the film speed in the cut out on the rewind knob. On the IVB and VFB, the rewind knob has to be pulled upward to reveal the film speed and other settings.

Point the camera to the subject. Light acting on the photocell causes the meter needle to move.

Turn the outer ring of the rewind knob until the follow pointer lines up with the meter needle.

Read off an appropriate pair of shutter speed and aperture figures from the inner and outer rings of the rewind knob and set them on the shutter and lens controls.

Check composition and focus and release the shutter.

rapidly. Some protection can be obtained by switching the meter to its stopped-down mode. This disconnects the aperture-teller circuit and reduces the drain on the battery.

Using the Prakticamat, Super TL and LTL meters

To use the meter of the Super TL, you first set the speed of the film in the camera by pulling upwards on the rim of the shutter-speed knob and turning it until the dot on its side wall lines up with the appropriate figure on the disc below. You may have to turn the shutter-speed knob, taking the film-speed disc with it, to bring the required figure away from the side of the pentaprism, which conceals some of the figures.

The Prakticamat film speed setting is on a disc around the rewind knob. You turn the disc until the film speed required is opposite the white arrow.

Film speed on the LTL is set by pulling up the outer rim of the shutter-speed knob and turning it until the required speed shows in the cut-out.

The next step is to set either the aperture or shutter speed you wish to use. You may need to shoot at a certain aperture to obtain the required depth of field (see page 82) or a particular shutter speed may be required to suit the movement of the subject. Assuming that you have set the shutter speed, you focus and compose the picture in the viewfinder and, keeping the subject properly framed, hold the meter-switch on the front of the camera depressed while turning the aperture control. The switch also puts the automatic iris control out of action and, as the lens aperture opens or closes, the needle in the right-hand edge of the viewfinder moves up and down. When it is cutting the small circle in the Super TL and LTL or opposite the V mark in the Prakticamat, the aperture and shutter speed are set for correct exposure.

If you set the aperture first and then line up the needle by altering the shutter speed, you have to perform some rather uncomfortable finger contortions on the Prakticamat and Super TL because both shutter control and meter switch are on the right-hand side of the camera and rather well separated. It is best to practise this procedure with an empty camera to find the most convenient method of operation. On the LTL, the meter switch position is a little more convenient.

The needle of these models also tends to be a little over-sensitive and you must give it time to settle down after each

alteration of shutter speed or aperture. It may tend to rise rapidly and then sink slightly before becoming steady.

Using LB, Nova and older meters

The meter of the LB, Nova B and Nova 1B is a selenium type that does not read through the lens and is not connected to the aperture or shutter-speed controls. Its needle is visible in a small window between the rewind knob and the penta-prism. A diamond-shaped pointer is also visible in the window and an exposure reading is obtained by lining up pointer and needle.

First, however, the film speed is set by turning the disc immediately beneath the rewind knob until the nick in the cut-out is opposite the required figure. DIN speeds are in the cut-out at the back of the camera and ASA speeds at the front. The disc is turned by means of a small protruding stud.

Having set the film speed, you point the camera at the subject and turn the large black ring below the rewind knob, moving the pointer until it coincides with the position of the needle. Suitable combinations of shutter speed and aperture then appear opposite each other on the two discs. The white and orange figures indicate fractions in the usual manner of shutter speeds, the speeds in orange being those for which a rigid camera support is required. The green figures indicate seconds. Thus, the white 30 indicates 1/30 sec but the green 30 indicates 30 sec for which you have to use the B setting of the shutter. You choose the combination that suits the subject and set the appropriate values on the camera controls.

The exposure meters of the B models of the Praktica IV and V are similar to those of the Nova models. The film speed is set in the same way by rotating the disc under the rewind knob after pulling the knob fully upwards. The fixed pointer in the window is controlled by turning the milled ring surrounding this disc. Thus, the camera is pointed at the subject and the milled ring turned until the needle and pointer line up. A suitable combination of aperture and shutter speed is then read off the ring and disc and transferred to the aperture and shutter-speed controls. This, too, is a selenium-type meter that does not read through the camera lens and needs no battery.

FOCUSING
AND DEPTH OF FIELD

Focusing and depth of field are so closely interrelated that it is advisable to deal with the latter first. It is a subject on which it is very easy to theorise but very difficult to write in practical terms. Depth of field is the distance between the nearest and farthest points of the subject that are reproduced on the film as reasonably sharp images. There are various formulae which enable you to calculate depth of field *in given circumstances* to several places of decimals. But what practical value is there in knowing, for example, that a 50mm lens set to $f8$ and 7m will provide depth of field from 3.265 to 167.452m. In practical terms, that means 3.3m to infinity.

How image points are focused

We can think of the image on the film as being built up from innumerable points on the subject, each reflecting light which is collected by the lens and focused on the film to produce an image of the point. The light reflected from one such point travels to the lens in straight lines and can therefore be regarded as a solid cone of light with its base on the front glass of the lens.

Similarly, behind the lens, there is a cone converging to reform the point on the film when the lens is correctly focussed.

Consider what happens if this point is much closer but the lens is not refocused. The lens has a fixed ability to bend light so it in fact brings this nearer point to a focus some distance behind the film. The cone of light cuts the film and forms a large disc instead of a point. This is an out-of-focus image and you can well imagine that a complete image made up of such discs instead of points would not look very sharp.

At some point between these two, however, and indeed, beyond the farther of the two, the difference in cone shapes is so slight that the disc formed on the film is indistinguishable from a point. Thus, objects at any distance from the camera

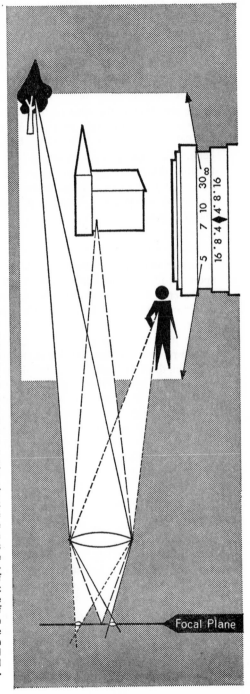

When an object is correctly focused by the camera lens, such as the church in this diagram, each point of light reflected from it is reproduced as a point in the focal plane and the image is sharp. Points reflected from objects nearer to and farther from the camera, such as the man and the tree, send out rays which come to a focus in front of or behind the focal plane, so that the image on the film is made up from discs instead of points and is not so sharp. If, however, the size of these discs is such that at normal viewing distance of the final print, they are indistinguishable from points, the image looks sharp. The man and the tree represent the maximum distances in front of and behind the subject at which sharp images can be produced, the range of distances between the man and the tree represent the depth of field in the given circumstances of focal length of lens, focused distance and shooting aperture.

between the latter two points can be imaged by the lens in such a manner that they all look equally sharp. The distance between these two points is the depth of field of the lens in those circumstances—at the original focused distance, full aperture of the lens and the given focal length.

It is evident that, as the focused point becomes more and more distant, the cone of light becomes narrower until, at near infinity, the light rays striking the lens are virtually parallel and the cone is infinitely longer than that formed behind the lens. You can travel a long way down the cone towards the lens before you reach a sufficiently wide part of the cone to cause a point to be reproduced as a disc of significant proportions. Thus, depth of field is greater at longer range.

Effect of lens aperture

A further influence on depth of field is exercised by the lens aperture, for very similar reasons. As the aperture decreases, so the cone of light becomes slimmer and, again, the range of distances in which sharp images can be produced becomes larger.

For practical purposes, we can consider aperture in this case to refer to the physical size of the aperture, whatever the focal length of the lens. Then, at a given focused distance, we can see that depth of field depends solely on aperture.

It is common practice to say that depth of field depends on focal length *and* aperture, but this is only because we normally think of aperture in f-number terms. Certainly the focal length then has its effect because the f-number depends on the physical size of the aperture and the focal length of the lens (see page 39).

Effect of enlargement and viewing distance

So now we know that depth of field is greater at longer range and at smaller apertures. At a given distance, it is virtually the same when the physical aperture size is the same, e.g. at $f4$ on a 100mm lens or $f2$ on a 50mm lens. But this evidently holds good only when we compare like with like, i.e. a contact print with a contact print or a 5× enlargement with a 5× enlargement. All Praktica pictures are subsequently enlarged and, although a disc may be indistinguish-

The extent of the depth of field with a given lens is affected by lens aperture and focused distance. Thus, on the left of the diagram, with the lens focused at nearly 10 ft., the man at 7 ft. and the church at 30 ft. from the camera can both be reproduced sharply at an aperture of *f*11— a depth of 23 ft. If however, the focus were placed on the man at 5 ft. the depth extends only from 4 ft. to 7 ft.

At a much larger aperture, *f*4 on the right, the depth is less even though the focused distance is increased to about 9 ft. To obtain depth of field from close to the camera (the man at 5 ft.) to the church at 30 ft. the lens has to be closed down to *f*16.

able from a point on the film, it may become very distinguishable indeed when we make a 10 × 8in print.

On the other hand, if we view that 10 × 8in print from 3ft, the discs may become points again.

So depth of field evidently depends not only on shooting distance and aperture but also on degree of enlargement and viewing distance. And, as there is no consistency in the last two factors, no rigid rules can be laid down to suit all circumstances.

Using depth of field tables

Moreover, we do not always want to know the extent of depth of field in order to make use of it. We often need to ensure that certain details are *out* of focus. In such cases, we cannot say that, because depth of field stretches to, say, 15ft 3in, detail at 15ft 4in or even 16ft will be unrecognizable.

Depth of field tables must, therefore, always be used with some caution. Those in the Facts and Figures section at the end of this book, for example, are mathematically calculated and are subject to all the provisos mentioned in this chapter. They give some idea of the results to be expected in the conditions for which they were calculated, i.e., when the resulting prints or transparencies are viewed at a distance related to the degree of enlargement. It is always advisable, however, to make at least one stop allowance for the mathematical nature of the tables. If you want to be sure of getting everything within a certain range of distances sharp, check the range in the table and then stop down to the next smaller aperture. This is particularly important in close-up work, where depth of field is often negligible. It is usually advisable to stop down as far as other circumstances will allow. If you want to throw background and/or foreground thoroughly out of focus, open up the lens to at least one stop larger than the table indicates.

Depth of field indicators

Most lenses have depth-of-field indicators engraved on their mounts. The usual form is a series of *f*-numbers on each side of the index mark opposite the focusing scale. When the index is set to the focused distance, the *f*-numbers indicate the approximate near and far limits of the depth of field. This is adequate as a quick reference for most purposes and

FOCUSING SCREENS

The focusing screens of the Prakticas have developed from the plain ground glass screen of the early models to the addition of a split-image rangefinder spot on the IVM and the further addition of a fresnel screen and a fine-ground collar on the IVF. Current models have a fresnel lens and ground-glass with microprism rangefinder spot surrounded by a fine focusing area.

The split-image rangefinder works on the principle of a discontinuous image across the two halves. As the lens is brought into focus, the image becomes continuous. This type of rangefinder is easy to use when the subject has strong vertical lines or tonal boundaries but presents difficulties with textured or finely patterned subjects.

The microprism rangefinder presents a broken, shimmering image when the lens is not properly focused. As it is brought into focus, the image steadies. Both types of rangefinder have to be used at reasonably wide apertures, say f4–5.6.

The Praktica VLC screen can be changed by the user. There is a choice of seven screens.

On the Praktica models with instant-return mirrors, a signal appears in the viewfinder when the shutter is not tensioned. It disappears when the transport lever is operated.

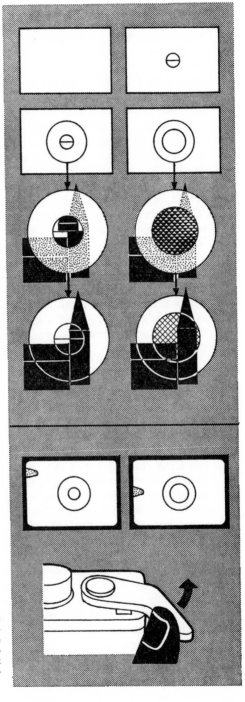

is, in fact, very useful when the utmost depth is the prime requisite. Then, the infinity symbol on the focusing scale can be set to the f-number in use on the "far" side of the depth-of-field indicator, instead of simply setting the distance of the main subject to the index mark. This method ensures that there is no wasted depth behind the subject and that the maximum depth is obtained in front of it.

Naturally, any screen-focusing camera can give a direct indication of depth of field simply by observation of the screen image at the shooting aperture. This is not always practicable with the 35mm camera, however. In common with most such eye-level reflexes, the Prakticas use a fresnel lens on the focusing screen and a rangefinder spot in the middle. These features tend to become obtrusive when the lens is stopped down (particularly in the older models) and, as the image is also darker, clear observation is not always possible.

Nevertheless, it is rarely convenient to carry depth-of-field tables around with the camera and intelligent interpretation of both indicator and screen image should be cultivated. With practice, the limits of depth of field can be fairly accurately assessed in this way, so that a suitable shooting aperture can be chosen with reasonable certainty of obtaining the result required.

Mechanics of focusing

Focusing is normally a fairly straightforward exercise. The subject is a certain distance from the camera and the lens has to be set to that distance. With the screen-focusing camera, however, you do not need to know the distance. You simply rotate the lens until the image in the viewfinder is sharp and you know that the lens is then correctly set. The Prakticas make it easier because, except in the very earliest models, the magnifying eyepiece gives you, *via* the pentaprism, a large, eye-level view of the subject that is right way up, right way round and evenly illuminated. Additionally, the screen contains a split-image rangefinder in the middle of the screen of the earlier models and a microprism-type rangefinder in later models. The models using a fresnel lens to illuminate the screen also have a plain ground-glass ring (or "collar") surrounding the rangefinder zone. Thus you have almost an embarrassment of aids to focusing. You can use the whole screen, the rangefinder or the ground-glass collar where

available. Each has its own uses and each photographer has his own preferences and prejudices. If you own a Praktica VLC, you have an even wider choice, because you can change the screen to suit your particular needs.

The Praktica camera instruction books are at pains to point out that the models with fresnel screens can use only the rangefinder sections for focusing. The screen area outside the rangefinder section is not intended for focusing. This is understandable with some earlier models in which the fresnel rings are very prominent and could form a spurious image. Practical working with the later models, however (from the Super TL onward) suggests that the whole screen area can safely be used for focusing except, perhaps, for the most critical work.

The split-image type of rangefinder spot used in the earlier models has certain drawbacks. Although it is very fast and accurate when the subject has vertical lines or clean shapes, it is not too easy to use on textured material, the fur of animals, foliage or items with closely spaced lines or patterns. More important, however, is that such rangefinders need a fairly wide beam of light from the lens and can therefore only be used at relatively large apertures. When you stop down beyond a certain limit, which varies with the lens and from model to model, one half of the rangefinder spot goes completely black and it becomes impossible to line up the subject. This is particularly troublesome on long-focus lenses of moderate maximum aperture.

The microprism type works on a similar principle but the rangefinder zone contains a large number of much smaller wedges or prisms which give a shimmering effect when the lens is incorrectly focused. When the shimmering stops and the image becomes steady, it is focused correctly. This type of rangefinder can be used at slightly smaller apertures than the split-image type, but should not be relied on when the pattern of the prisms remains obtrusive.

Focusing, whether by rangefinder or screen, should generally be effected at full aperture. When focusing the screen image, the reason for this becomes obvious. At large apertures, depth of field is limited and the images moves in and out of focus quite abruptly, making the focusing operation swift and positive. Wide-angle lenses, in particular, need full aperture focusing. Even then, with, say a 21 or 28mm lens

used at 15ft or more, the depth of field is so great that it is difficult to see when the image is at its sharpest. Rangefinder focusing, on the other hand, is actually unreliable at small apertures.

When you focus on the whole screen image, full aperture is advisable not only because of the limited depth of field but also because it provides a bright, easily seen image. You can stop down afterwards if you wish to examine the depth of field.

Interchangeable viewing screens

The design of the Praktica VLC takes account of the fact that many forms of specialist work require different focusing techniques for which the standard type of screen is not particularly suitable. There are also occasions when com-position of the picture and the reproduction ratio can be more easily seen on a special type of screen.

The screens of the Praktica VLC are located in the bottom of the finder head. To remove the head, you press the button protruding from the side of the mirror box, just in front of the rewind knob, and lift the head straight off. If you turn the finder head over, you see the screen, held in position by two clips on one long side and one clip on the other. With the tips of the two index fingers at the corners of the screen on the single-clip side (placing the thumbs below the edge of the screen on the other side), press the screen against the double clip. There is sufficient spring in the double clip to allow the screen to disengage from the single clip so that it can be lifted out. It can then be replaced by the required screen, inserted in the reverse manner under the double clip first.

There are two more-or-less standard screens, one with a split-image rangefinder surrounded by a microprism zone plus a very narrow fine-ground rim, all on a fresnel field. The other has the more normal microprism centre with surrounding fine-ground area on a fresnel field. Either of these screens can be used for general work according to preference. The other five screens are for more specialist work.

The clear screen with central cross lines is sometimes used for very critical focusing or close-ups, particularly in con-junction with the waist-level or magnifying finders. It pro-vides an aerial image with the help of the glass surface and

frame surround, but such an image cannot be focused accurately in a given plane by the human eye without a point of reference. The eye accommodates to the image in various planes so that it seems equally sharp at all settings of the lens focusing ring. If, however, you move your eye slightly in the magnifying eyepiece as you focus, you notice that the cross moves in relation to the image except at a particular setting of the lens. That is when the image on the glass at the equivalent focal plane is correctly focused.

The chequered screen is useful for lining up horizontal and/or vertical lines in shots of buildings and other rectangular or similar straight-lined objects. It helps you get the camera square to the subject in some copying jobs, and it can aid composition when the placing of subject components is critical.

The cross-graduated screens, one plain and the other with a focusing surface, allow image size to be controlled accurately, particularly in close-range work.

The plain, fine-ground screen is for those who prefer straightforward reflex viewing and focusing of the whole image area without interference from rangefinder spots in the middle of the image area. This, too, is useful in close-range work where critical sharpness is required over the whole image area.

The interchangeable viewing screens are available only for the Praktica VLC. They are easily fitted and removed and, being of plastics construction, are not easily damaged. Nevertheless, they should be handled with caution. Clumsy handling can chip them or strain their retaining springs. Dust, dirt and hairs certainly do not improve their performance.

An advantage of the VLC metering system is that its location below the screen makes it independent of the type of screen fitted. It measures the light before it reaches the screen.

Technique of focusing

The question sometimes arises as to where you should place your plane of sharpest focus. If you have a scene of some depth—a landscape, perhaps—with a hedge, gate, trees or other prominent object in the foreground, buildings, animals, people, etc., a little farther back, and hills, mountains, trees

or other feature in the background—which feature do you focus on? Normally, it will be the focal point of the subject —the eye-catcher or main interest, such as the building, animals or people.

If, as is likely in such cases, you are shooting at about *f*8 or *f*11, it is sufficient to focus on the main feature in the normal way. Depth of field will take care of the foreground and background. If you are obliged to shoot at a larger aperture, you may have to resort to the method described on page 86 to ensure the greatest possible depth of field. The effect then is to focus a little in front of the main subject in order to bring the foreground within the limits of the available depth of field.

A similar procedure can be used for any subject with appreciable separation between foreground and background. When focusing a scattered group of people, for example, you could set the distance of the person farthest from the camera to the "far" aperture marking on the depth-of-field indicator and check that the corresponding "near" aperture marking brings the nearest person within the depth-of-field range. This has the added advantage of throwing the background out of focus, which can sometimes be a useful technique to prevent the background overpowering the subject.

Focusing can, in fact, often be carried out with the object of excluding part of the subject from the depth of field rather than including it. You might photograph a close-up isolated bloom against a distant background of hills. It would be easy then to make sure that the background were sufficiently subdued to allow the main subject to stand out sharply. If, however, the background is foliage, grass, other blooms, etc., close behind the subject, you need a large aperture and, even then, may need to focus on the very foremost parts of the bloom to make sure that the background is sufficiently unsharp. This is the type of subject for which depth-of-field tables can give you some guidance, but it is generally advisable to make several exposures at different apertures and focus settings.

Focusing moving subjects

The moving subject may pose focusing problems. A typical example is in child and animal photography. Here the movement is likely to be erratic and unpredictable. Again, there

VLC FINDER SCREENS

There are three alternative viewfinders for the Praktica VLC and each can be fitted with seven alternative viewing screens. The procedure for replacing a screen is the same for all units.

First, remove the viewfinder head by pressing the lock button in the side of the mirror box. Lift the viewfinder unit out of the camera body. Turn the finder over and remove the screen by pressing with the two index fingers toward the finder eyepiece to disengage the screen from the single clip. Lift it clear of the finder. To insert the alternative screen, press one long edge against the two clips until they give sufficiently to allow the other edge to slip under the single clip.

Focusing screens are always located with their focusing surfaces facing the mirror in the camera body.

The alternative screens for the Praktica VLC are:

Fresnel lens with microprism centre and ground glass collar

Fresnel lens with split-image rangefinder and microprism-type collar

Plain ground-glass screen

Ground-glass screen with 6mm clear spot and cross lines

Ground-glass screen with divisions on bisecting lines

Clear screen with divisions on bisecting lines

Plain ground glass screen with 5mm squares

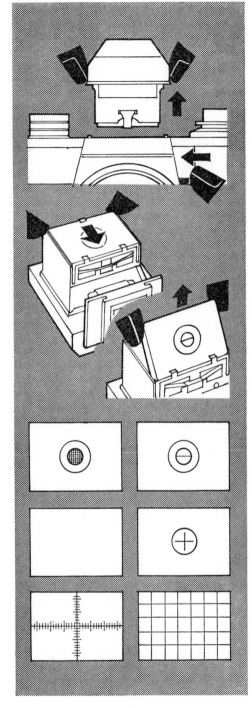

are various methods of overcoming the difficulty. You can set the lens to a suitable distance and wait for the subject to move into focus. That might work where the movement is relatively slow but you still need a fairly quick trigger-finger. Even if you catch the subject, however, the expression, attitude, etc., may be all wrong.

You can try confining the subject to a particular area and setting your aperture and shooting distance in such a way that the depth of field covers most of that area. Then you can shoot at almost any time, waiting for the moment that provides the type of picture you want. This is really the only possible solution if the movement is fast and erratic.

When the movement is predictable, as with racing cars, race horses, athletes, etc., you can focus on a point through which the subject has to pass, releasing the shutter as soon as the subject appears in the viewfinder. If the movement is very fast and you are relatively close to it, you may have to release the shutter fractionally before you see the image in the viewfinder. To do that satisfactorily, you need both eyes to view the subject—one through the viewfinder and one direct—or you have to forgo your reflex viewing and use a sports or frame finder.

Focusing in dim light

If you find it difficult to focus when the subject is dimly lit, there are various methods available. You can, for example, shine a small pocket flashlight on to the subject and focus on the patch of light. You can place a piece of white paper, tinfoil, etc., in the subject position. If the subject is a person, you can ask them to strike a match or use a cigarette lighter to enable you to focus on the flame.

If none of these are feasible, there is always the focusing aid that reflex camera users tend to forget—the focusing scale on the lens. You can measure or pace out the distance or just guess.

Zone focusing

For general shooting at medium distances and moderate apertures, it is possible to be too fussy about focusing. If you are photographing action in a crowd, for example, goalmouth activity in a football match, or similar incidents in a relatively restricted area, your lens can often be set to provide

adequate or even admirable sharpness over the whole area. You can forget about focusing and concentrate all your attention on framing the picture and shooting at the right moment.

If you are using a lens with automatic diaphragm control, the full-aperture view may tempt you to attempt constant refocusing as the characters move to and fro. That way you stand to lose a lot of opportunities and perhaps even to miss your focus altogether. It is better to sacrifice maximum sharpness to the certainty of getting a selection of usable pictures.

Similarly, if you make a habit of carrying a camera everywhere with you, leave its controls pre-set to mid-distance, mid-aperture and a shutter speed appropriate to the aperture and light. If a picture opportunity suddenly arises and looks as if it will be gone in seconds, shoot first and reset the controls only if you get a second chance.

HANDLING THE PRAKTICAS

Whether you carry your Praktica with you all the time or take it out occasionally on picture-seeking expeditions, it is generally wise to carry it in its ever-ready case to protect it from dust, rain, excessive heat and the occasional bump it will inevitably receive.

The ever-ready case is the somewhat optimistic name applied to the case consisting of a bottom part that holds the camera securely by a screw through the bottom into the tripod bush, and a top part that folds down from the top of the camera and hangs underneath it while the camera is in use. It is probably the best method that can be designed but it is not particularly elegant and can be a nuisance, particularly when you turn the camera on its side to take vertical format pictures. At a time when you need to use your hands as efficiently as possible to keep the camera steady, you may have to waste the effort of a finger or two holding the top of the case out of the view of the lens. Many users consequently prefer to use only a strap fixed to the side lugs or the bottom half only of an ever-ready case.

Holding the camera steady

Whether you use a case, which has its own strap, or a strap alone, do not carry it slung over one shoulder. That is simply inviting knocks and bangs as the camera swings freely with every movement you make. Moreover, the strap can slip off your shoulder and it will inevitably do so when you are standing on concrete or over water. Put your head through the strap so that it crosses the body and the camera rests on the hip, or tighten the strap and let the camera lie on the chest. Do not carry the camera on a long strap around the neck where it can swing outward whenever you bend the upper part of the body.

The camera strap is a useful accessory in itself. One of the most important requirements of shooting with the Praktica

HOLDING
THE PRAKTICA

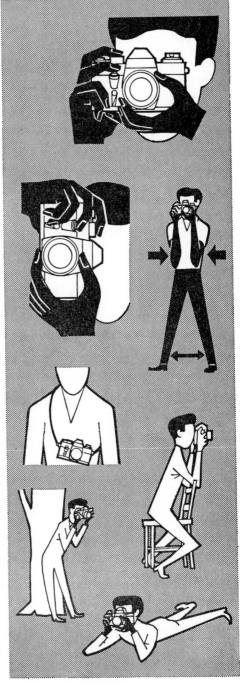

It is important that you hold your Praktica rock steady while you release the shutter. The slightest shake can have a considerable effect on image sharpness. Gripping only the ends of the camera is rarely advisable, especially with long-focus lenses. It is better to take most of the weight of the camera, whether held vertically or horizontally, with the left hand grasping the lens barrel. When actually shooting with the long lens, after setting the aperture and focusing, you will find that you can steady the camera by sliding the left hand forward to the front of the barrel. Always take advantage of any support that is available and when shooting from a standing position, keep the elbows well tucked in and the legs slightly apart.

The safest carrying position is with the shortened strap passing over one shoulder and across the chest so that the camera cannot either slip off the shoulder or swing out from the body.

is that you hold it rock steady while you release the shutter. A useful method of ensuring a steady hold is to shorten the strap to the extent that you can either pass it under one elbow or wrap it around the wrist so that only by pulling strongly upwards can you get the camera to eye level. The upward pull, combined with bracing the camera back against the forehead or cheek leads to a particularly shake-free hold.

With the camera held in this way, you can risk, if you have to, exposures longer than 1/30 sec, which is normally the slowest shutter speed you can use with a reasonable chance of a shake-free result. Do not overestimate your ability to hold the camera steady. If you are not over critical, you can persuade yourself that your results are sharp but you have only to shoot at a sheet of newspaper or other finely detailed subject, hand held and tripod mounted, to discover the difference.

Support the camera whenever you can. The support may be indirect. It helps to lean against a wall, tree trunk, telegraph pole, etc., or to rest your elbows on a wall, chairback, even on your knees or on the ground from a prone position. You have first-class equipment, capable of producing bitingly sharp pictures. It is silly to allow camera shake to take the edge off that sharpness.

Gripping the camera

The positioning of the hands on the camera when shooting depends very much on the size of your hands and your particular preferences. It is not a very good idea, however, to grasp just the ends of the camera with the fingers, especially when you use a long lens. You will find your own grip but one worth trying is that illustrated in the diagram on page 89. Essentially this is a one-handed hold, the left hand giving all the support and the right hand guiding and steadying. The lens barrel is gripped by the thumb and forefinger of the left hand with the second finger in support and the third and fourth fingers crooked under the base plate. The right hand grips the end of the camera with the thumb pressed against the back and the forefinger resting on the shutter release. Thus, either hand can hold the camera while the aperture and focus are operated by the left hand and the shutter speed and transport lever by the right hand. On the Super TL and

SHOOTING PROCEDURE (TTL MODELS)

On the Prakticamat, Praktica Super TL, Praktica VLC, LLC and LTL, the shooting procedure is as follows:

Transport the film and tension the shutter if this has not already been done.

Set the shutter speed.

Frame the picture in the viewfinder and focus.

Switch on the meter by partially depressing the shutter release on the LLC and VLC or pressing the meter switch on the Prakticamat, Super TL and LTL.

Turn the aperture ring until the needle lines up with its mark in the viewfinder.

Release the shutter.

Alternatively, the aperture can be set first and the shutter speed setting used to line up the meter needle.

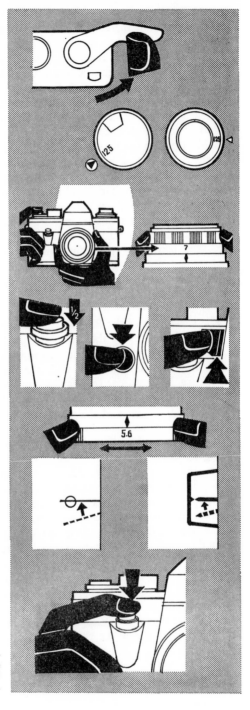

Prakticamat, the meter switch can be operated by the second finger of the left hand.

The hold for the vertical format is simpler because the rewind-knob end of the camera can easily be grasped in the left hand, the thumb resting over the rewind knob and the fingers passing diagonally across the camera body beneath the lens. In this case, the meter switch of the Super TL and Prakticamat is operated by the third finger of the right hand.

Most people use the right eye for viewing and focusing but there is, in fact, a lot to be said for using the left eye. It enables the right thumb to be pressed against the nose as an aid to steadiness in horizontal shots and the back of the same thumb to be pressed against the forehead for horizontal shots. These, however, are largely matters of personal preference.

Whichever eye you view with, it is useful to train yourself to keep both eyes open. You can then see both the general scene and the viewfinder frame within it and you are not troubled with the sustained effort of keeping one eye closed.

Preparing to shoot

The viewfinder of the Praktica shows you an almost life-size image of the subject that will be reproduced on your film, allowing you to compose your picture with ease and precision. The type of image varies with the model but, from the Praktica IV onwards, you have a rangefinder section in the viewfinder surrounded by a finely ground ring. You can use either of these parts of the viewfinder for fine focusing. The split-image rangefinder of the earlier models shows a disjointed image of part of the subject. You rotate the focusing ring on the lens mount until the two half images line up and the lens is then focused. The microprism zone of the later models presents a shimmering, disintegrated image when the lens is not correctly focused. As you bring the subject into focus, the image steadies and becomes continuous.

Except on the Praktica IVF and VF models, you can focus on the whole screen image, checking that it is sharp from corner to corner. Where the subject is finely detailed, you may find it easier to use the fine ground-glass ring. Fuller details of focusing technique are given in pages 86–93.

With your picture composed and focused, exposure calculated (see pages 63–79) and the camera securely held, you are ready to release the shutter.

SHOOTING PROCEDURE WITHOUT METER

Transport film and tension shutter if this has not already been done.

Set shutter speed.

Set aperture.

Compose and focus picture in the viewfinder.

Release the shutter.

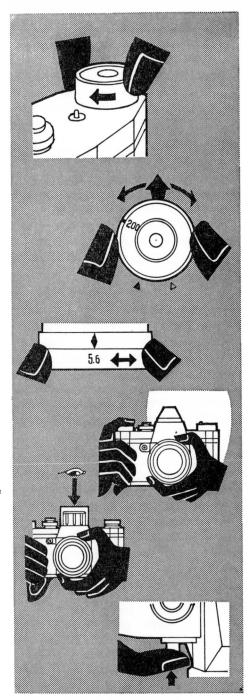

On models with instant-return mirror a signal in the viewfinder indicates whether the shutter is tensioned. If the signal shows, you operate the rapid-wind lever to transport the film and tension the shutter. In any case, on all models, the shutter cannot be released unless the film has been transported after the previous exposure.

On models with angled shutter-release button (except the VLC) there is also a device that allows the shutter button to be locked against accidental release. The button has to be unlocked before the shutter can be released.

When you are satisfied that everything is in order, press the shutter release smoothly and firmly, without jabbing or snatching. All the precautions you have taken to hold the camera steady can be nullified by the manner in which you release the shutter. A quick jab will almost certainly lead to movement of the camera and a blurred picture.

Panning the camera

There are occasions, however, when you might deliberately move the camera when taking your picture. The most obvious example is when you are shooting a fast-moving subject travelling more or less at right angles to the lens axis. Depending on the speed of the subject, you can sometimes produce a sharp picture by using your fastest shutter speed. If, however, the subject is a racing car or motor-cycle, even a racehorse or athlete at fairly close range, the movement is usually too rapid to give a blur-free result.

In any event, sharp pictures of this nature tend to destroy all impression of speed and it is often preferable to pan the camera. Panning is a technique that is not too difficult to acquire. The object is to frame the subject in the viewfinder and then to swing the camera in the direction of the movement, keeping the subject in the same position in the viewfinder throughout the swing or pan. You release the shutter at your chosen moment, usually when the subject is directly in front of you so that you can continue panning after the shutter has been released. You will probably find at first that you tend to stop panning as, or even just before, you release the shutter. That, of course, destroys the whole object. You must continue panning while you release the shutter.

The result of perfect panning is that, because the subject is kept stationary in the viewfinder, it is reproduced sharply.

Background and foreground, however, are blurred to a greater or lesser degree. The degree of blurring depends on the shutter speed you use and the speed of the panning movement—but the speed of the pan, of course, depends on the speed of the subject.

Theoretically, almost any shutter speed can be used. In practice, panning is sufficiently difficult with very fast-moving subjects to make it advisable to use speeds no slower than 1/125 sec. Naturally, faster speeds can be used and may be advisable where there is other, apart from directional, movement in the subject—such as the movement of legs, arms, wings, etc.

Not every moving subject is suitable for the panning technique. A horse or athlete jumping an obstacle would not generally be a suitable subject because the image of the obstacle would be blurred.

When you pan the camera, the blurred surroundings help to create an impression of speed. Deliberate blur can be used in many other ways and can be produced by movement of the camera, considerable defocusing of the image, a slow shutter speed, or changing the image size with a zoom lens during the exposure. Such techniques can produce impressionistic pictures of movement—directional or multi-directional, form and shape, disintegration, dream-like images, etc.

Choosing the shooting angle

The pentaprism of the Prakticas encourages you to use the camera at eye level—but don't forget that you can change your eye level by bending your knees or even lying on the ground, by climbing a wall or shooting from an upper storey. Children, for example, unless you wish to draw attention to their size, are best photographed from *their* eye level, not yours. The interchangeable viewfinders and screens of the Praktica VLC (see page 88) are useful when you wish to make low-level or other special-viewpoint shots.

Many familiar scenes can take on a completely unfamiliar appearance when shot from a low or high viewpoint. Obtrusive backgrounds can often be eliminated by either of these methods. Even landscapes can occasionally be improved by exclusion of the sky.

Similarly, the general rule is to keep the camera level with its back parallel with the principle plane of the subject. If

you tilt the camera upward, vertical lines converge. If you tilt it downward, vertical lines diverge. A sideways tilt turns horizontals into diagonals. These are generally undesirable characteristics but in the right circumstances, they can create the picture. The bows of even a small yacht can be made to loom up like those of an ocean liner if you approach them closely and shoot upward.

Again, you must normally avoid too close an approach to a three-dimensional subject because you will cause its various parts to be reproduced in seemingly incorrect proportion. Parts nearer the camera look disproportionately larger than those further away. But that can be an advantage, too. If a statue stands in front of a distracting background, a close approach with a shorter-focus lens may make the statue loom large and the background sink into insignificance.

Think about your picture before you take it. Confront six imaginative photographers with the same subject and they will probably produce six entirely different pictures. Try the same exercise with six inexperienced average photographers and they will probably produce six almost identical pictures. Your Praktica offers almost limitless opportunities for picture making—depending on how you handle it. You have apertures, shutter speeds, focus control, filters and a pair of hands. All can have their effect on the type of picture you produce.

Loading and unloading

The practical aspects of loading and unloading the Prakticas are discussed in pages 30–36. Unfortunately, loading is not really helped by the fact that all 35mm films in cassettes are still sold with rather long half-width leaders which were originally designed for the old bottom-loading Leica cameras. This leader is unnecessary for any Praktica and is a positive hindrance in the automatic-loading models. These models require that the film be taken across the back of the camera and slipped under the guide near the take-up spool (see page 30). There is a slight danger, however, that the half-width of film will slip upwards as the wire bracket of the automatic mechanism presses down on it and cause the film to slip off the sprockets. It is preferable to cut off all the leader and ensure that the film engages both the top and bottom perforations before closing the camera back.

The danger is not so great with the older models but the long leader is still superfluous and greater certainty of correct loading is ensured if the leader is wound fully on to the take-up spool before the camera back is closed.

When loading your own cassettes from bulk film (see page 110) a short leader can be cut for the non-automatic models to fit the slit in the take-up spool. The automatic models need no leader and the film can be cut square or with slightly rounded corners.

Safety precautions in handling

The shutter release of all models since the Nova (except the VLC) incorporates a lock. The value of this device is debatable. Its ostensible purpose is to prevent accidental exposures, because only after turning the button can you open the shutter. It is certainly not too difficult to fire the shutter of these models accidentally because only a light pressure is required. On the other hand, if the shutter is locked, it is quite easy to forget that fact and fail in an attempt to grab a suddenly-observed picture.

With the LLC camera, however, the shutter release lock also serves the purpose of locking the switch of the electrical circuits and it is advisable to lock it at all times when the camera is not in use (see page 75). Strangely, the VLC has no lock.

The front lens surface is the most vulnerable part of any camera and you must take the greatest care when handling the camera to avoid contacting this surface with your fingers. The inevitable greasy mark is difficult to remove and there is an additional danger that secretions in the skin can actually attack the coating of the glass. The best protection is a lens cap and there is no excuse for not keeping one in place on the lens at all times when not actually shooting. With a reflex camera, you can never forget to remove the lens cap because, naturally, you can see nothing in the viewfinder with the lens covered.

It is difficult to justify the practice of always keeping a UV filter on the lens for protection purposes. If there is any real danger that the lens is going to suffer damage or become dirty, then the filter will suffer it instead and you will subsequently shoot through it. The lens cap seems a better proposition. The filter may be justified if you take your camera close to salt-water spray or similar corrosive substances but its permanent use is questionable.

The Praktica bodies are solidly constructed and no excessive care need be taken in handling them. They are built to be used. Nevertheless, they contain mechanisms which can suffer from carelessness such as leaving the body in a dusty, damp, corrosive, etc., atmosphere with no lens or body cap attached. Dust, sand or other solid particles inside the body can lodge in the shutter mechanism and at least make its operation less smooth. At worst, it can jam or damage the blinds. Excessive heat can make the rubberised fabric of the shutter blinds tacky and cause them to slow down or even stick open. Moisture or corrosion can attack the surface of the mirror and make viewing and focusing difficult. It is advisable to take a soft brush to your camera occasionally and ensure that no tiny particles of film, sand, dust, etc., have lodged in its interior, in the threads of the lens flange or of the lens itself. Do not touch the mirror unless absolutely necessary, however. Its front silvering is very easily damaged and constant cleaning will soon reduce its ability to reflect a clear image to the focusing screen.

Fuller details on the general care and maintenance of your Praktica equipment is given in pages 226–230.

Delayed action release

Some later Praktica models have a delayed-action mechanism which releases the shutter 8–10 sec after the operating button is depressed. The DA lever is below the shutter release on the camera front. To set the mechanism, the lever is swung upwards as far as it will go, either before or after transporting the film and so cocking the shutter. The operating button is on the pivot of the lever. When using the DA, you do not press the shutter release.

The DA mechanism can be used with all shutter speeds and in conjunction with flash exposures. It can also be used on the B setting of the shutter to give a delayed time exposure of about 2–4 sec.

The obvious use for a delayed exposure is in self-portraiture or the inclusion of the photographer in a group photograph or as the "human interest" in a scene. It can be useful, too, for other tripod-mounted shots of static subjects to ensure shake-free results. After operating the DA mechanism, the camera has 8–10 sec to recover from any possible vibration in effecting the release before the shutter opens.

FILMS FOR THE PRAKTICA

You have to use 35mm perforated film in the Prakticas. The film is 35mm wide and of various lengths according to the number of pictures it is intended to provide. The most popular lengths are those for 20 and 36 exposures and, in the latter case, the film is more than 150cm or 5ft long. With this length of film it is not practicable to use backing paper to protect the film from light while you load it into the camera. Thirty-five millimetre film is bare film and therefore has to be supplied and loaded in a light-tight container. The container, known as a cassette, is a simple construction of outer shell with a velvet-lined slot and an inner spool on which the film is wound tightly. The ends of the shell are held by lipped discs which can be prised off if you wish to reload the cassette (see page 113).

The velvet-lined slot provides reasonable protection against light but it cannot give total protection and films should therefore be kept in their protective wrapping until just before loading into the camera. Similarly, when removed from the camera, they should not be exposed to strong sunlight and should, in fact, preferably be wrapped up or stored in a dark place until you are ready to process them or have them processed.

There are, of course, two main types of film—colour and black-and-white—but it is to be hoped that you will not regard these as alternatives. You should use each for its own specific purpose. If you work only with colour, you tend to ignore a great many photographic opportunities—simply because they do not look colourful enough. This is an entirely wrong approach to the use of colour film, but many people do react this way, whereas they might not if they were more used to using black-and-white film.

There are, for example, pictures made up almost entirely of patterns—perhaps of lines and shapes or of light and shade—to which colour would add nothing. There may not

even be any colour in them. The colour photographer might ignore such pictures. He should not, because colour film can be used very effectively on virtually monochrome subjects, but he often does. The black-and-white photographer is more likely to seize such opportunities and also to realise that he can still take similar pictures when he uses colour film.

So do not treat black-and-white and colour film as alternatives. Make the most of both types of film.

Film speed ratings

There are very many makes of black-and-white film and they are all made in several speed ratings. So now is the time to consider the often misunderstood matter of film speed.

Film speed is usually expressed by a single figure followed (or preceded) by the letters ASA or DIN. These letters simply indicate that the system used is that laid down by the standard authorities of the United States (ASA) or Germany (DIN). In the UK, we generally use the ASA rating. The DIN figures are more commonly used in continental Europe. Thus, your film may bear the film speed rating 125 ASA. The figure means nothing in itself. It is just a label, but it indicates that the film has a certain sensitivity to light, i.e. a certain amount of light falling on the film will produce a certain degree of reduction of silver halide crystals if the film is processed for a certain time in a certain developing solution at a certain temperature and in a certain manner.

Note all those provisos carefully. They explain why so much rubbish is talked and written about film speed and how it can be increased by the use of specially formulated developers. The film speed specified by the manufacturer holds good only if all the provisos above are satisfied. Depart from any one of them and the rating becomes meaningless.

However, the manufacturer does not just settle arbitrarily on a certain degree of blackening and set a figure to it. He relates the degree of blackening a certain amount of exposure will produce after the film is processed in a standard developer to the agreed scale of speed figures used by exposure-meter manufacturers and compilers of exposure tables. Thus films that reach the agreed degree of blackening with the same amount of exposure are given the same figure. Films that need less exposure to produce the same result are regarded as "faster" and are given a higher figure. The ASA

FILM SPEED, GRAIN AND RESOLUTION

Broadly speaking, the graininess of the film image increases as the speed of the film increases, while contrast and resolution decrease with increasing film speed.

With constant improvements in emulsion characteristics, however, these differences are no longer as great as they once were. The very slow films certainly give better resolution of fine detail and greater contrast, while very fast films (above 400 ASA) can show unpleasant grain effects, but most films in the middle region are now fine-grained and, with suitable processing capable of giving superb image quality.

Nevertheless, there are occasions when it may be necessary to suit the film to the subject. For fine copying work, for example, it is reasonable to take advantage of the special qualities of the slow film. Indoor shots in poor lighting are better handled by the fast film. Static subjects can be handled by the slow-to-medium film while fast action generally calls for a slightly faster emulsion.

In black-and-white, 125 ASA is generally accepted as a good all round compromise. In colour, the equivalent is the 50–64 ASA film.

figures are on an arithmetic scale, so that a figure twice as large as another denotes a film twice as sensitive (or twice as fast). The DIN figures are logarithmic: a doubling of film speed or sensitivity is indicated by an increase of 3 in the DIN figure.

These figures are related on exposure-meter scales or in exposure tables to combinations of aperture and shutter speed that will produce what is generally accepted as the optimum density of tone in a negative to give the best possible print of an average subject, i.e. a subject with no large areas either of intense black or brilliant white, but in which reasonable shadow and highlight detail are required.

Now it is obvious that if a subject had only one tone, a wide range of exposures would produce sufficient density on the negative to allow that tone to be reproduced on a print with various exposures from the enlarger lamp. So the film speed for that subject could be anything from, perhaps, 50 ASA to 400 ASA or more. To a lesser extent, the same applies to any subject with a restricted range of tones. Only when the subject has a fairly long range of tones, and detail is required at both ends of the scale, does the film-speed rating become at all critical.

Adjusting the film speed

There is another point, however. You can obtain more or less the same densities on a film by rating it faster than its maker recommends and developing it for longer than he suggests as you can by treating it normally. But overdevelopment has a tendency to blacken the silver halide grains to a greater extent and perhaps to a greater depth in the emulsion. This can cause an overlapping of the grains, known as clumping, that makes them more apparent on the enlarged print and destroys the resolution of fine detail. A similar result can be brought about by departing radically from the recommended film speed and giving the film too much exposure.

Thus, the figure the manufacturer puts on the film is a guide to the exposure required for an average subject and, for such a subject it should be treated as fairly critical although with modern emulsions it is very unlikely that anybody could tell the difference between prints made by a skilled printer from negatives given one stop more and one stop less exposure.

Exposure latitude

As the tone range of the subject becomes greater or less, the importance of adhering to the film-speed figure becomes similarly greater or less. If you have brilliant highlights in which you wish to reproduce delicate detail, you must be careful not to overexpose. If you have deep shadows with important detail, you must be careful not to underexpose. If you have neither, a moderate amount of over- or under-exposure will generally do no harm.

This tolerance of over- and underexposure is known as exposure latitude. Every film has some latitude but, generally speaking, slower films have less than faster films. Slower films tend to be of finer-grain construction and to produce greater contrast than faster films, although this tendency is much less marked with modern films than it was with the films of a few years ago.

These factors, however, point to the reason for the popularity of films in the medium-speed group—from about 100 to 200 ASA. They are of sufficiently fine-grain construction to provide images of excellent quality for enlarging; they have reasonable exposure latitude; and they have adequate contrast characteristics. Their sensitivity, especially when used with the large-aperture lenses available for the Prakticas, is sufficient to enable them to be used on almost any subject without the necessity for excessive stopping down in bright sunlight.

Uses of slow and fast films

Slower films, in the 40–50 ASA range, used to be popular for their extremely fine-grain characteristics, but most medium-speed films are now practically their equal in this respect. The appeal of slower films now lies more in their low sensitivity, which enables them to be used at relatively wide lens apertures in bright lighting conditions. The faster film sometimes has to be used at an aperture that gives more depth of field than the subject requires.

There are many photographers who prefer to use a faster film (usually 400 ASA) all the time, on the grounds that it gives them "something in reserve" for the unexpected poor-light shot. This is understandable for the press photographer or photo-journalist, perhaps, but less so for the average

photographer, who generally sticks to certain types of photography and is not very likely to encounter once-in-a-lifetime shots that the medium-speed film cannot handle adequately. It is even less understandable for the photographer who is seeking good-quality results rather than "the picture at all costs".

The fast film is really only necessary for fast action shots in very poor light, hand-held indoor shots and similar subjects where tripod-mounted shots on a slower film are impossible or impracticable. Manufacturers have recognised this fact in recent years and both Ilford and Kodak have withdrawn the superfast 600–800 ASA films they used to market.

Choosing the make of film

Which make of film you choose is entirely a matter of personal preference and availability. Once you get used to handling your own particular brand, you will no doubt swear that no other can approach it, but there is little to choose between the well-known makes. There is not much point, however, in buying a brand that is not easily obtained everywhere. If you run out of film far away from your supplier and have to buy a brand with which you are not familiar, you will find that you lack the confidence that comes from knowing the characteristics of your own film.

There are many suppliers of "surplus", outdated and other films at cheap rates. You may have some use for such film for practice shots, experimental work that you do not intend to repeat precisely and so on, but you would be unwise to use it for work you regard as important. More often than not it may prove to be completely reliable, but you can be sure that if anything does go wrong, it will be on an absolutely unrepeatable shot.

Handling refills and bulk lengths

Apart from buying film in standard 20- or 36-exposure lengths loaded into cassettes (which is rather expensive) you can buy refills of the same lengths or bulk film in 5m and 17m lengths.

The refills are trimmed with tail and leader ready to load into a cassette. The loading is not difficult but it has to be done in total darkness. You simply take one end off the cassette, extract the spool, unwrap the film and attach its end

LOADING CASSETTES

The standard cassette (*upper left*) consists of a shell with a felt-lined slit containing a spool with one end protruding beyond the flange and the other containing a bar to engage the camera rewind knob. The ends of the cassette can be prised off, some with more difficulty than others.

The loaded cassette (*upper right*) is supplied with a leader (cut away in the diagram) protruding from the slit and ready to be attached to the take-up spool in the camera. The film is now often attached to the spool by adhesive tape passing round the spool and adhering to the film on both sides. This is the method recommended when loading your own cassettes from bulk film. Loading can be carried out by hand as shown (*centre*). The film must wind in the direction shown. A short leader is sufficient for the early Prakticas, while those with the quick-load device need no leader.

Daylight loaders are available for loading cassettes from bulk film (*bottom*). The model shown takes 100 ft. of film and has an automatic frame counter. Its features are:

1. Film magazine
2. Magazine lock
3. Frame counter
4. Cassette
5. Cassette chamber cover (removable only when magazine light trap is closed)
6. Film winder

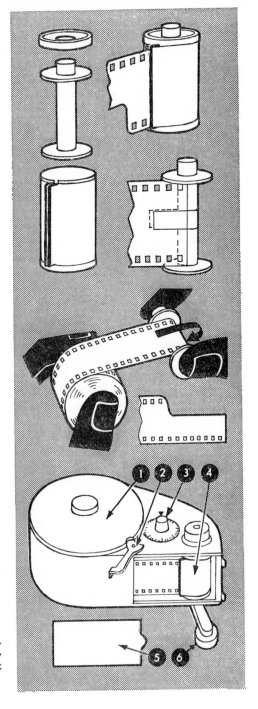

to the spool (preferably with a small piece of adhesive tape passing round the spool and adhering to the film on both sides). Then you wind the film on to the spool, holding it by its edges only and keeping your fingers well clear of both the emulsion and the back. Insert the spool in the cassette, allowing the leader to slide down the slot, and replace the end of the cassette.

Be careful to wind the film tightly on the spool but do not pull on it to tighten the coils. That will almost certainly produce scratches. If you find that you have wound it too loosely to fit into the cassette, unwind it carefully and start all over again.

The bulk lengths of 5 or 17m are not quite so easy to handle. The five-metre length gives you three 36-exposure lengths and the 17m gives you ten. It is as well, therefore, to cut off the length you require before attempting to load the cassette. This has to be done in darkness and is generally achieved by providing prominent marks on a bench, doorframe, wall, etc., that can easily be felt. If you can allow two small nails to protrude at the required distance apart, so that you can hook the film perforations over them, so much the better.

Once you have the required length, you can load the cassette as previously described. There is no need to trim the tail, and the leader can be trimmed after the cassette is loaded. The early Prakticas need only a short leader, while the quick-loading models really need no leader at all (see page 30).

Bulk film can be handled much more easily if you have a cassette loader. There are various models, consisting basically of a light-tight chamber to hold the roll of film and a loading chamber with a winding handle attached to hold the cassette. Once you have placed the roll of film in the loader in darkness you can carry out all loading operations in the light. Generally, however, you have to pull a few inches of film out of the loader to attach it to the cassette spool. It then becomes fogged if you carry out this operation in ordinary lighting and you may in fact prefer to do that in the dark, too. If you do not and if, like so many, you go on shooting until the transport lever refuses to operate any more (instead of watching the exposure counter), you will inevitably find that your last (unrepeatable) shot is fogged and perhaps even part of the previous one, too.

112

Manufacturers' cassettes can be used repeatedly if they are kept clean and not allowed to collect dust in the velvet light trap. It is a rare occurrence for cassetttes to be responsible for the scratches (tramlines) so often found on films. These are more likely to be caused by careless handling during processing or printing or by a damaged or dirty pressure plate in the camera.

Types of colour film

Colour films are supplied in cassettes like black-and-white film, usually in 20-exposure or 36-exposure lengths, but some are also available in 12-exposure lengths. Refills and bulk lengths are not available in the most popular makes, mainly because processing is geared to the standard lengths but also, no doubt, because the manufacturers are reluctant to allow their films to be subject to the risk of careless handling and storage. Nevertheless, some makes occasionally become available in bulk lengths and are useful for those who do their own processing and those who like to experiment.

There are fewer colour films than there are black-and-white and the speed range is smaller. There are, however, two distinct types—colour negative (or colour print) film and colour reversal (or colour slide) film.

They are of similar construction, consisting basically of three separate emulsion layers sensitive individually to red, green and blue light. Colour print film is, however, processed comparatively simply in a colour developer to produce a negative image (i.e., with the tones reversed) consisting of colours complementary to those of the original. The colours are usually overlaid with a quite heavy orange or yellow masking dye designed to improve the printing quality. A colour negative is thus rather difficult to read and few people can judge its quality without having a print made.

Generally speaking, however, if the negative is of such density that the image details can be clearly seen and if it is sharp, it can be taken that it will print well. The colours will be reasonably true unless you departed radically from the recommended lighting conditions or used mixed lighting (see page 115). The printing stage allows reasonable corrections to be made of any overall colour faults that may be present in the negative.

Colour slide film is processed differently. It is first treated

in a black-and-white developer to produce a normal negative image. The film is then exposed to light (or treated chemically) to make the unblackened parts developable. These parts naturally correspond to a positive image and, when they are treated in a colour developer, dyes are produced in the three layers to reproduce the original colours of the subject. The negative parts, having been already developed, are not affected by the colour developer. Finally, all the silver images are bleached out and the positive dye image remains.

The colour slide so produced can be viewed directly by transmitted light or can be placed in a viewer or projector (see page 249) to give an enlarged image. It is generally much more brilliant and satisfying than the colour print but has the disadvantage that it really needs to be projected to be appreciated fully, whereas colour prints can easily be passed from person to person for individual appraisal.

The speed of colour print film is generally about 64–80 ASA and it can be used in either artificial light or daylight. The artificial light, however, should preferably be studio lighting or photofloods. Ordinary domestic lighting is rather low in intensity and colour temperature (see page 115) to allow satisfactory colour rendering.

There is a wider range of speeds for colour slide film— from 25–200 ASA, and even one at 500 ASA. Probably the most widely used are those in the 50–64 ASA range, but the super-fine grain and brilliant colour characteristics of Kodachrome II at 25 ASA made it still a very popular film long after much faster speeds were easily attainable and all other manufacturers had abandoned Kodachrome-style processing.

Colour slide film also comes in two versions—one for use in daylight and the other in artificial light. This is necessary because there is no separate printing stage during which corrections of colour rendering can be made. The colour appearing on the film is that of the subject and, although the human eye is rarely aware of it, colours are very different in artificial light and in daylight. If you use daylight film in artificial light you will find that all colours are overlaid with a heavy red or yellow cast. Conversely, artificial-light film used in daylight produces an overall blue cast. These divergences in colour rendering are caused by the fact that the daylight film has to be made rather less sensitive to blue and more sensitive to red than the artificial-light film because

there is relatively more blue in daylight than in artificial light.

Colour temperature of light sources

Daylight in this context includes electronic flash and blue-tinted flashbulbs, which are specially made to approximate to daylight in colour temperature. The concept of colour temperature is simple although its full scientific explanation is rather involved. Essentially, however, it stems from the fact that a heated substance emits light of different colours at different temperatures. If we standardise the substance used for measurement, we can relate the various colours to temperature. This has been done, but the temperature scale used is not the normal Centigrade or Fahrenheit but the Absolute, in which zero is minus 273°C and the unit used is known as a kelvin.

Thus, we can describe the colour of the light provided by domestic lamps, photofloods, flash tubes and bulbs, sun and sky, etc., by a series of figures, and the type of light in which a particular film is designed to be used can be simply specified. Daylight film, for example, is intended to be used ideally in light of a colour temperature of about 5500–6000K (kelvins), so flash tubes and bulbs are made to emit light of that colour temperature. Photofloods emit light of a colour temperature of 3400K, and artificial-light film is so made that it will give correct colour rendering in that light. There is also another type of artificial-light film (sometimes known as Type B) which is designed for studio lamps, which are rated at 3200K.

Because of this special formulation of colour films, each colour slide film can be used only in the type of light for which it is "balanced" and all the light on the subject must be of the same type or colour temperature. You cannot mix the lighting using, say, daylight through a window with a photoflood to fill in the shadows. But you can use electronic flash or blue-tinted flashbulbs for this purpose, because their colour temperature is close to that of daylight.

The mixed-lighting rule applies to all colour films, including colour print film. The correction made at the printing stage to allow for the type of light used cannot be selective. You cannot make different degrees of correction for different parts of the film.

PRAKTICA FOCAL PLANE SHUTTERS

All the Prakticas use focal plane shutters, which take their name from the fact that they are situated in the back of the camera as close as possible to the film. The shutters of models before the Praktica L consisted of two cloth blinds rolling and unrolling on two spring-loaded rollers. The blinds remain close together and light tight while they are moved across the camera to tension the shutter so that the film is always shielded from light except when the actual exposure is made. Thus, the lens can be removed from the camera at any time to be exchanged for another or to enable accessories such as extension tubes or bellows, tele-extenders, etc., to be fitted.

How the focal plane shutter works

Exposure is effected by tensioning the shutter and depressing the shutter release. The first blind then moves horizontally across the back of the camera and is followed by the other at a distance varying with the shutter speed set. At high shutter speeds, the second blind follows close behind the first, so that the film is exposed piecemeal in narrow strips. The speed of travel of the blinds is constant, so that each strip receives exactly the same exposure.

As the shutter speed slows, so the gap between the blinds widens until, at about 1/50 or 1/60 sec it covers the full width of the film frame, the second blind not moving until after the first has uncovered the complete film area. At even lower speeds, there is a delay before the second blind begins to move, so that the whole frame is exposed for a large part of the exposure time.

On the Prakticas up to and including the first Novas, the slow speed delay had to be separately set on a retarding device controlled by a smaller knob on top of the shutter speed knob. This bears a red triangle which has to be turned to the red triangle below it on the camera top plate when the speeds of

PRAKTICA SHUTTERS

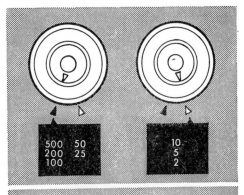

The older Praktica shutters have a retarding device controlled by a separate knob on top of the shutter speed knob. When the arrow head on this knob is set to the black marker, the faster speeds are obtained. When it is set to the red marker, the 1/10, 1/5 and 1/2 speeds are obtained.

Models before the L series have cloth focal plane shutters moving horizontally. The shutter consists of two blinds, one following the other after a delay varying according to shutter speed set. The blinds are wound from the rewind end of the camera to the transport knob end with a slight overlap so that they are light tight and are released in the opposite direction.

The L shutters follow the same principle but consist of six thin metal leaves moving vertically. They are wound upward and released downward.

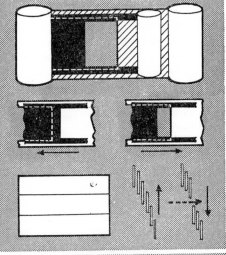

Focal plane shutters can cause distortion of moving objects. When the shutter blinds move in the opposite direction to the movement, the object may be compressed. When shutter and subject move in the same direction the subject length may be extended. Vertical movement of the shutter with a horizontally moving subject can give a leaning impression.

½, 1/5 or 1/10 sec (engraved in red on the speed dial) are required. When the faster speeds are used, the red triangle is turned to the black triangle on the top plate.

If you set the marker to the "wrong" position so that the retarding device is disengaged when you use the 1/5 and 1/10 speeds or, on later models, 1/4 and 1/8, the actual shutter speed obtained is about 1/30 sec.

The faster speeds are not affected by the setting of the retarding device except that a narrow strip at one end of the image area may be underexposed owing to a sudden slowing down of the first blind if the retarding device is engaged. This has no harmful effect on the mechanism.

The separate retarding device control was dropped on the Prakticamat, which has a shutter speed ring around the rewind knob. All later models have the usual single knob with all speeds marked and easily set by turning the knob in either direction (except between 1/1000 and the flash symbol on the L models and 1/500 and the flash symbol on the Super TL).

Shutter speeds are designed to "double up" at each setting so that they can be related to lens aperture settings, which work in a similar manner. On Praktica models before the Praktica VF, however, the principle was not adhered to very closely and the speed range was 1/2, 1/5, 1/10, 1/25, 1/50, 1/100, 1/200, 1/500.

As exposure meters began to be used more frequently by amateurs and as the fully automatic camera became popular, this progression of shutter speeds was succeeded by one approximating more closely to the doubling up principle. The universally accepted range is now 1, ½, ¼, ⅛, 1/15, 1/30, 1/60, 1/125, 1/250, 1/500, 1/1000, so that ½ sec at ƒ8, for example, is virtually the same as ⅛ sec at ƒ4, or 1/30 sec at ƒ2 and so on. Similarly, in exposure terms, moving from 1/60 sec to 1/125 sec is the same as closing the lens aperture by one stop, say from ƒ11 to ƒ16.

Metal shutters of Praktica L Series

The shutters of the Praktica L models work on exactly the same principle as those of the previous models but are very different in construction. They are made of thin metal leaves instead of cloth and move vertically (downwards for the exposure) instead of horizontally.

The relative merits of cloth and metal may be debatable but

the advantage of the vertical movement is that the shutter blades have less distance to travel and can expose more of the film at a given moment. The most notable effect of these factors is that the film can be totally uncovered at a faster shutter speed, generally in the region of 1/100–1/125 sec, which is important for flash synchronisation (see page 121).

Operations coupled with shutter release

The shutter controls are rather complicated—particularly on the later models. The shutter springs are tensioned when the film transport lever or knob is operated. Thus, winding on the film also tensions the shutter. At the same time, it brings an automatic locking device into play so that the film cannot be further wound on without releasing the shutter. Similarly, once the shutter has been released, it cannot be opened again unless it has first been retensioned, which involves winding on the film. Inadvertent double exposures are thus avoided.

The shutter release also performs more than one function. Its first pressure closes the lens diaphragm of automatic lenses to the pre-selected aperture. Further pressure causes the mirror to spring upward out of the light path and the final pressure releases the shutter. On models VF and later, the mirror returns automatically to the viewing position after the shutter has closed and (on all automatic-lens models) the lens diaphragm returns to the fully open position.

The shutter release of the Prakticamat also switched on the exposure meter when lightly depressed, but was not intended to be so used. In fact, the meter does not read accurately at this stage and readings must always be taken with the meter switch pressed. On the other hand, the VLC and LLC meters can only be switched on by pressing the shutter release. There is no separate switch. This can lead to problems, as noted on page 71. The Praktica VLC and LLC shutter also has a delayed action mechanism, the function of which is described on page 104. The D/A is an optional extra on the Praktica LTL.

Using the brief time setting

All Praktica shutters except the earliest have, in addition to the normal range of speeds, a B setting which allows exposures of unlimited duration to be made. As long as the shutter release

is kept depressed, the shutter remains open. If very long exposures are required, a cable release with a locking mechanism should be used. If you attempt to hold the release button for any length of time you will undoubtedly impart some vibration to the camera.

If the B setting is used with automatic diaphragm lenses (see page 40), the aperture will remain closed to its preselected setting as long as the shutter is open (because the release button must be kept depressed). If, however, the normal slow speeds are used, the diaphragm reopens as soon as you let go of the release button of the older Praktica models. Thus, it is possible to obtain a considerable measure of overexposure and, perhaps, other evidence of wide-aperture shooting (lack of depth of field, poor edge definition) without realising why. The only solution is to keep the release button depressed until the shutter closes. This trouble is not encountered on the Praktica L models.

Distortion caused by shutter movement

It is evident that the focal plane shutter exposes the film in such a way that different parts of the image are formed at different times. Where a vehicle travelling parallel with the film plane is photographed, for example, the image of either the front or the back is formed first, depending on whether the vehicle is travelling in the same direction as, or against, the direction of the shutter blinds. The image of the other end of the vehicle is formed, say, 1/60 second later. In that time, a vehicle travelling at about 50 mph would move more than a foot and the image could thus be elongated or squashed.

With the vertically-moving shutters, or where the camera is turned on end to take a vertical-format picture, the effect is to make the moving subject appear to lean forward or backward, because, depending whether the shutter moves upward or downward, the bottom of the subject is recorded fractionally before the top, or vice versa.

These effects are rarely noticed in general photography because subjects moving directly across the camera at such speeds are likely to be taken by a panning method (see page 100) or are rendered deliberately unsharp. Were you to attempt to record such actions as, say, a golfer's swing, however, from a direct, side-on view, you might, indeed, produce a misleading image.

Flash synchronisation of Praktica shutters

All Praktica shutters have been synchronised for flash work since the Praktica FX of 1955. Early models had non-standard contacts, at first in the base of the camera but later on the front beside the lens. Since 1956, however, the contacts have been the standard 3mm coaxial sockets and have been of the F and X type for flashbulbs and electronic flash respectively, except in the latest models (see page 124).

Synchronisation of a shutter for flash is necessary to ensure that the flash is fired at the correct time during the brief moment when the film is fully uncovered. The focal plane shutter, as explained on page 116, exposes strips of the film sequentially through a gap between the shutter blinds at speeds faster than about 1/125 sec on the Praktica L models and about 1/60 sec on all other models. As the duration of the usable light from a flashbulb is about 1/100 sec and from a flash tube about 1/500 sec or less, it is evident that flash cannot be used at all with the faster speeds of a focal plane shutter. The effect would simply be exposure of only the strip of film that happened to be uncovered at the time the flash fired. This is not strictly true of all focal plane shutters because special flashbulbs are available which burn at a steady intensity rather longer than the ordinary bulb—long enough, in fact, for the opening between the shutter blinds to traverse the film. These bulbs are expensive, however, and are not always easily available. Moreover, the tendency for some years now (since 1956 on the Prakticas) has been to make the F synchronisation suitable for M-class flashbulbs and not for focal-plane bulbs.

The M-class flashbulb is the popular PF1, Type 1, AG1, etc. It ignites when sufficient voltage is applied to it, takes about 5 or 6 msec before any light at all is emitted and a further 10 msec to reach peak brilliance. It dies away at a rate similar to its build-up time. The really useful illumination is from half-way to the peak to half-way to extinction—the half-peak to half-peak time—which is, in most M-class bulbs about 10–12 msec or 1/100 sec. Thus, a shutter speed of 1/100 sec or slightly slower could accommodate most of the light that the flashbulb emits. However, the horizontally-moving focal plane shutter fully uncovers the film only at speeds rather slower than 1/60 sec, and 1/30 sec is therefore the fastest speed at which bulbs can be used. The vertically-moving shutter fully

uncovers the film at rather less than 1/125 sec and bulbs could therefore be used at 1/60 sec. The recommended speed is, however, still 1/30 sec because these cameras have only one flash contact—with X-synchronisation characteristics, which do not allow for the build-up time of flashbulbs. Use of 1/60 sec leads to a considerable loss of light output, because the bulb barely reaches its peak brilliance in that time.

Electronic flash has no build-up time and virtually no tail, so it can be used at the fastest shutter speed at which the shutter blinds are fully open. As these speeds are not in the standard range, special settings marked with a lightning flash symbol are provided to give speeds of about 1/40 sec on the horizontally-moving shutters and 1/100 sec on the vertically-moving shutters.

Many of the earlier Praktica models (see page 123) have two flash contacts with different types of synchronisation—F and X. X-synchronisation is primarily designed for electronic flash. It closes the flash circuit as soon as the first shutter blind clears the image area so that the electronic flash can fire immediately and be used at the fastest shutter speed at which the film is fully uncovered. Flashbulbs can be use with X-synchronisation, but, as explained above, they have to be used at slower shutter speeds.

F-synchronisation is for flashbulbs only. It closes the flash contact fractionally before the first blind reaches the end of its travel, so that the build-up period during which the bulb is emitting little light does not occur during the fully-open shutter time. Flashbulbs can be used with F-synchronisation at speeds of 1/30 sec and slower. Electronic flash cannot be used at all with F-synchronisation because the flash fires instantaneously on the closing of the contacts—while the first blind is still covering part of the film.

The F-synchronisation socket was originally for use with special long-burning focal plane bulbs and it then served a more practical purpose. It is evident that it now offers no advantage over using flashbulbs with X-synchronisation, which is no doubt why it has been dropped with the introduction of the Praktica L range. Nevertheless, some Praktica users have claimed that they can synchronise flashbulbs at faster speeds than 1/30 sec with the flashgun connected to the F socket. If you feel so inclined you can experiment with your camera.

If you want to be certain of even exposure across the whole

FLASH
SYNCHRONIZATION

Flash synchronization on the Prakticas has had a chequered history and if you acquire an old model with no instruction book, its characteristics are best ascertained by practical tests.

The top three sections indicate the various types of synchronization found on the FX models. The F socket was then for special long burning flash-bulbs and allowed them to be used at all shutter speeds.

The fourth panel indicates the type of synchronization that has been standard since the Praktica IV on the horizontally moving shutters. With electronic flash you set the shutter to the flash mark which gives about 1/40 sec. With the normal short-burning flashbulb you can use 1/30 sec. or slower.

Faster speeds cannot be used.

The "hot shoe" contact of the L series shutters synchronizes short-burning bulbs at 1/30 sec. (the bulb symbol) and electronic flash at about 1/100 sec. (the flash symbol). Exceptionally, the Praktica VLC has a single X-synchronised coaxial socket in the sidewall. It has no hot shoe contact.

The flash symbols of the Super TL (*left*) and the L series (*right*).

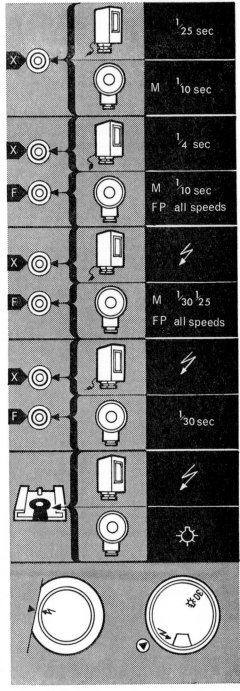

frame, however, you must use the X socket and the flash symbol shutter speed setting for electronic flash and the F or X socket and 1/30 sec for flashbulbs. Naturally, you can use slower speeds if you wish.

The vertically-moving shutters of the Praktica L models (except the VLC) have no coaxial contacts. Their single flash contact is in the accessory shoe and is designed for use with flashguns with a contact in the foot (the so-called "hot-shoe" contact). If your flashgun has no such contact, you have to buy a separate attachment that fits into the accessory shoe and has a coaxial (X-synchronisation) socket in the side. If, on the other hand, you have a hot-shoe flashgun but an earlier Praktica with no hot-shoe contact, you have to use the special cable supplied with the flashgun to raise the foot contact and prevent short-circuiting to the camera body.

The Praktica VLC has no hot-shoe contact because the pentaprism is removable. A single X-synchronised coaxial flash contact is placed in the sidewall at the rewind end of the camera. A special flashholder can be slipped into grooves around the rewind knob to provide either hot-shoe or normal accessory shoe facilities. The hot shoe has a cable to complete the circuit from the coaxial socket.

FLASH EQUIPMENT
AND OPERATION

Except in the simplest cameras, where tiny flashguns are sometimes built into the camera, electronic flash is tending to become more popular than flashbulbs. This is mainly due to the progressive reduction in the size and price of electronic units over the past few years. Many are now smaller than the average size bulb unit of, say, the 1950s. They are still quite a lot more expensive, but their running costs are lower. Unfortunately, most of these small units cannot compare in light output with the smallest of flashbulbs. The AG1 or PF1 type bulb generally gives about four times the light of a small electronic unit.

Flashbulbs and capacitor units

Flashbulbs are expendable, i.e., they can be fired once only. They consist essentially of highly inflammable metal foil in a glass envelope containing oxygen. They burn brilliantly for a short period (see page 121) and, once used, are discarded.

The power source for flashbulbs is now invariably a small capacitor charged from a battery of about 15V. The capacitor is used because direct firing from a battery becomes unreliable as the battery voltage drops. The whole unit can be made extremely small by the use of the "peanut" AG1 bulb and a bladed, collapsible reflector. The strength of the light, however, is considerable, generally allowing (with 100 ASA film) an aperture of $f8$ or $f11$ to be used with a flash distance of 10ft.

The flashgun is attached to the camera either by sliding its foot into the accessory shoe of the Praktica L models or by first attaching to the other models the accessory clip designed for them (see page 180). Alternatively a flash bracket (see page 132) can be used. The electrical connection is via a cable terminating in a standard 3mm coaxial plug which fits the flash socket of the earlier Praktica cameras and the VLC. Bulb flashguns should be plugged into the F socket (see page 121).

The other L models have cableless connections in the accessory shoe (see page 124).

All small flashbulbs are now tinted blue so that the quality of their light is similar to that of daylight. They can thus be used with all types of film—colour print, daylight colour slide and black and white—except artificial light colour slide film. Their light can be mixed with daylight, i.e., blue flashbulbs can be used for fill-in lighting in daylight.

Electronic flash units

Electronic flash used to be powerful but heavy and expensive. It often used wet accumulators as the power source and sometimes large, expensive dry batteries. Consequently, it was rarely used by the amateur. Nowadays, there are remarkably small and light electronic flash units which, while more expensive than bulb-firing units are still reasonably priced. Their batteries are either small, rechargeable types or dry pen cell types. Many can be fired from domestic electricity supplies, too.

Unfortunately, these advantages could not be attained without losses in other directions, the principal of which is light output. Most of the very small units have a limited output that cannot approach that of the smallest flashbulb. They can generally be used satisfactorily only at very close range or as fill-in lights.

There are more powerful units of rather greater bulk, but to reach the power of the small flashbulb we have to go to even larger and still rather heavy semi-professional units that are by no means inexpensive. To attain the power of the larger bulbs, such as the PF5, you would have to buy a costly studio unit of considerable bulk and weight.

In short, a powerful electronic flash unit is not cheap. Nevertheless, it has quite considerable advantages over the bulb unit. First, you do not have to carry a stock of bulbs with you and change the bulb after each shot. Secondly, you can use much faster shutter speeds on the later Prakticas (the L models) which synchronise with electronic flash at about 1/100 sec. This may make fill-in flash with moving subjects in daylight possible (see page 135). Perhaps most important of all, you do not have to pay out for at least one flashbulb for each shot you take. The cost of your electronic unit may be equivalent to that of many hundreds of flashbulbs, but it still hurts to add the cost of a flashbulb to every shot.

FLASH EQUIPMENT

Flash equipment has become smaller over the years. There are new pocketable electronic units (*left*) and even smaller bulb guns with folding reflectors (*right*).

Some units have no cable connector. They have a contact in the base to suit the type of contact in the accessory shoe of the Praktica L models (*left*). This type of contact can be converted to the cable connecting type by inserting an accessory cable (*right*) which raises the shoe contact. Cable connecting flash equipment can be used on the L series by fitting a converter which connects the shoe contact to a coaxial socket into which the flash unit can be plugged.

The small electronic units are not very powerful and for real power rather larger electronic units are necessary. These often have the additional advantage that extension heads can be fitted to permit more sophisticated lighting setups.

The Praktica VLC has no hot shoe contact but an adaptor can be slid into grooves under the rewind knob. A short cable connects the adaptor to the coaxial socket.

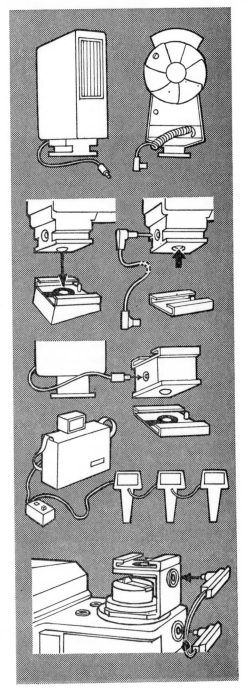

The quality of the light from electronic flash units is, as with blue-coated flashbulbs, similar to that of noon-day sunlight (see page 115). Naturally, it may vary a little with different units and, if critical colour work is undertaken, very slight filtering may be required to correct a tendency to blue. This can be discovered only by careful experiments with the particular equipment.

Electronic flash is always used via the X-synchronisation socket with the shutter set to the lightning flash symbol. This is about 1/40 sec on the horizontally moving shutters and 1/100 sec on the vertically moving shutters. The same considerations as to hot-shoe contacts apply as for flashbulbs (see page 126).

Multiple flash facilities

The larger electronic units often have facilities for adding an extension head, which can be very useful with many types of flash photography. The big studio units incorporate several flash heads and a variety of other attachments to provide lighting arrangements of great versatility.

Alternatively, there are so-called slave units available incorporating a light-sensitive cell which triggers a flash tube when light from the main flash reaches it. These units need no connection to the main flashgun and, providing the main unit is reasonably powerful, can be used at some distance from it.

If neither extension head nor slave unit can be used, it is possible to connect two separate flash units to the same socket via a small Y-junction available from photographic dealers. It is advisable to use two similar units because occasions can arise when different units have their synchronising leads connected in different ways so that firing is unreliable.

It is even possible, with static subjects totally flash lit, to connect an electronic flash to the X socket of the Praktica Super TL with two sockets and a bulb flashgun to the F socket. The flashes will occur at different times but, provided the subject does not move during the exposure, that is of no importance.

It is also possible to fire several flashbulbs from the same power source. The normal flashgun battery has sufficient power to fire several bulbs but a larger capacitor has to be fitted. A safe margin is generally obtained by allowing 50 mfd for each bulb. Thus, if four bulbs are to be fired a 200 mfd capacitor

should be fitted. Alternatively, of course, the holder for each bulb can incorporate its own capacitor. The most reliable method of connecting such extension units is via a multi-way adaptor but they can be arranged so that the extensions are connected to each other and then one end to the shutter contacts and the other to the main flash unit.

Flash exposures

Calculating the exposure required for flash pictures is facilitated by the guide number system. Every flashbulb and every electronic flash unit has a guide number allocated to it by the manufacturer as a basis on which to calculate the exposure required. This guide number can be divided by the f-number to which you wish to set the lens to give the distance from the subject at which the flash should be placed. Or it can be divided by the distance at which you intend to place the flash to give the f-number to which you must set the lens.

The system works satisfactorily in most cases because it depends on a law of physics known as the inverse square law. This law says that the strength of the light emanating from a point source falls off with increasing distance in inverse proportion to the square of the distance. Thus, an object 3ft from the light source receives less than half of the light that falls on an object only 2ft distant—actually $(\frac{2}{3})^2 = 4/9$. Expressed another way, if the distance of the lamp is doubled, the intensity of the light on the subject is reduced to one quarter. The same applies to the f-numbers used to designate lens apertures. Double the number—say from $f8$ to $f16$—and the lens transmits four times less light. Thus, whenever distance and f-number multiplied together give the same answer, the light reaching the film is the same, such as 8ft and $f8$, 4ft and $f16$, etc., or 3ft. and $f22$ (approx.). If those combinations should also happen to give correct exposures with a particular flashbulb or flash unit and a film of a particular speed, the single figure 64 can be called the exposure guide number in these conditions.

Every flashbulb and every electronic flash unit has a guide number allocated to it for each film speed, and correct exposure is ensured whenever f-number and distance multiplied together equal the guide number.

That, of course, is the theory; in practice, various other considerations have to be satisfied.

For example, no flashbulb or flashtube is a point light source. In most cases, this is academic. Provided the light source is small in relation to the subject it can be considered as a point light source. When the flash is placed very close to a small subject, however, the operation of the inverse square law may be upset.

More important, the guide number assumes that the bulb or tube is used in conjunction with a reflector of a certain efficiency and that the surroundings include reasonably close mid-toned reflecting surfaces. The lamp reflector raises no problems with electronic units but bulbs may be used in flash-guns of various sizes. If the reflector is too small, the guide number may need to be reduced.

Similarly if you shoot in a very large room or outdoors at night, there will be little or no light reflected from surrounding surfaces and, again, the guide number is too optimistic. Outdoor shots at night may require as much as two stops' increase in exposure, which is equivalent to halving the guide number.

When you calculate flash exposures, you must remember that it is the distance of the flash on which you base your calculations—not the shooting distance. Naturally, if you place the flash on the camera, the distances are the same, but it is usually preferable to position the flash well away from the lens axis (see page 132).

Exposure with two flashguns or flash heads need not raise exposure problems. In most cases, indeed, the second lamp can be ignored. In portraiture or similar subjects, where the function of the second lamp is merely to lighten the shadows, it should be only about one-quarter to one-half the strength of the modelling or main light and has only a marginal effect on the overall lighting strength.

In copying, however, or similar applications where both lights are placed at about 45° to the lens axis and at the same distance from the subject, the light intensity is approximately doubled and the exposure required is about half that recommended for one lamp. In that case the guide number of the flash unit should be multiplied by 1.4—the square root of 2.

Automatic flash exposure

Some electronic flashguns incorporate a light-sensitive cell which measures the amount of light reflected from the subject and automatically quenches the light when the tube has emitted

Every flash unit and flashbulb has a guide number quoted by its manufacturer. When the guide number is divided by the distance (there are different guide numbers for feet and metres) from the flash to the subject, the resulting figure is the *f*-number to set on the lens. Some rounding off may be necessary. The diagram shows the apertures required at various distances with a guide number of 64. It also shows the rapid fall-off in illumination with increasing distance. This follows the inverse square law, so that, if *f*11 were used at 24 ft., the subject receives only 1/16th of the light required for correct exposure.

enough for correct exposure. The idea is ingenious but, naturally, there are drawbacks. First, the exposure can be as short as 1/50,000 sec. That could lead to considerable colour distortion on some films owing to different responses of the three layers to such a brief exposure.

Secondly, a similar difficulty arises to that experienced with an exposure meter (see page 64). The automatic action has to be set to operate at a certain level. It cannot take account of the nature of the subject. If it is set to expose a mid-tone adequately, there will be a tendency to underexpose light and overexpose dark subjects.

Also, early models generally had to be used at one particular aperture setting according to the speed of the film in the camera. That aperture setting may not be suitable for the subject. Later models offer a restricted choice of apertures.

The automatic flashguns can be used normally if the sensor cell is covered.

Methods of mounting the flash unit

Generally, flash is used when the existing light is insufficient to give the type of photograph required. Its job then is to act as sole light source, ignoring the existing light altogether. The Praktica models before the L range have no provision for mounting a flashgun, but an attachable accessory clip is available for connection to the eyepiece of the viewfinder. This clip allows any accessory with the standard shoe fitting to be mounted on the camera top above the pentaprism.

The top of the camera is not, however, the ideal position for a flashgun and this type of mounting should be used only if other methods are inconvenient or impracticable. The effect of a flash mounted close to the camera is to provide flat lighting that does little to convey the form and shape of objects. If the background is close to the subject, the flash also throws a harsh outline shadow on to it. Occasionally, also, in flash photographs of the faces of people looking straight at the camera, the camera-mounted flash can produce large false highlights in the eyes caused by reflection from the back of the eye. This is the well-known "red eye" effect in colour photographs.

A slight improvement can be obtained by using a flash bracket (various designs are available) that attaches to the base of the camera via the tripod socket and allows the flashgun to be mounted beside the camera. The improvement, however, is

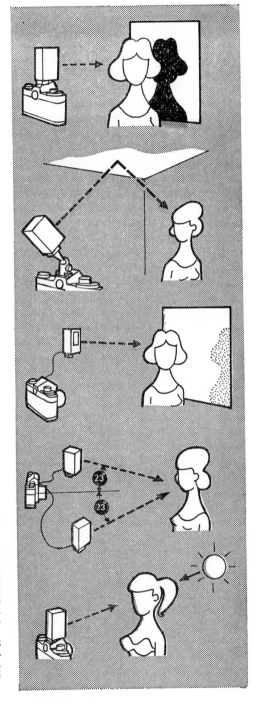

Direct on-camera flash should be avoided if possible. It gives no modelling and throws harsh shadows.

Bouncing the light from the ceiling gives a softer light, less harsh shadows and better modelling.

The small unit is often not powerful enough for bounced lighting. Whenever possible, however, it should be removed from the camera so that shadows can be thrown clear of the subject and a degree of modelling provided.

Cross-lighting is not usually recommended but it is often very effective with colour portraits where the single flash from one side can throw unattractive deep shadows that might also cause colour distortion.

The small electronic unit is particularly useful as a frontal fill-in in daylight. Its guide number should be at least doubled.

only marginal and, whenever possible, the flash unit should be placed in the off-camera position that gives the type of lighting most suited to the subject. This demands some kind of support for the flash unit (a tripod, perhaps) or an assistant to hold it. It also calls for an extension flash cable to connect the flash unit to the camera socket. These cables are freely available in various lengths and at comparatively little cost.

Using flash off-camera

When the flash is removed from the camera it inevitably throws harsh shadows on any subject that has prominent features. The obvious example is the human face. Photographed with a flash directed from one side it shows a marked shadow beside the nose. If the flash comes from above, the eye sockets and the area below the chin are in shadow. Similar considerations apply to other subjects and, if these heavy shadows are undesirable, some method must be found of lessening their density. A simple method is to place any kind of reflecting surface in such a position opposite the flash unit as to catch some of the light and reflect it back into the shadow areas. The reflector can be almost anything from a small mirror for a strong, localised effect to a mid-toned wall for a broad, diffused effect.

More elaborate is a two-lamp system, using a flash unit with an extension head or two separate flash units connected to the camera by a Y-junction. The two-lamp system offers more control over the lighting and allows more imaginative effects to be produced. Naturally, a further lamp or lamps can be added in the form of additional flash heads (to provide background and effect lights, perhaps) but this is approaching a form of studio portraiture that is less popular than it used to be. Or it could be a necessity for subjects of large area or considerable depth.

A popular method of using flash is to bounce the light from a reflecting surface so that all light reaches the subject indirectly, lighting it relatively softly and evenly and casting no heavy shadows. Such bounced lighting can be provided by directing the flash at a wall or the ceiling or into a corner of the room to achieve an almost all-enveloping light. It can be provided by using a specially designed reflector such as commercially available white umbrellas, shaped to make the most efficient use of the light emitted by the flash unit.

Flash and colour

Flash is a particularly suitable light source for colour film, in that electronic flash and the popular sizes of flash bulb emit light of a colour temperature (see page 115) similar to daylight. Thus, a single cassette of daylight colour film can be used for both normal outdoor shots and indoor shots by flash illumination. You must be careful, however, when bouncing the flash or using reflecting surfaces to ensure that the surfaces from which the flash is bounced are either white or neutral toned. If they are coloured, they will reflect that colour on to the subject.

A drawback frequently encountered in the use of flash, and particularly in colour, is the rapid fall-off in the intensity of the light with increasing distance. This fall-off accords roughly with the inverse square law (see page 129) and can be awkward when the subject has some depth and is relatively near the camera. A group of people, for instance, of which the nearest is 6ft from the camera and the furthest 9ft will be rather unevenly lit because the nearest figures will be more than twice as strongly lit as the furthest. If the subject is, say, a party at a long table, the problem can be almost insuperable for a single flash unit. It might be necessary to bounce the flash from about a mid point (calling for a powerful unit) or to use two or three bulbs or flash heads.

In colour, the light fall-off frequently causes unsatisfactory results because underexposure of the background does not simply leave it dark but also distorts the colour. A white door or wall, for example, could become quite strongly green or brown.

Flash in daylight

Flash is not always used as the sole light source. Outdoor lighting is sometimes so brilliant that a secondary source is needed to throw some illumination into the shadows. Reflectors can be used, in the form of specially constructed folding boards, newspapers or almost anything that happens to be handy, but the small, pocketable electronic flashguns so popular nowadays are particularly suitable.

The general aim of fill-in flash in daylight should be simply to relieve any excessive density in the shadows. The flash should, therefore, be rather weak—and most of the small guns excel in that direction. A rule of thumb is to give about a quarter of what would be a normal flash exposure if the flash

were the sole light source. This is most effectively accomplished by doubling the guide number of the unit (see p. 129).

A limitation on this practice with the earlier Prakticas with horizontally moving shutters is that flash exposures have to be made at a shutter speed of about 1/30 sec or slower. If, however, the light is so bright that fill-in flash is required, 1/30 sec may be much too long. It could call, with medium speed film, for an aperture of *f*22 or smaller. It becomes more practicable with colour film of, say, 25 ASA. Then, you might be able to use 1/30 sec at *f*16 as your basic exposure in brilliant sunlight and divide 16 into your doubled guide number to find the distance at which to place your flash. Thus, if your guide number is 40, the distance for the flash is 80/16 = 5ft, which is frequently a practicable shooting distance for such work.

Naturally, if you have an extension flash cable and an assistant to hold the flash, the flash distance need have no effect on your shooting distance.

The technique is useful for against-the-light portraits. It is generally unwise to allow your subject to look toward the sun. It can cause an unpleasant strained effect on the eyes. If you place them with their backs to the sun you can often obtain attractive rim-lighting effects. You must, however, be careful not to destroy that effect by overlighting with the flash, providing only just enough light to make the features satisfactorily distinguishable.

There is a further limitation imposed by the slow shutter speeds at which flash is used. It can raise problems with moving subjects because 1/30 sec is not fast enough to arrest any but the slowest of movement. Even with electronic flash, which can by synchronised at 1/125 sec on the Praktica L range, trouble can still arise from double images caused by the short duration of the flash and the longer duration of the daylight exposure. Movement in such cases can produce what appears to be a dark shadow alongside the flashlit image.

Using flash as the main light source in daylight is a less common practice and is not generally desirable. By overpowering the existing light it naturally results in considerable underexposure of any parts of the picture not reached by the flash, producing both dark and colour-distorted shadows. It may be necessary in order to obtain any picture at all or it may suit a particular effect you are striving to obtain but it is rarely suitable for subjects that you wish to look natural.

SUSPENDED ANIMATION
The large clear viewfinder image enables you to watch this type of scene for the right moment to expose. If you release the shutter just before the ball reaches its peak, you need not use a very fast shutter speed. Photo: *B. C. Wignall*, Colwyn Bay, Wales.

CHILD OF NATURE
It isn't a portrait that would necessarily please a mother but the gesture is probably characteristic and it looks completely natural. Photo: *Pentacon VEB*.

Jumping around in the sand-dunes is a natural enough activity for young boys and, with care, you can preserve the spontaneity even though you have asked them to go through the motions for the camera. A low viewpoint emphasises the height of the leap. Photo: *Pentacon VEB.*

BIRDS AND BEASTS

(*Above*). First catch your snake. Then, after many attempts, you might be able to catch him in deadly action. Photo: *Herbert Bessiger*, Leipzig, Germany.

Page 141. You might keep a respectful distance from this little play-mate in the wild, but when he is safely tucked away in a zoo enclosure, a 135mm lens is quite long enough for a head-on shot. Photo: *S. W. Burrows*. Wilmslow, England.

(*Left*). Two very different shots of birds. The chick is 'posed' for flash lighting in an indoor set-up while the owl peered suspiciously at the photographer with a long-focus lens practically touching the netting of his cage. Photos: *Pentacon VEB* (*top*), *Harald Lange*, Leipzig, Germany (*bottom*).

Page 143. Many squirrels are tame enough to be bribed with a peanut but the close approach then demands careful focusing. Even when flash helps you to use a smaller aperture, depth of field is very restricted. Photo: *R. F. Miles*, Edgware, England.

Page 144. The horse is a noble animal, but he has his moments. Shots such as this are obtained by keeping an eye on events away from the main action. Photo: *Vladimir David*, Pardubice, Czechoslovakia.

Page 145. Careful manoeuvring by the cameraman put the giraffe against a dark background and the strong sunlight outlined him distinctly. Photo: *S. W. Burrows*, Wilmslow, England.

OUT AND ABOUT
The whole building no doubt looked attractive but by concentrating on a detail the photographer avoided a hackneyed presentation and, at the same time, gave some information about the structure. Photo: *J. R. Barton*, Winsford, England.

Pop art on the parking lot. A part of a heavy lorry provides a composition of circles and straight lines emphasised by the strong lighting and head-on camera position. Photo: *Raymond Lea*, Marlow, England.

Out and about in woodland you need never be lost for a subject. Find the right angle to show the texture of the tree bark Photos: *J. Heashaw*, Ilminster, England (*top*), *Raymond Lea*, Marlow, England (*bottom*).

(*Above.*) Outdoor speakers are captive subjects. You can choose your viewpoint and watch and wait for right expression. Photo: *B. C. Wignall*, Colwyn Bay, Wales.

Page 148. Shapes and textures in contrast. You can use the lighting to restrict the tones and lay emphasis on the design rather than the structural detail. Photos: *Raymond Lea*, Marlow, England.

Page 149. Modern architecture offers innumerable opportunities for so-called perspective distortion. The steeply tilted camera produces converging verticals that look impressively right. Photo: *Volkman Herre*, Leipzig, Germany.

Page 150. Winter and autumn lighting have their own charm. The Windsor Castle gates are isolated against a misty background, while the low sun creeping over the churchyard wall highlights the autumn leaves and brings the central headstones out in silhouette. Photos: *Raymond Lea*, Marlow, England.

LIGHT FOR THE PICTURE

When you own a Praktica camera, you are freed from all worries about the strength of the light. You can take pictures in any light—sunlight, stormy conditions, mist, fog, domestic lamps, street lamps, even candles and matches.

Nevertheless, most of your pictures will probably be taken in daylight. We tend to think of daylight as beyond our control. In a sense, so it is, but we can choose when and from where to make our exposure and we can decide whether to supplement the light falling on the subject by the use of reflectors or fill-in flash (see page 135).

With subjects you cannot move (buildings, statues, trees, etc.), you can influence the appearance of the subject by choosing the time of day and, indeed, the season of the year, to make your exposure. You can shoot in brilliant sunlight, wait for the sun to go behind clouds, shoot in dull light, morning or evening light, and so on. You can move around the subject to make it look flatter or more three-dimensional, as you wish. You can shoot from close in to exaggerate the importance of part of the subject or move farther back to preserve the correct proportions and, perhaps, to include some of the surroundings. You can shoot so that the light comes from the side, the back or the front or any intermediate angle. Each position can change the appearance of the subject.

If the subject is movable, as in outdoor portraiture, you can save yourself some legwork by moving the subject instead of the camera, but for most effects you still have to move around a bit yourself. It is rather unlikely that the background will be suitable through the full 360°. Portraiture gives more scope than most subjects for this type of exercise because you can light the human face and figure from almost any angle and obtain pleasing results, whereas buildings generally need to be photographed with most light on the side reproduced the largest.

Disadvantages of direct sunlight

Direct sunlight from a cloudless sky produces a rather harsh lighting that does not suit all subjects. It is not the best lighting for landscape work in black and white if you wish to show subtle tonal differences or the recession of planes that gives an impression of depth to the picture. It rarely suits portraits because it throws harsh shadows and, for normal portraiture, it is better to wait for the sun to be at least partially obscured by light cloud, or to move the subject into shadow, where all the light comes from the sky, or wait for a totally overcast day.

Most colour subjects are best shot on a bright but lightly overcast day. Sunlight helps to produce brilliant colours but it also introduces extreme contrasts that the colour film may not easily be able to handle. The lighter colours may tend to burn out to white or the darker colours become lost as almost black.

Similarly, whether in colour or black and white, contrasty subjects should not be shot in strong sunlight unless you intend to increase the contrast deliberately. The classic example is the wedding couple, with the bridegroom in a dark suit and the bride in white with delicate detail. It is almost impossible to show detail in both black and white if the lighting is harsh. Again, you have to move the subject out of the direct sun or use considerable fill-in light. The usual technique with this particular subject is to use fill-in (see page 135).

Praktica photography need not be concerned solely with what the countryside or any other subject looks like in fine weather. There are impressive pictures to be made from a storm-laden sky and a dark, gloomy landscape with detail-less half-images. Mist and fog can simplify pictures by eliminating unwanted detail, either leaving the principal subject in isolation or enabling you to make a composition of form and tone out of an otherwise prosaic scene.

Daylight, in other words, is an enormously variable light source. If you want an interesting exercise, see how many pictures you can produce using daylight in all its various forms —not forgetting indoor daylight, or windowlight.

Daylight through windows

Large windows can make superb light sources for many types of picture. Generally, direct sunlight through the window is unsuitable for the same reasons as in outdoor photography. It

154

is highly directional and casts heavy shadows. Additionally, many windows have cross-members and framing that can throw even more disturbing shadows over the subject. Reflectors can be used to lighten the shadows, of course, but diffused lighting is usually preferable.

When the sun does not shine directly on the window, the light is still directional but is diffused, and the larger the window the less heavy the shadows formed in the subject.

Small subjects—flowers, glassware, ornaments, machinery components, etc.—can be photographed very satisfactorily by windowlight because the light source is large relative to the subject and because the fall-off with increasing distance is not so important with the small subject.

Larger subjects—portraits are the inevitable example—are particularly suitable for window lighting. It provides a soft light akin to that from a bank of floodlights. If the window is large or there are two or three, the model can be moved to different positions to give an almost infinite variety of lighting effects. Walls or specially prepared reflecting surfaces can be used to redirect the light where necessary to lighten the shadow areas.

Windowlight is generally quite satisfactory for colour film but any fill-in light has to be carefully handled. The reflecting surface must contain little or no colour and certainly no strong colour. Otherwise, the areas affected by the reflected light pick up the colour of the reflector and distort the colours of the subject.

Photofloods and other lamps

When there is no daylight to shoot by, you can use artificial light. This, too, comes in various forms and, unlike daylight, can be infinitely controlled at a given moment in time—provided you have the equipment.

Special lamps are made for indoor photography. Professional studio lamps are outside the scope of this book and we are concerned mainly with those known as photofloods. These look just like ordinary domestic lamps and cost very little more but have specially constructed filaments that burn at a much higher temperature. The result is that the No. 1 photoflood will give a light output of about 800W although it consumes only 275W. This is achieved by "overrunning". These lamps would give a 275W output if run at a much lower voltage.

Running at the normal domestic supply voltage is overrunning. The price of the increased light output, however, is a shorter life. The photoflood has a life of only about two hours of continuous running. It should, therefore, be used sparingly, switching on only for metering and the actual exposure. There is also a No. 2 photoflood, consuming about 500W but giving the equivalent of about 1600W light output.

When two or more photofloods are used it is a good idea to connect them to a series-parallel switch so that they can be switched to half power for posing, focusing, etc., and switched to full power only for the actual exposure.

Photofloods are generally used in large metal reflectors designed to throw all the light forward over a reasonably large area. Nevertheless the light is quite harsh and has to be used with some care. It *is* possible to work with just one photoflood, or one photoflood and a reflector but, in truth, it would be rather pointless because lower wattage lamps could just as easily be used to give the same, generally rather low key, result.

Photofloods are useful if you want a lot of light so that you can work with short exposure times or long bellows extensions for close-up work. They are essential if you require true colour rendering on artificial light film of the Type A variety (see page 114). For black and white photography in which exposure times are not important, however, ordinary domestic lamps can be quite powerful enough.

The photography of small objects, still life arrangements, stamps, documents and so on can be effected with 100–150W lamps without needing to resort to time exposures. If you are prepared to use long exposures, even lower power lamps can be used, with the advantage that they generate far less heat and are more easily handled. The photoflood gets extremely hot within a minute or two and has to be used in good quality porcelain or similar holders. Plastic lampholders become very brittle when hot and can also give off an unpleasant smell.

Low-power light sources

Once we start talking about the power of the light we can use for photography, we realise that there is really no limit at the low power end. The Praktica cameras can give exposures of any duration simply by setting the shutter speed to B and locking the shutter open with a suitable cable release (see page

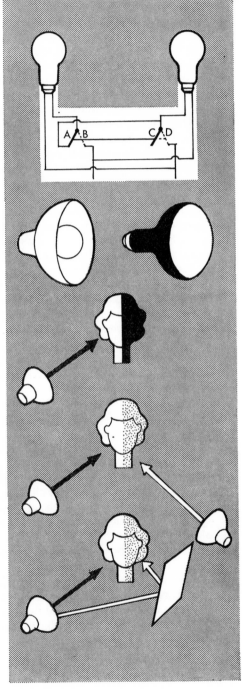

Photoflood lamps have a short life. Their life can be lengthened, however, by wiring two lamps to a series-parallel switch. These are available commercially or can be wired up as shown. With the switches in the A and C position, the lamps are in series and share the voltage between them, burning at half power. With points B and D in circuit the lamps are in parallel and burn at full power. The series position is used for setting up and focusing. The lamps are switched into parallel only for the duration of the exposure.

Photofloods are available as ordinary bulbs for use in reflectors or with built-in reflectors.

A one-lamp set-up casts heavy shadows.

A second lamp used at a greater distance throws light into the shadows.

A reflector placed close to the subject can serve the same purpose as a second lamp.

174). Thus, exposures by the light of a candle, a match, a pocket torch, etc., are all possible.

By adjusting the degree of exposure, we can vary the effect of the lighting, making the more powerful light look weaker by underexposure or the weaker light look more powerful by overexposure. This should be done only if you have a particular effect in mind, because the more powerful light is a harsher light that tends to spread into the shadows, whereas the weaker light tends to leave the shadows completely empty, giving the effect of shadows spreading into the lighter areas. The result is softer and more truly indicative of low light levels.

Shooting at night

When daylight fades outdoors, there is generally still sufficient light for photography with your Praktica. In town, there are street lamps, lights in shop windows, advertising signs and car headlights. Some buildings may be floodlit.

You can use any of these to take photographs. If you use a fast black and white film you can find many pictures that do not even necessitate a tripod. If you cannot shoot at 1/30 sec or faster, you can usually find something on which to rest your elbows, support your body or brace the camera.

Night photography of this nature is often improved by reflections on wet roads or pavements. They relieve the inevitable heavy shadows and add interest and sparkle to what might otherwise be a lifeless scene.

It is often advantageous, too, to take your photographs before the daylight has completely disappeared. Even a small amount of light still left in the sky can save the background, or at least the outlines of buildings, from merging into the sky tone. This is particularly useful with colour film which is slower than most black and white films and would fail to register an unlit background at all. The type of colour film to use is a matter of personal choice. Probably the technically correct film in most circumstances is the artificial light type, although no film is balanced for street lamps, window lighting, etc. In practice, however, most people prefer the rather warm rendering given by daylight film.

Out of town, the sky is often surprisingly light, even when there is no moon. A full moon in a clear sky can, with no tall buildings to absorb its light and throw heavy shadows, illuminate large areas with extraordinary clarity. The moon itself,

many thousands of times less powerful than the sun, can be included in some types of picture with little danger of lens flare causing an overall lack of contrast. Even shots of the moon itself can be very effective if taken with a lens of, say, 600–800mm focal length—or a 200–300mm lens with a tele converter (see page 60). The exposure for a full moon on a fast film need be no more than about 1/30 sec at f2.8 or its equivalent. If you include a distant tree or a part of a building in your shot the flattening of perspective caused by the very long shooting distance (see page 58) can produce an apparently enormous moon against what we think to be a tree or building much closer to the camera than it actually was.

Light is controllable

Thus, the prospects for photography with your Praktica are limitless. There is nearly always light of a kind. There are always reflecting surfaces with varying characteristics so that the light becomes form and shape and line that can be fashioned into a picture. Whatever the light, you can control it, at least to the extent that you choose how much of it to use, which reflecting surfaces to include in your picture, what viewpoint to take up so that the reflections make the picture you require, and so on.

The subjects are similarly limitless—from simple portraiture by daylight or photoflood to impressionistic moonlight patterns on river or landscape, from copying a document to freezing the action of a racehorse. All you need is light.

CHOOSING AND USING FILTERS

The films you use in your Praktica are panchromatic, which means that they are sensitive to light of all colours and must generally be handled in total darkness. This was not always so. At one time, most films were known as orthochromatic. Such films are now used only for special purposes but when they were the only types available, filters for black-and-white photography were rather more important than they are today.

Blue light, for example, had a disproportionately strong effect on the film and tended to reproduce as white. Thus, clouds in a blue sky disappeared and the sky was rendered as a stark white expanse. The remedy was to place a yellow filter over the lens to prevent some of the blue light reaching the film. The effect of a filter is to pass freely light of its own colour but to impede the passage of light of its complementary colour. As few colours are pure, the effect of filters is never entirely predictable, however. Reds can contain blue or yellow. Yellow light is a mixture of red and green. Green can be bluish or yellowish and so on. Nevertheless, the general effect of coloured filters on black and white panchromatic film is as shown in the diagram on page 161. Orthochromatic film is not now available in the 35mm size.

When to use filters

Filters are not often required for black-and-white photography except for those who specialise in particular treatments of certain subjects. Photographers of architecture, statuary, etc., sometimes like to have a strong sky tone behind the edifice to give a more contrasty or even dramatic effect. They may use yellow, orange or red filters to diminish the effect of a blue sky on the film and thus make it darker on the print. Filters can also help to differentiate between colours that are rendered as virtually the same tone. Greens, reds and blues can be of similar brightnesses so that all are reproduced as the same

FILTERS

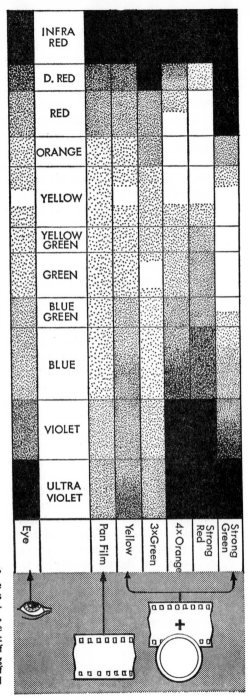

Panchromatic film "sees" colours in much the same way as the human eye. This relationship can be considerably altered, however, by placing filters over the camera lens. The chart gives an approximation of the darkening or lightening effect on various colours of the most commonly used filters.

shade of grey. A bright yellow might photograph as almost white. A green filter can make the green lighter and the red darker. A blue filter can make yellow reproduce darker and so on.

Except in these and similar special cases, the use of filters should be the exception rather than the rule. Panchromatic film, properly exposed, can cope satisfactorily with most subjects and produce a faithful tonal reproduction. Too often, the purchaser of a camera asks immediately what filters he can attach to it, without having any very clear idea of what a filter is, let alone what it does. He may be told that a yellow or green filter can be used to improve sky rendering and is forever thereafter convinced that he must use a filter for every landscape shot he takes. The result is likely to be rather flat-looking pictures, often with unnaturally dark skies.

Ultra-violet filters

In recent years, the filter fetish has tended to concentrate on two special types of filter—the ultra-violet and the polarising. Strictly speaking, the u.v. filter commonly used should be called an u.v. *absorbing* filter. In the pure form it is colourless and absorbs radiation beyond the blue end of the spectrum that is invisible to the human eye but to which all normal films are sensitive. When u.v. radiation is excessive the film "sees" more blue in the scene than is actually there. The effect is most noticeable on colour film—all the colours in the picture being overlaid to a greater or lesser extent with blue.

Naturally, you do not know when u.v. radiation is excessive, because you cannot see it. There are, however, certain conditions under which we can forecast that the proportion of u.v. is likely to be greatest. The main condition is that the atmosphere be clearer than usual—and that is most likely to occur at high altitudes or near large expanses of water. The reason for this condition is that most forms of radiation are subject to scatter by the atmosphere and the shorter the wavelength of the radiation, the greater the scatter effect. Blue light and u.v. radiation is of shorter wavelength than light of other colours and can easily be scattered in a normal dusty atmosphere and so prevented from reaching the film.

Thus, when colour film is used in a clear atmosphere it may be necessary to use a u.v. filter. It may not be necessary, however, because, even though the u.v. is present it may not reach

the film. All glass absorbs u.v. to some extent and some lenses absorb it quite strongly. The only certain way to find out whether this filter is required is to take test pictures.

Generally, it does no harm to use a u.v. filter even when it is not necessary, but that applies only if the filter is the pure u.v. colourless type. Many so-called u.v. filters are, in fact, haze filters with a faint pink or yellow colouring. It would be unwise to use these indiscriminately because they impart a yellow or red bias to the colouring of the picture if there is not an excess of blue or u.v. in the conditions.

There are many who believe in keeping a u.v. filter on the lens at all times, simply because it has no effect except when it is necessary and can therefore be used as a lens protector. If you feel that that makes sense (see page 103) there is no reason why you should not follow the practice—provided you keep the filter clean. Continual cleaning of the filter will soon damage it, however slightly, and take the edge off the lens performance. It seems more sensible really to use the lens protector designed for the purpose—the lens cap.

Effect and uses of polarising screen

The other filter around which a few myths have developed is the polarising screen. It is constructed in such a manner that it acts as if it is slotted in one direction with slots so closely spaced that only light vibrating in the same direction, or polarisation, as the slots can pass.

The light reflected from most objects vibrates in all directions at right angles to the line of its travel—it is random. Light reflected in certain conditions from some surfaces—water, glass, polished wood, etc., but not metal—is polarised. It vibrates in one plane only. Thus, if the polarising screen is placed in the path of this light—on the camera lens usually—with its slots at right angles to the light vibrations, the light cannot pass. The effect is to eliminate unwanted reflections, glare, etc., in shop windows, on table tops, mirrors, clock faces, etc.

The polarising filter can be so used, however, only in certain circumstances. Complete polarisation occurs only with the light striking the reflecting surface at about 57° from the normal (perpendicular). So it is only when you shoot at an angle of about 33° to the plane of the reflecting surface that you can expect to eliminate reflections completely. At any other angle

only partial elimination can be obtained—less and less as the viewpoint moves towards the perpendicular, when no reflections are polarised.

The effect of the polarising filter can be seen on the Praktica viewing screen as the filter is rotated in front of the lens. When the best position is determined the filter is attached to the lens. Some polarising filters are fitted in mounts which allow them to be rotated while fixed to the lens. Some have edge markings to allow them to be held to the eye for viewing purpose and the edge marking noted when the correct position is found.

Some of the light from a clear blue sky is polarised by reflection from particles of dust, moisture, etc., and the polarising filter can be used to cut out some of this light and so make the sky darker on black-and-white film or a deeper blue on colour film.

Polarising filters have a certain density and when they are used with the Prakticas that do not have TTL meters, you have to increase the exposure to allow for the light loss. The usual increase is about $1\frac{1}{2}$ to 2 stops. This is a 3–4 times exposure increase and we usually say, in fact, that the filter has an exposure factor of 3–4.

Filter factors

All filters except the clear u.v. type have exposure factors because they all absorb a certain amount of light and therefore oblige you to give an exposure different from that required when the filter is not used. The exposure meter, for example, gives a reading that assumes that the amount of light acting on the meter cell is the same as that which will subsequently act on the film. So you have to adjust the reading as indicated by the filter factor. A medium yellow filter might have a filter factor of 2. That means that you should give twice as much exposure as the meter recommends—either by opening up the lens to the next larger aperture (smaller f-number) or by doubling the exposure time (next longer shutter speed).

This applies to separate meters and to the built-in meters of the Praktica IVB, VFB, LB, Nova B and Nova 1B but not to the TTL meters of the Prakticamat, Super TL, VLC, LLC and LTL because they take their readings through the lens with filter attached. Actually, such a reading is not strictly accurate, because the meter has a slightly different spectral

sensitivity from that of the film. In practice, however, the method works well enough.

Conversion filters for colour

The relatively strongly coloured filters used with black-and-white film are unsuitable for colour film, unless you are striving for special effects. They so radically alter the colour of the light reaching the film that they impose a strong cast of the colour of the filter on all the colours in the picture. Filters for use with colour film are only very slightly tinted—except those required to alter the character of daylight to make it suitable for artificial light film or vice versa.

These are known as conversion filters and the filter that converts artificial light into an approximation of daylight is quite strongly blue. Artificial light (generally tungsten lamps) has very little blue content in comparison with daylight. The filter therefore has to compensate for the deficiency by reducing the red content and it has to cut out so much red light that the filter factor is usually about 4. The effect is to reduce the speed of the daylight film used in artificial light by about 75%, making a 64 ASA film, for example, the equivalent of 16 ASA. That is why it is generally regarded as impracticable to use daylight films in artificial light.

The opposite filter, to allow artificial light film to be used in daylight, is less strongly coloured and cuts film speed only by about 20%, making a 40 ASA film the equivalent of 32 ASA. Thus, if you expect to shoot in both daylight and artificial light on the same roll of film, it is advisable to use artificial light film.

Correction filters for colour

Filters intended for less radical alterations of the character of the light are generally known as correction filters. The most common type has various names according to manufacturer—such as haze or skylight. Its function is to offset the over-blue effect caused by a brilliant blue cloudless sky or distant haze brought about by the scattering of blue light. It is a very pale pink and can, in fact, be used whenever lighting conditions encourage a tendency to blue.

Once again, the opposite effect (to offset a tendency to red) is provided by a very pale blue filter and some manufacturers produce a "morning and evening" filter. In early morning and

late evening, the sun's rays reach the earth at a more acute angle than in the middle part of the day and thus travel a longer path through the earth's atmosphere, which has a light-scattering effect. Blue rays are more subject to scatter than red, so at these times of day more red rays reach the earth than blue. If you do not want this effect to show you have to use the weak blue filter to absorb some of the excess red light. You do *not* use such a filter when shooting sunrise or sunset scenes.

Use filters with care

There are many other filters available for use with colour film (sometimes described as colour-compensating filters) but few Praktica users will ever need to use them. They make minute adjustments to colour rendering and may be necessary for commercial photographers where a particular colour must be reproduced with greatest possible accuracy.

The general rule with colour film is to use no filter at all unless you experience a definite need for it. It is unwise to assume that certain conditions call for a filter and therefore you must use it. Most colour films will reproduce all colours with surprising accuracy but once you filter the light you can never be quite sure what the result will be. Pure colours are virtually unknown in nature and the exact make-up of any particular colour is never obvious. A pink filter might have the desired effect of removing the blueness in the shadows but only at the expense of an over-red rendering in other parts of the picture that are more important.

USING COLOUR FILMS

Naturally, the Praktica cameras and all the Zeiss and Meyer lenses made for them are eminently suitable for colour photography. The types of colour film available and the light in which they are intended to be used are described on pages 113–115. Basically, your choice is between prints, for which you use colour print or colour negative film, and slides, for which you use colour slide or colour reversal film.

Choosing between print and slide

Many people find the colour print preferable because it can be viewed directly in the hand and can be carried around like a black-and-white print for showing to friends and relations. You can have extra prints and enlargements made from the negative at any time and the negative can be stored safely in the meantime.

On the other hand, all colour prints need a certain amount of care at the printing stage. They have to be printed through a filtered light source and the filtration required varies from negative to negative and between batches of printing paper. The machine-produced en-print supplied by photofinishers cannot be given individual treatment and the colour print is consequently not always completely satisfactory.

The reversal colour film does not go through a printing process. The positive image is produced on the film that you put in the camera and, provided you expose the film correctly, it can be batch processed in complete confidence that the colours will be as good as the film is capable of making them. Moreover, the transparency of the colours in a colour slide film makes them considerably brighter and richer than those of a print on paper.

The reversal or colour slide film has its drawbacks, too, of course. The 35mm transparency, or slide, is too small to be viewed comfortably in the hand and, in any case, the frequent passing of slides from hand to hand is not advisable. Their real

function is to be projected on to a screen and for that purpose they must be kept clean and free of blemishes. So, if you use colour slide film, you really should have a projector and a good screen to view them at their best. Hand and table viewers are available to show a magnified image but the hand viewer can be used only by one person at a time and only three or four people at most can comfortably observe the picture on a table viewer.

Controlling the colour content

Whichever film you choose, however, there are various basic rules to remember. Perhaps the most important is that, when looking for colour pictures, you should not be looking only for colour. You should be looking for pictures first and colour second. Virtually every picture has some colour. Not many naturally occurring scenes are riots of colour. It is very rarely necessary to force colour into your picture. A picture taken on a grey day, with almost all the colours overlaid or subdued by the nature of the light or atmosphere, can still be a very effective colour picture. It may even be much more effective than a picture in which many full, rich colours fill the whole frame.

It may sometimes help to add a small splash of colour simply to contrast with the general hue of the picture and so add life. A snow scene, for example, might be helped by the inclusion of a road sign, a small figure in bright clothing, or a vehicle's brake lights. It must not be taken as a general rule, however, that all colour pictures need this colour accent or focal point.

Colour mood

The colours should accord with the mood of the picture. It would be pointless to photograph a windswept winter beach scene carefully composed to include a brightly coloured lifeboat, beached boat, bathing hut, etc. But the same scene photographed at the height of the holiday season can be full of colour—regardless of contrast, harmony, etc.

Colour harmony is important in some pictures—such as certain types of portrait. A mother and baby study, for example, would not generally look too good in brilliant clashing colours. The phrase colour harmony implies that certain colours "go together" and others do not. Those that do not are said to clash. Such colours are those that are relatively close

COLOUR FILMS

Both types of colour film can be used to produce various end results. Colour negative film is primarily designed for colour prints (3) but can also be printed on to special film to provide transparencies (1). This service is available commercially. Black - and - white prints (2) can be made on ordinary bromide paper or on special panchromatic paper.

Colour reversal film is designed for the production of colour slides.

Black and white prints can be made from the slides either on direct reversal material or via an internegative.

The relationship between colours is largely subjective but, generally speaking, colours opposite each other on the colour wheel contrast strongly and can be used together for lively effects. Colours close to each other on the wheel generally tend to harmonize but that depends a great deal on their strength and purity.

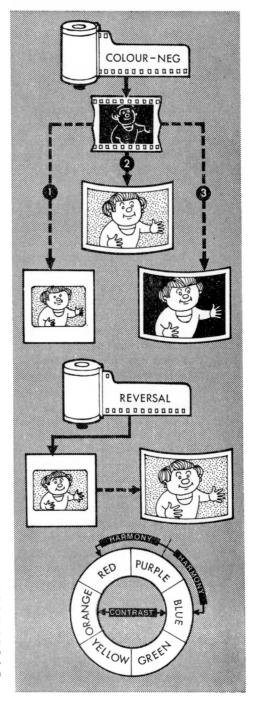

together in hue, such as red and purple, blue and mauve, orange and yellow and so on. Clashing colours, however, must not be confused with contrasting colours. Blue and orange are in violent contrast. So are red and green. But these colours do not clash. They can be used together to add life to a picture by introducing contrast. Generally, however, when you introduce one colour to contrast with another, the two should not be equal in area or "weight". One colour should dominate and the other act simply as a foil—important but subsidiary, rather like the accessories to a woman's outfit.

Colour and sunlight

Colours are at their most brilliant in bright sunlight. The dimmer the light, the more subdued the colour. Nevertheless, bright sunlight is rarely very good light in which to take colour pictures. It introduces extreme contrasts in brilliance, so that a bright yellow, for example, may be 50 times brighter than a dark blue. Ideally, there is one exposure that will reproduce a colour perfectly on colour film. In practice, a limited range of exposures will give an acceptable result. But the range from bright yellow to dark blue might be six stops or more and even an exposure placed midway between the extreme limits cannot cope with that. You would have to bias your exposure either towards the yellow (short exposure) or the blue (long exposure) with the result that one or other of them would show some colour distortion.

The effect of over- or underexposure on colour film is more noticeable than on black and white. Overexposure causes colours to lose brilliance and, in extreme cases, even to lose virtually all colour. Underexposure leads to increased colour intensity or saturation. But there are side effects, too, varying with the film, so that both faults lead to distortion of colour as well as tone. An overexposed blue sky might look green or purple. An underexposed white wall might look blue or green.

Thus, it is wise to avoid strong sunlight when using colour film and try to shoot instead when there is plenty of cloud in the sky to spread the light and add a great deal of fill-in skylight to the direct rays of the sun.

Using reflectors for fill-in light

Alternatively, of course, you can add your own fill-in light. How you do that depends very much on circumstances. If your

interest lies in photographing flowers or other small subjects you can carry reflectors with you in the form of white card, specially-made folding reflector boards, even newspapers. Reflector boards are available commercially or you can make them up by taping pieces of stiff card or millboard together in such a way that they can be folded up like a map. Cover the surfaces with white paper or metallic foil that has been crumpled and smoothed out again.

Reflectors of this type can be used for portraits and other outdoor shots, too, but they generally need additional equipment or an assistant to hold them. Their effect can be quite remarkable. Placed close to the subject so as to direct the strongest possible reflections into the shadows, a large reflector can reduce the subject contrast dramatically. It can be quite effective when placed in front of a back-lit subject, so that the effect of back-lighting can be retained without casting the front of the subject into deep shadow.

Colour casts

With colour film, however, it is important to remember that the reflector must be white, silver or other neutral tint. If the reflector is strongly coloured it reflects light only of its own colour and that colour is strongly registered by the colour film in the areas the reflected light reaches. This is known as a colour cast and it can, of course, be caused by any reflecting surface close to the subject.

Outdoors, colour casts are commonly caused by grass, coloured walls, large hat-brims, etc. Usually, they are undesirable and should be avoided. If, for example, a model in a light-coloured dress stands close to strongly reflecting foliage or a grassy bank, the colour picture is likely to show a strong green cast on the part of the dress nearest the reflecting surface. If, in addition, the model is wearing a large-brimmed blue hat, her face might show an unpleasant blue tinge.

Colour casts are not always easy to avoid, because the eye often fails to notice them in advance. Those mentioned above, for instance, could easily pass unnoticed by the unpractised eye. Although the eye may register the colour, the brain refuses to accept it, just as it generally refuses to accept that the shadows in snow under a blue sky are blue.

171

Avoiding mixed lighting

Reflectors are not the only method of providing fill-in light to reduce contrast. We can also use lamps. Outdoors, this invariably means flash (see page 135) because electricity supplies are not generally available and, in any case, normal tungsten lamps do not give light of the correct colour temperature (see page 115).

Thus, if you use daylight indoors (see page 154) on any type of colour film, you must not use a tungsten lamp (domestic or photoflood) to fill in the shadows. If you do, the result is similar to a colour cast. The light of lower colour temperature than the film is designed for throws a red or yellow cast into the areas it reaches, leaving the day-lit parts in correct colour. Even with colour negative such partial colour distortions cannot be filtered out at the printing stage.

Mixed lighting must, in fact, be avoided in any type of colour picture. Colour films are designed for use in light of a particular colour temperature (see page 115). If they are used in any other type of light, colours are distorted by being overlaid with red or yellow when daylight film is used in artificial light or blue when artificial light film is used in daylight. An overall cast of this nature can be prevented by using filters (see page 160), but if the cast is only partial because part of the light is of one colour temperature and part of another, filters are useless.

The only solution then is to filter one of the light sources to balance it with the other. This is done with flash bulbs, which are commonly coated blue to simulate daylight, and electronic flash tubes, the gas filling of which is adjusted for the same purpose. Thus, daylight and electronic flash or blue flashbulbs can be mixed, but no other mixtures can be used.

Adjusting the brightness range

Artificial light colour films are generally designed for use with photoflood lighting and formal portraits indoors can be lit more or less in the same way as for black-and-white portraiture. As a rule, however, it is wise to keep the contrast low. A rule of thumb is that the lighting should be kept to a 4:1 ratio, which means that the main, or modelling, light should not be more than four times stronger than the fill-in light. This is simply to keep the subject contrast, or brightness range,

within the range of the film for correct colour reproduction. If the brightness range is allowed to go much higher, the film can, of course, correctly reproduce the various densities, but there is no level of exposure that will correctly reproduce the colours at both ends of the range.

The rule of thumb can be adapted to the subject. If the subject itself has no great brightness range, the lighting can be contrastier and vice versa. If the colours at one or other end of the range are not important to the subject, they can be allowed to distort or disappear into blackness.

Lighting the background

The colour distortion caused by incorrect exposure is often particularly noticeable in the backgrounds of artificial light colour shots. The background of a black-and-white shot can be lit at various levels to produce almost any tone from white to black. Similar treatment of the background to a colour shot, however, alters not only the tone but the colour. An overlit blue background might reproduce as almost white, while under-lighting can produce, perhaps, a green or purplish tinge according to the characteristics of the film. For correct colour rendering, the background must be lit to the level of the most important tones of the main subject. *Slight* variations in lighting can make the background colour lighter or darker as desired.

Basic rules for colour

Colour film is not difficult to use but it does have these few main characteristics that have to be borne in mind:

1. All colour films are designed for use in light of a particular colour temperature.
2. The level of exposure affects not only density of tone but accuracy of colour.
3. Lighting should generally be rather "flat". Strong, directional light makes accurate colour reproduction difficult.
4. Reflected light must be neutral in colour.

If these facts are kept in mind, plus the fact that exposure for colour slide film is rather more critical than for black-and-white film, you should have no trouble in producing perfectly acceptable colour pictures.

ACCESSORIES
FOR THE PRAKTICA

The great advantage of the single lens reflex system used by the Praktica cameras is that you view the subject through the lens you use to take the picture. Thus, no matter what lens you have on the camera or what accessory or attachment you place behind or in front of the lens, you see the subject just as it will appear in the subsequent picture. This means that the range of accessories you can use is enormous. You can use lenses of any focal length the manufacturers can produce (see page 37). You can put a converter lens (see page 60) behind any of them and double or treble those focal lengths. You can shoot through a telescope, a monocular or a microscope. You can increase the extension of the lens by means of intermediate rings or bellows to take pictures at close range.

There are accessories of all kinds to make the Praktica one of the most versatile cameras ever marketed. Apart from the equipment produced by the Pentacon works specially for use with the Prakticas, there are innumerable items from other manufacturers, either of a kind that can be used on most cameras or suitable for the many cameras with the same type of screw-thread lens mounting as the Prakticas.

Cable release

One of the most fundamental accessories but one the value of which is often overlooked is the cable release. The Praktica cameras have the standard screw thread in the shutter release button to take the most commonly produced type of cable release. It consists of a spring loaded plunger moving in a flexible sheath, so that pressure on the operating button at one end causes the plunger to emerge at the other end and operate the shutter release. When you release the button the plunger retracts but there are special models available which allow the plunger to be locked in the extended position so that a shutter

set to B will stay open even though the operator lets go of the cable release. A twist of a ring or a locking screw releases the lock when the shutter is required to be closed.

The value of the cable release is that, used properly, it eliminates the risk of camera shake caused by a rather heavy finger on the release button. "Used properly" means that the cable must not be drawn taut so that it can set up a tremor of its own. It must always be held slackly so that the finger pressure is completely absorbed.

Naturally, the cable release is intended to be used with the camera on a tripod so that absolutely shake-free results can be achieved.

Camera supports

When you want the sharpest possible results that a camera can give, the camera must be rigidly supported. Many people will boast to you that they can hold their Praktica perfectly steady at $\frac{1}{8}$ sec or even longer. They cannot. They might get quite reasonably sharp pictures but they will never attain absolute sharpness. It is possible to incur camera shake even at 1/1000 sec.

It is also possible for a camera to shake even when it is on a tripod. Some lightweight, multi-section tripods are so unsteady and have such badly designed heads that they make the camera more likely to shake than if it were hand held. When you buy a tripod, make sure that it stands firmly and that the legs have no springiness or tendency to twist with the slightest movement of the camera. If you can afford it, buy the universal type that allows the camera to swivel in all directions and also allows it to be mounted near ground level by reversing the centre column.

Miniature or table tripods are also available. Single section legs raise the camera by perhaps only as much as six or nine inches but support it quite steadily. The tripod can be placed on a table, car bonnet or other such support or even on the ground for close-range work with flowers, plants, etc.

The head of a tripod is either a ball and socket joint surmounted by a relatively small platform with a central tripod screw or a pan-and-tilt head, usually with a rather larger platform and a handle to control the side-to-side or up and down movement. The ball and socket gives the greater range of movements but the pan-and-tilt head can often be a steadier

support and is generally capable of more positive locking in position.

Various other types of camera support have been devised for those who do not feel like carrying even a miniature tripod. Their value is a little doubtful but there might conceivably be occasions when their use could be justified. The common arrangement is a ball and socket head on a clamp, spike or other means of attachment to whatever rigid object may be handy. Or there is the monopod—a telescopic single leg surmounted by ball and socket head. A tripod screw on a chain is a further alternative. The screw is attached to the camera and the chain stretched taut by being held under the foot. You pull the camera upward to the eye against the tension of the chain and thus hold it steady.

Yet another device is the pistol grip. The name describes the shape. The camera is secured to the top by the usual tripod screw and the "trigger" operates a cable release connected to the shutter release button. This device can be quite useful when very long lenses are fitted to the Praktica. The lens barrel can be supported on the crook of the left arm, which is folded across the body with the hand grasping the right wrist. Or a rifle-like hold can be used if the left elbow can rest on a wall or similar support.

Lens hood

A lens forms an image by transmitting the light reflected from an object to the film. Unfortunately, not all light rays collected by the lens are image-forming rays. Some come from outside the image area, striking the lens very obliquely. The lens cannot bend these rays so sharply that they reach the film so they tend to be reflected and re-reflected between the lens components. Some of this light may reach the film and degrade the image by lowering its contrast. Such non-image-forming light is known as flare and it can become very troublesome when a very strong light is present just outside the image area.

Flare can also be caused by strong light within the image area but the effect is minimal if the lens is well designed. If the lens is not well designed, there is no simple cure for the fault. You must simply avoid shooting against the light with that lens.

Flare originating from outside the image area, however, can be eliminated by using a lens hood that prevents the oblique

CAMERA SUPPORTS

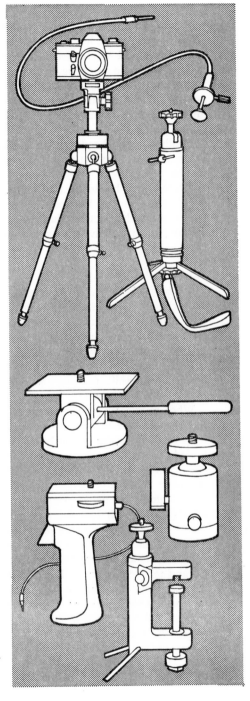

Where absolute sharpness is essential, in copying and when using long focus lenses, a rigid support for the camera is essential.

Tripods vary from the substantial types with large, pan-tilt heads and often an adjustable centre column to small table-top versions with ball and socket heads. A cable release, preferably with a locking screw, should always be used with a tripod-mounted camera.

The pan-tilt head generally has a sizeable platform and tilts up and down as well as turning through a complete circle with the camera horizontal. It cannot tilt horizontally.

The ball and socket head has a smaller platform to allow the camera to be tilted and turned in almost any direction.

Other supports include pistol grips with built-in cable release operated by a trigger and various types of clamp with ball and socket head.

non-image-forming rays from reaching the lens. That is the prime function of the lens hood and it is evident that, as lenses of different focal lengths have different angles of acceptance of light, lens hoods must be of different lengths for each focal length. A too-short lens hood fails to cut off all the oblique rays. A too-long lens hood cuts off some of the image forming rays and causes vignetting (underexposed or unexposed corners of the film).

Ideally, the lens hood opening should be of the same shape as the image format but for convenience most lens hoods are tubular.

Whether lens hoods are absolutely necessary or even very useful with modern high-performance lenses is an endless argument but they can certainly do no harm and can, at least, help to protect the lens in adverse weather conditions.

Interchangeable viewfinders

The Praktica VLC has interchangeable viewfinders. The normal pentaprism finder can be removed very easily. Press the button protruding from the mirror box in front of the rewind knob and the clips holding the finder head are freed, allowing the finder to be pulled straight out. Removal is so easy in fact that you have to be careful not to turn the camera upside down while pressing the release button. The finder falls out immediately.

When re-attaching the pentaprism or fitting an alternative finder, make sure that you press the release button and hold it in until the finder is firmly seated. The button is spring loaded but the clips are not and if you push the finder in without releasing the clips you jam it and risk rather expensive damage.

The alternative finders are a waist-level type and a magnifying finder both requiring the eye to be placed over the top of the camera for a straight-down view on to the screen. These are most useful for tripod-mounted shots where the crouching stance behind the tripod is not a comfortable viewing and focusing position. Their value is also apparent when shooting at any level below the normal eye level (particularly for those whose knees no longer bend without complaint) and especially at very low levels when it is necessary to keep the camera back truly vertical.

VLC VIEWFINDERS

The pentaprism of the Praktica VLC is interchangeable with a waist level finder and a magnifying finder.

To remove a viewfinder from the camera, press the stud protruding from the mirror box to the right of the lens (viewed from the front) and pull the finder straight up. Lay it down carefully on its side to avoid damage to the viewing and focusing screen.

To attach a finder to the camera, press the stud as for removal and push the replacement straight in. Be sure to press the stud because the clips securing the finder are not spring loaded.

The magnifying finder is for close-range work where critical focusing is required and the camera can be rigidly supported.

The waist-level finder can, in fact, be used at various levels and is particularly useful in restricted spaces, where an overhead or floor-level view may be the only practicable shooting position.

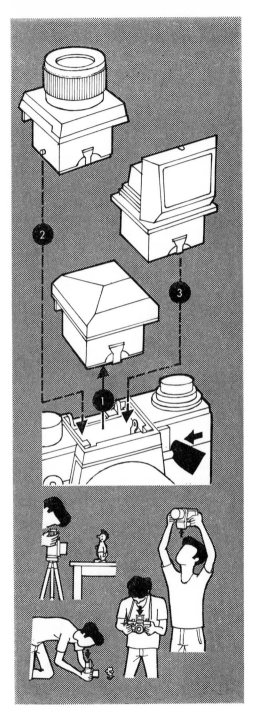

Eyepiece attachments

The circular viewfinder eyepiece frame of the Prakticas IV and V is specially shaped to accept various accessories. These items have lugs which fit into the gaps in the eyepiece frame to form a bayonet fastening. The Praktica L range have rectangular eyepiece frames and accordingly take different versions of the following attachments.

Accessory clip. The Prakticas before the L models had no accessory clip or shoe for attaching flashguns or other accessories. There is, however, an attachable accessory clip that can be fitted to the pentaprism models. It is a bracket, one end of which is secured over the eyepiece of the viewfinder. The other end bends over to rest on the rear of the pentaprism and carries the accessory shoe.

Angle finder. There are various occasions when it is not easy to look directly into the viewfinder eyepiece in the normal manner, e.g., in photomicrography, some copying, work at or near ground level and so on. For these occasions an angle finder can be attached to the eyepiece to enable you to view the screen image at right angles to the optical axis. The finder can be rotated to any position around the axis to allow viewing from the most suitable angle. It can be adjusted for individual eyesight and care has to be taken to make this adjustment so that the screen is sharply focused by the finder before you attempt to focus the lens.

Focusing telescope. When particularly critical focusing is required a focusing telescope can be attached to the camera eyepiece. It gives a 2.7 magnification of part of the viewfinder image and has built-in eyesight correction. The telescope part of this attachment can be unclipped and swung upwards to allow the whole screen to be viewed. The focusing telescope is particularly useful for photomicrography and any photography of items containing extremely fine detail. Occasionally, too, it can be useful for critical focusing of distant objects shot through very long focus lenses.

Correcting lens mount. Spectacle wearers who find it difficult to use the camera with their spectacles on can obtain a miniature spectacle lens from their opticians (for the eye they

180

ACCESSORIES

Among the wide range of accessories for the Praktica cameras are lens hoods of various sizes for lenses of different diameters and and focal lengths. It is important that the lens hood is suitable for the focal length. Too short a hood has little effect. Too long a hood causes vignetting.

A rubber eyecup fits over the viewfinder eyepiece to reduce the effect of extraneous light. It also offers protection for spectacle lenses.

A focusing magnifier attaching to the eyepiece gives a 2.7 magnification of part of the viewfinder image.

For the earlier models without accessory shoe there is an attachable version fitting to the viewfinder eyepiece and resting on the pentaprism.

Photomicrography can be carried out by means of the special microscope attachment.

An angle finder attaches to the eyepiece and can be rotated to any angle to permit viewing and focusing at right angles to the lens axis.

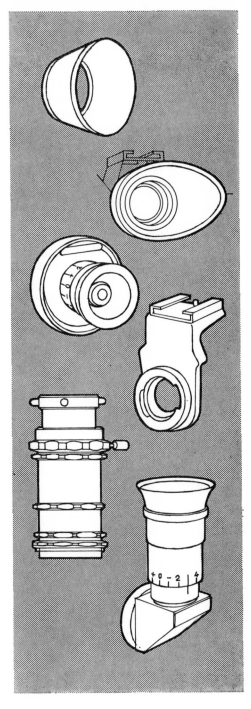

habitually use for viewing) and fit it into a correcting lens mount. When the mount is attached to the viewfinder eyepiece, they can use the camera without spectacles.

Rubber eyecup. If you find that light leaks past your eye into the camera eyepiece and makes viewing and focusing difficult, you can attach a rubber eyecup to cushion your eye and make such light leaks impossible. The eyecup also makes the camera more comfortable to use for long shooting sessions.

Reversing ring

Most camera lenses are designed to give their best performance at moderate shooting distances. The Praktica cameras, however, can be used to photograph small objects only a few inches from the lens. At that range, the performance of the lens is often improved, sometimes quite dramatically, by reversing it so that the normal rear of the lens faces the subject. To facilitate this arrangement, reversing rings are available with screw threads at each end, one fitting the filter thread of the lens and the other being the standard 42mm.

Extension tubes

To focus on objects very near the camera, you need more separation between lens and film than can conveniently be built into the focusing mechanism of normal or long focus lenses (many wide angle lenses can focus down to six inches or less). On the Prakticas, the required extra extension is easily provided by fitting threaded tubes which screw into the camera body and allow the lens to be screwed into the other end. There are very many makes of such extension tube but those made specifically for the Prakticas (Pentacon call them intermediate rings) come in a set of three sizes: 7, 14 and 28mm.

There are two models: automatic and non-automatic. The automatic types are fitted with plunger pins connecting with the automatic diaphragm control mechanism in the camera and thus allowing close-ups to be taken while retaining the automatic diaphragm control facility. There are special versions for the VLC and LLC to enable the full-aperture metering facility to be retained.

Extension bellows

Each extension tube gives only a limited focusing range. The

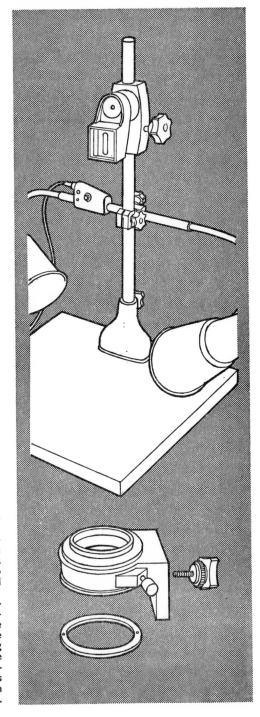

The Pentacon Copying Stand is a versatile unit consisting of baseboard and rigid vertical column with a variety of attachments. Adjustable reflectors can be fitted in any position on the column to provide full, even lighting over the baseboard area.

The camera can be attached directly to the sliding support on the column, which has a swivelling portion slotted for tripod bush mounting of the camera. The slot and swivel together provide considerable side-to-side movement of the camera position.

Alternatively, the camera can be attached by its lens filter ring to a repro arm which also screws to the swivel mount.

Various other applications are possible, including the use of the Small Bellows, Large Bellows and Focusing Rail, etc. The Angle Finder, or interchangeable finders and screens of the Praktica VLC can also be used to advantage.

7mm tube, for example, allows lens-to-subject distances of 403–206mm on a 50mm lens, the range being provided by the focusing mechanism of the lens. To focus between, say, 90 and 77mm, you have to fit the 7mm tube and the 28mm.

To obviate such tube changing and to make the precise selection of the scale of reproduction easier, close-up bellows devices are available. Again, many models are available from various manufacturers. Some of these are very simple items of equipment with no pretensions to precision manufacture. They are adequate, providing they can be rigidly attached to the camera and that the bellows can be securely locked at any extension.

The better models, such as those provided by the Pentacon company specifically for the Praktica cameras, are strongly and sturdily made, with positive locks and accessories for special purposes. There are two versions. The larger model has an integral focusing slide and provides for the attachment of a slide copier. The smaller version can be attached to a separate focusing slide (see page 186) but has no slide copier. The bellows units and their operation are fully described in the next chapter.

Intermediate ring and double cable release

Automatic diaphragm control can be retained when using extension bellows or reversing ring by adding to the back of the lens the special intermediate ring with cable release socket. When a cable release is connected to this socket its plunger actuates the stop down pin in the back of the lens. A double cable release is supplied with the intermediate ring (Pentacon call it a Z-ring) so that diaphragm and shutter can be operated simultaneously. The double cable release consists of a two-part plastic and metal case with a large plunger at one end with a locking screw and finger grips. The other end has openings for the cables with screw-in adjusters allowing the operation of the two cables to be synchronised. The two parts of the case are separated by pressing buttons on either side and pulling the two pieces apart. The cable releases can then be passed through the holes and the parts of the case pushed together again. A special intermediate ring set for the VLC and LLC consists of two rings with electrical contacts connected by a cable. One ring attaches to the camera and the other to the back of the lens to connect the electrical contacts necessary

CLOSE-UPS

The supplementary lens transmits parallel rays to the camera lens from an object placed in front of the supplementary at one focal length distance. The camera lens accepts these rays as coming from infinity and brings them to a focus on the film.

When the same strength supplementary is used on lenses of different focal length the lens to object distance remains the same but the angle of view and thus the scale of reproduction changes.

When different focal length lenses are used with bellows or extension tubes the camera subject distance is different for the same reproduction ratio. Thus, a given size of image can be obtained at a greater working distance by using a long-focus lens. This can be useful for lighting purposes and to minimize perspective distortion.

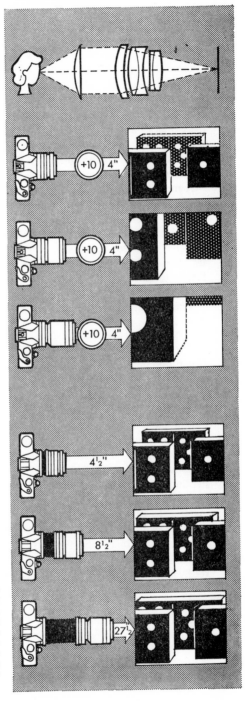

for full aperture metering. The double cable release is still required for automatic diaphragm operation.

Focusing slide

Focusing at very close range is more easily achieved by moving the camera toward or away from the object than by using the focusing mechanism of the lens. Normally, however, you have the camera on a tripod and it is not easy to move the tripod smoothly back and forth. Sometimes you can overcome this difficulty by moving the object and then using the lens focusing movement for fine focus.

A more satisfactory solution is to use a focusing slide, which is basically a tripod screw sliding along runners. The whole unit can be attached to a tripod. The Pentacon model has a large locking ring for the tripod screw, but the screw itself does not turn (see page 198). It has large diameter, smoothly finished runners. A locking sleeve allows the camera to be firmly fixed in position when the correct camera-to-subject distance has been found.

The focusing slide can also be used as a stereo slide (see page 216).

Copying stand

If you intend to do much copying of flat originals (documents, drawings, postage stamps, etc.), a copying stand is a useful accessory. There are many models available but all basically resemble an enlarger baseboard and column with various attachments. The Pentacon model has a well designed collar that slides on the column and has a quick-attachment shoe to take the camera. Two arms are clamped to the column under the bracket with lamp holders and reflectors to provide even lighting on the baseboard. A push switch is attached to one arm with a cable for connection to the electricity supply. The material to be copied is held flat on the baseboard by a glass pressure plate which is always at the same distance from the camera. Thus objects of different thickness can be copied without refocusing. A Repro Arm is also available to accept any reflex camera up to 6 × 6cm attached to the arm by the filter thread of its lens.

Pentaprism attachment

The Praktica FX2 was originally sold as a chest- or waist-level

186

viewing camera. Subsequently, however, an attachable penta-prism unit (called a reversal prism by Pentacon) was made available to convert the camera into an eye-level model. The pentaprism gave a right way up, right way round image and a 4× magnification of the screen image.

Gadget bag

If you acquire much equipment, you need something to carry it in. You *can* carry a camera, two lenses, a filter or two, films and other small items slung about your person but it is gener-ally more convenient to use a gadget bag or case.

Gadget bags come in many shapes, sizes and fittings and you would do well to study the various types before deciding which is most suited to your purpose. They generally give entry at the top to enable large items such as camera and lenses to be handled quickly and safely and often have adjust-able compartments inside. Some versions have pockets on the outside for small items. All are fitted with shoulder straps and some, additionally, have carrying handles.

The points to look for are reasonable strength and rigidity to afford adequate protection against bumps and scrapes; in-ternal padding (usually foam plastic) so that you do not have to replace items too delicately; and quick access to the contents —zips and catches are generally preferable to straps with buckles.

The alternative to the gadget bag is a fitted case. This can be almost any type of suitcase fitted internally with a block of expanded polystyrene with recesses cut into it to accommodate the various items of equipment and hold them firmly in place. Commercial versions are available but it would seem to be preferable to tailor make such a case to your own requirements.

You need a case or bag that will accommodate all the equipment you are likely to carry, of course, but it is rarely advisable to obtain the largest on the market—unless you never walk anywhere. A bag full of equipment can become very heavy indeed after a short walk uphill on a hot day. You should normally be able to decide that only a small amount of equipment is necessary for any particular trip and a small to medium sized bag or case should be adequate.

WORKING AT CLOSE RANGE

The resolution of the average camera lens is a great deal better than that of the human eye. Consequently, it can often "see" detail that is invisible to the eye. A 300mm lens, for example, can "read" the small print in a newspaper at 5m (16ft) or more.

At the other end of the scale, camera lenses can focus at very close range (down to a few centimetres even), whereas the healthy eye finds it difficult to focus anything closer than about 25cm. At such close range the lens can magnify considerably and bring out a fascinating amount of hidden detail.

Most lenses need assistance to focus at very close range. Focusing a lens is achieved by increasing the separation between lens and film plane. All lenses for Praktica cameras are in focusing mounts but the amount of adjustment possible in most lenses is limited at the close range end because the amount of movement needed is then proportionately much greater. The standard lens might therefore focus to 30in (0.75m) although the 50mm Pentacon $f1.8$ comes down to about 1ft. (30cm). Longer focus lenses might focus no nearer than 5ft. (1.6m), whereas a wide angle lens might focus to 4in (10cm).

Supplementary lenses

A simple method of achieving closer focus is to use close-up lenses. These are comparatively simple, one-glass lenses that push on or screw in to the camera lens in a mount rather like a filter mount. They are of relatively long focal length, the most popular types being of 1, $\frac{1}{2}$ and $\frac{1}{3}$m. Close-up (or supplementary) lenses are, however, usually designated by their dioptre strength, not their focal length, but the focal length is easily derived by dividing the dioptre number into 1m. Thus, the 1, $\frac{1}{2}$ and $\frac{1}{3}$m lenses have dioptre strengths of 1, 2 and 3 and are commonly known as 1D, 2D and 3D lenses.

The principle of the supplementary lens is that it transmits parallel rays of light emanating from a subject at a distance

from its front surface equal to its focal length. These parallel rays can be picked up by the camera lens set to infinity and bent to come to a focus at the film plane. Thus, the 1D lens allows the camera to focus an object at 1m. That is no advantage with standard and wide angle lenses but can sometimes be useful with a long-focus lens.

The stronger supplementaries enable you to focus closer and, by using the focusing movement of the camera lens, they come closer still. Thus, with a 3D lens you can focus down to 9in (0.22m) or less depending on the close-focusing limits of the camera lens.

The supplementary lens always focuses on the same distance, no matter what the focal length of the camera lens. Thus, when the camera lens is set to infinity and a 3D lens placed in front of it, objects at about 13in (0.33m) are in focus, whether the camera lens is of 50 or 200mm focal length. The only difference is that the 200mm lens has a narrower angle and thus produces a larger image (four times larger).

There are no exposure problems with simple supplementary lenses. The lens to film distance and the diaphragm opening are unchanged, so no extra exposure is necessary. The very short distance between subject and lens, however, means that depth of field is considerably restricted and you should illuminate the subject as brightly as possible while focusing, so that you can examine the depth of field closely with the lens stopped down. The focusing magnifier (see page 180) can be a great help in these circumstances.

Good quality supplementary lenses of moderate strength are quite inexpensive and can give very good results, but as the power increases (say to 5, 8 or 10 dioptres) there is a greater risk of loss of quality. Moreover, the cost of high quality lenses in these powers is much greater.

Extension tubes

The limiting factor on close focusing with the camera lens is the attainable separation between lens and film. It is, however, a simple matter to increase the separation by placing a tube between camera body and lens. The tube is threaded at one end to fit the Praktica body and at the other to accept the Praktica lenses. Thus, with one or more tubes in place, the camera lens can focus as close as you wish, down to the limit of its focal length. No lens can focus closer than its focal

length, because the emerging rays then diverge instead of converging.

Extension tubes are available in manual or auto form, the auto tubes having spring-loaded pins to engage the automatic mechanism in the Praktica body and on the Praktica lenses. Thus, the automatic diaphragm facility can be maintained even in extreme close-ups. The extension tube set supplied for the Prakticas (see page 182) consists of three tubes of 7, 14 and 28mm length. When all are used together with a 50mm lens the image on the film is virtually life-size, being at almost exactly the same distance from the lens as the object, i.e., 50mm plus 49mm. That is the condition when the lens is said to be at double extension.

The increased light path from the back of the lens and the unusually short distance from lens to subject can impair the quality of the image, because these are not the conditions for which most lenses are designed. If you do find that the image is not as sharp as you would expect, try reversing the lens so that the front faces the film and the back faces the subject. This you can most easily do by using the lens reversal ring specially designed for the purpose (see page 182).

A further effect of the increased light path is to spread the light and lessen the amount falling on the film in accordance with the inverse square law (see page 129) so that the film receives only one-quarter of the amount of light that it would for a more distant subject. Thus, the exposure calculated as correct for a normal subject has to be increased fourfold at double extension by lengthening the shutter speed or opening up the lens by two stops. If you have a Praktica Super TL, Prakticamat, Praktica VLC, LLC or LTL, however, the correct exposure is given automatically by the through-the-lens meter.

With the other Praktica cameras you have to calculate the exposure factor by which the normal exposure has to be multiplied. This is easily done by using the formula $(E/F)^2$, where E is the total lens extension, i.e., focal length of lens plus length of extension tube, and F is the focal length of the lens. Thus, with a 50mm lens and a 14mm extension tube, the factor is $(64/50)^2 = 1.6$ approximately, which indicates about half a stop extra exposure. You can deduce that the 7mm tube calls for no extra exposure, while the 28mm tube demands about one stop extra exposure.

Extension bellows

Instead of extension tubes, which have to be changed or added to when you want to alter the reproduction ratio, you can use extension bellows (see page 182) which allow you to alter the extension at will.

The extension bellows for the Praktica cameras go under various names. The smaller version is known as the twin-slide bellows attachment, the miniature bellows, the close-up bellows attachment or simply the small bellows. The larger version has been variously called the large close-up bellows attachment, the large bellows attachment and the large bellows. We propose to use the simpler small and large bellows descriptions.

Praktica small bellows

The small bellows is a one-piece unit consisting of substantial front and rear standards separated by extendible bellows, the front standard sliding on two heavy rods to which the rear standard is fixed. The rear standard has a rotatable ring with a male thread to enable the unit to be screwed into the camera body. The camera can then be rotated to any angle relative to the bellows. Both standards have tripod bushes in their bases to allow the complete assembly to be mounted as near as possible to the point of balance. The front, movable, standard is threaded to take Praktica lenses.

There are various methods of attaching the lens to the bellows. When an automatic iris lens is fitted the normal way round, a plain intermediate ring can be used to press in the diaphragm operating pin and so convert the diaphragm to manual operation. Alternatively, a special plunger-operated ring (sometimes known as a Z-ring, see page 184) can be interposed between lens and bellows to allow a double cable release (see page 184) to separate the functions of shutter release and diaphragm operation and so allow the lens to be used in its normal automatic-diaphragm manner.

For extreme close-ups, it is sometimes advisable to reverse the lens. A reversing ring (see page 182) allows the lens to be attached to the bellows by its filter thread. Automatic operation can then be restored by attaching the Z-ring to the rear of the lens (which faces the subject) and using the double cable release.

An additional special intermediate ring is required at the rear of the bellows when attaching cameras with protruding pentaprisms, such as the Praktica IVB and the Super TL. This ring adds 7mm extra extension and enables the rear of the bellows unit to clear the pentaprism base. Any extension ring will serve the same purpose.

With the bellows attached to the camera and the lens to the bellows, you have a variable lens extension from about 34 to 116mm. The extension values are marked on one of the tubular runners from 40 to 110. The table on page 296 shows the reproduction ratios and exposure factors for lenses from 35 to 135mm focal length used in conjunction with the small bellows, both with and without the 14mm special intermediate rings. With a 50mm lens, the bellows allows you to obtain any image size from about half life size to twice life size.

Praktica large bellows

The large bellows is of a totally different construction. You receive it in separate pieces that have to be assembled before the bellows can be used. It consists of the flexible bellows fastened to front and rear standards, a slide rail and a focusing slide block.

If the slide and the block are separated, note in re-assembling them that the blank end of the scale should be at the end of the block with the smaller locking wheels. Attach the bellows to the slide by first turning the small locking screw at one end of the rail so that its flat is upper-most. Loosen both star wheels on the bellows unit and push the front standard (the lens carrier) on to the slide. Follow it with the rear (camera) standard and rotate the locking screw again so that its flat is vertical and projects above the level of the rail. This prevents the rear standard from slipping off again. Push the front standard right forward and lock it there. The required extension is provided by moving the rear standard along the rail in either direction. The black figures visible on the slide rail behind the rear standard indicate the extension obtained. The red figures were used only for a special sunk-mount lens not now generally available.

CLOSE-UP EQUIPMENT

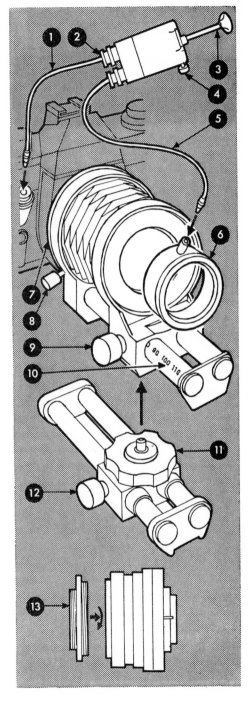

The Miniature Bellows Attachment is substantially made and provides reproduction ratios from 0.7X to 2.5X with a 50mm lens. A double cable release and special intermediate ring are supplied to enable automatic diaphragm lenses to be used on the bellows.

The bellows can be mounted on a focusing slide to facilitate close-range focusing.

Sometimes, at very close range, a lens performs better when reversed. Reversing rings are available to allow the front of the lens to be attached to the bellows.

1,5 Cable releases in twin housing
2. Adjusting screw for synchronizing release action
3. Plunger operating both cables
4. Time exposure lock
6. Z-ring for auto-diaphragm lenses
7. Bellows flange
8. Flange lock
9. Front standard lock
10. Graduated runner
11. Locking ring on focusing slide
12. Track lock
13. Reversing ring

Lenses are screwed into the front standard in the normal manner. Automatic-diaphragm lenses are converted to manual types as they are screwed in because the lens mounting plate depresses the diaphragm plunger. If you wish to retain automatic diaphragm operation, you must use the special plunger-operated intermediate ring in the same manner as with the small bellows.

Focusing is facilitated with the large bellows because of its built-in slide. You first achieve rough focus, with the extension set to provide the image size required (see page 296), by moving the whole assembly of bellows and camera back and forth or, if it is easier, by moving the subject. Precise focus is then attained by adjusting the large star wheels on the slide block so that the camera and bellows are moved along the rail without disturbing the lens-to-camera extension. At the point of correct focus, screw the right-hand wheel in while holding the left-hand wheel firmly. If you wish to shoot at a particular lens-to-subject distance, rather than for a particular image size, lock the slide and move the rear bellows standard as required after unscrewing its locking wheel. When you have focused sharply, lock the rear standard in place again.

Slide-copying attachment

The hole in the front of the focusing slide block of the large bellows allows a slide copier to be attached to the bellows. The slide copier consists of a tubular rod with a V-section support piece fixed at right angles to it at one end. The rod is pushed into the hole in the front of the block (with the support piece upward) and locked in position by the small wheel on the left-hand side of the block. The slide and film strip holder is slid on to the vertical support and locked in the required position with its own locking wheel. The up-and-down movement allows considerable adjustment for copying parts of images. Two clips on the front of the slide holder allow a small bellows and light shield to be attached.

To set up the attachment for same-size copying with a 50mm lens, extend the bellows to the 50 mark on the scale. Place the slide to be copied in the slide holder and illuminate it from behind if necessary. Any kind of light can be used for focusing purposes. Move the camera and bellows back

LARGE BELLOWS AND SLIDE COPIER

The Large Bellows Attachment is assembled on a focusing rail and slide. It extends from about 35mm to 220mm giving reproduction ratios with a 50mm lens from 0.7 to 4.4. Automatic diaphragm control is provided by a double cable release and special intermediate ring. TTL metering at full aperture with the Praktica VLC and LLC is provided by a pair of intermediate rings with electrical connections.

A Slide Copier can be attached to the front of the Large Bellows for same size copying or for reproducing sections of 35mm originals.

1. Front standard lock
2. Stop screw
3. Lens mounting ring
4. Focusing wheel
5. Rear standard adjustment
6. Bellows
7. Camera mounting ring
8. Focusing rail
9. Mounting ring lock
10. Slide copier mounting
11. Slide copier lock
12. Locking wheel
13. Slide holder
14. Diffuser
15. Film strip holder
16. Attachment rod

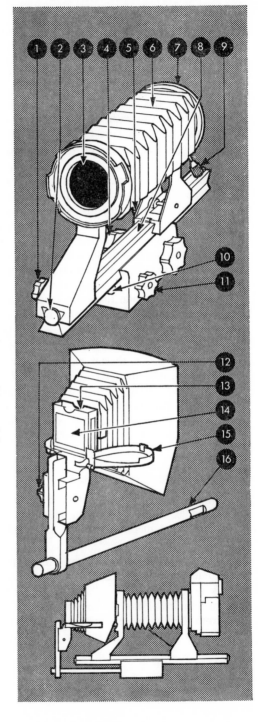

and forth on the focusing slide as necessary while observing the image on the viewfinder screen. The waist-level finder or magnifying finder of the Praktica VLC are useful for this job. When the image of the slide is sharply focused on the screen, lock the focusing slide. You may need to make adjustments to the bellows extension to copy the exact area you require. If you wish to copy only part of the slide, you have to extend the bellows further.

If you are copying on daylight film, exposure should be made with daylight, blue flashbulb or electronic flash illumination behind the opal glass of the slide holder. The advantage of flash illumination is that a few experiments enable you to standardise your exposure technique. If you use daylight, outdoors or near a window, you can accept the TTL meter reading as a reasonably accurate basis for experiment. Working in daylight with an ordinary hand-held meter or only the film manufacturer's recommendations to help you, the normal close-up rules apply (see page 190). For same-size reproduction, you double the lens extension and therefore need four times the normally-calculated exposure.

You may find it best to reverse the lens for slide copying, attaching it to the bellows via a reversing ring (see page 182). In that case, a shorter extension setting of the bellows is required. On the other hand, use of the Z-ring with an unreversed 50mm lens makes 1:1 reproduction impossible and you have to fit a longer-focus lens. If that should happen to be a telephoto lens, the exposure factor for 1:1 is much greater than 4× (see page 200).

Unorthodox approaches

Supplementary lenses, extension tubes and bellows are the orthodox methods of taking close-ups but there are various unorthodox methods that the experimentally minded might like to try.

You can, of course, use these three methods alone or in any combination. The effect of a supplementary lens in normal use is to form a compound lens of shorter focal length than the camera lens alone. As the extension of the lens (its distance from the film plane) is unchanged, it becomes longer than the focal length, which means that the lens can focus closer. If you

increase the extension by adding tubes or bellows you can focus closer still.

Similarly, if the bellows does not give you all the magnification you require, you can add extension tubes to it.

You can also develop the supplementary lens approach along rather unorthodox lines. If, for example, you placed two 50mm lenses together on a camera, you would create a 25mm lens. Each 50mm lens is a 20-dioptre lens (1000mm divided by 50mm) and dioptre strengths can be added to give combined strengths. Thus, two 50mm lenses are the same as one 40-dioptre lens and 40 dioptres is equivalent to 1000mm divided by 40, which is 25mm.

With two lenses mounted together in this way, however, the lens to film plane distance remains unchanged at 50mm which, for a 25mm lens, is a double extension. Thus, you can produce a life-size image.

The most popular application of this method is to use a 135mm lens on the camera with a 50mm lens on the front, which can give you an image about three times life-size. You can extend the method still further, however, by adding extension tubes or bellows to give six times life-size and more. These magnifications are on the negative, of course, and the further magnification provided by enlargement or projection can produce quite startling pictures.

An advantage of this hybrid method of added extension plus supplementary lens (the 50mm lens as used here is a high-quality supplementary) is that exposure does not have to be increased as much as when you use added extension alone. The supplementary lens generally has a negligible effect on exposure. It is again often advisable, however, to use the 50mm lens reversed and, in that case, the maximum usable aperture is generally restricted by the smaller front element of the "supplementary" lens. It is best to keep the 50mm lens wide open and use the diaphragm of the 135mm lens for exposure control.

Obtaining a sharp image

Whichever close-up method you use, you must ensure that the camera is held rock steady. A thoroughly reliable, really rigid tripod is essential and the shutter must be operated by a cable release. The closer the range, the more important this becomes, because it needs only the merest fraction of movement of the

camera during the exposure to produce considerable blurring of the image. This you will appreciate if you try to focus (or even frame) an enlarged image while hand-holding the camera.

Focusing, too, is really critical and must be carried out with extreme care. Use the clear ground-glass section of the viewfinder and, if you intend to do much of this kind of work, buy a focusing magnifier (see page 180) to help you attain the best possible focus.

The focusing slide (see page 184) can help with the small bellows, because in extreme close-ups it is often easier to focus by moving the whole camera toward or away from the subject rather than just the lens. The focusing slide allows this movement to be carried out smoothly and easily. It must be handled with care, however. The procedure must always be to attach the focusing slide to the camera or bellows before attaching the complete assembly to the tripod. The reason for this is that the screw by which the focusing slide is attached to the bellows or camera cannot be turned. If the slide is first attached to the tripod, the equipment has to be screwed on to the focusing slide and that is a reasonably certain method of crossing the thread. The more versatile large bellows has a built-in focusing slide (see page 192).

Depth of field is negligible in close-range work and becomes smaller with greater magnification and you have to be very careful, if your subject has any depth, to ensure that you are focusing on the correct plane of the subject.

Owners of the Praktica VLC have an obvious advantage in close-range work because they can change both viewfinder and screen. The eye-level pentaprism is not the ideal method of viewing close-ups when you are shooting horizontally. It frequently means that you have to get down on your knees to see the image or extend the tripod to such a height that steadiness is suspect. In such circumstances, the waist-level finder or magnifying finder make for much easier working.

Of greater importance in really close work and copying, however, is the construction of the focusing screen. Rangefinder focusing has certain limitations and should not be relied on for absolute accuracy. The normal screens have rather prominent fresnel ring patterns that can interfere with accurate focusing and can even obscure some fine detail. The VLC owner should change to one of the specialist screens (see page 88) designed for critical work and, if

necessary, add a focusing magnifier or angle finder to the pentaprism eyepiece.

Lighting the close-up

Illumination of the close-up subject often raises difficult problems. If you use a long extension and are working in colour, you generally need a lot of light. In black-and-white, you can give long exposures—running into several seconds if necessary —but colour films contain three carefully balanced emulsions and long exposures can raise problems of reciprocity failure. Normally, a long exposure at a small aperture gives the same result as a correspondingly shorter exposure at a larger aperture. That is the law of reciprocity. When the exposure is longer than a second or two, however, the law fails and, to attain adequate density, the exposure may have to be increased more than proportionately with the closing down of the aperture. With black-and-white film, the only problem is to discover, probably by trial and error, how much more exposure is necessary. With colour film, on the other hand, the possibility is that each emulsion will react differently and so distort the colour rendering. The only satisfactory solution is to increase the strength of the lighting to keep the exposure to one second or less.

The nature of the lighting depends on the result required. Any texture, raised pattern, irregularity, etc., can be emphasised by side lighting or subdued by diffused frontal lighting. If the subject is more than a few inches across and must be evenly illuminated, you will need a light on each side or, again, frontal lighting from a large diffuser.

A frequent cause of trouble in extreme close-ups is that the camera is so close to the subject that the lights can only be placed obliquely and frontal lighting becomes impossible. If there is room to place a sheet of glass at 45° between subject and lens, light can be reflected off the glass on to the subject from a lamp placed at right angles to the lens axis. The glass should be perfectly flat plate glass and scrupulously clean. A semi-silvered mirror (see page 262) would reflect more light.

A projector can make a useful small light source, particularly if a conical "snoot" is placed over the lens to give a "spot" effect. The light is not particularly strong but it can be used for black-and-white work.

Reflecting surfaces can be put to good use for close-up light-ing. Small subjects can be almost surrounded by white card, foil, mirrors, etc., according to the amount of fill-in light required. Outdoors, in the photography of wild flowers for instance, curved sheets of card or similar material can fre-quently be made to serve as both windshield and reflector.

Reflectors must, of course, be white or neutral-coloured when colour film is used so as not to throw a colour cast (see page 171) on to the subject. Similarly, the film must suit the light source. If you use tungsten lamps, you must use artificial light film (see page 114).

Flash is a useful light source and the very small electronic units now available can be used within a few inches of the subject to provide quite powerful lighting. For frontal lighting, special circular units known as ring lights are manufactured. They fit around the lens and provide even illumination on flat subjects. They are useless, however, for glossy surfaces: the light bounces straight back into the lens and causes consider-able flare.

The best lighting for close-ups, particularly where even lighting is essential, is frequently daylight and it is always worth considering taking the whole set-up outdoors. Even when slightly directional lighting is required, a set-up near a window can provide a large, reasonably diffused light source. It is generally preferable to choose a slightly overcast day.

Exposure problems

Exposure has to be carefully assessed. Apart from adjustments required to allow for any extra extension used (see page 190), you have to allow for the "mechanical" nature of meter read-ings. Exposure meters recommend an exposure to reproduce any subject they "see" as a collection of tones that average out (or integrate) to a mid-tone, because most subjects do contain a collection of tones that integrate to grey. If, however, as may often be the case, your subject is totally light-toned or dark-toned, the meter will recommend underexposure in the first case and overexposure in the second (see page 66).

A complication noted in recent years is the additional exposure increase often required when a telephoto lens is used for close-range work. At 1:1, for example, a normal 135mm long-focus lens calls for about 4× more exposure than a meter reading from the subject would indicate (see page 190). With

ANGLE OF VIEW AND FOCAL LENGTH

View across the Thames at Twickenham with four different lenses used from the same camera position. From top to bottom, the lenses used were 28mm, 50mm, 135mm and 300mm. There are shorter and longer focal length lenses than these available for the Praktica cameras. Photos: *Leonard Gaunt*. Hampton, England.

(*Above*). Birds in cages are still accessible. If you press the lens close to the netting it can resolve only a fuzzy pattern of the mesh that is easily lost in the bright parts of the subject. Photo: *S. W. Burrows*, Wilmslow, England.

Page 202. If you drove over this street, you would remember it. Why not photograph its characteristic surface? Choose the viewpoint and, if possible, the lighting, with care.　Photo: *Pentacon VEB.*

Page 204. The actual subject is unimportant when your aim is to present its lines as a composition in themselves. You choose or arrange the lighting to emphasise the pattern and frame the subject appropriately in the viewfinder. Photos: *J. Henshaw*, Ilminster, England (*top*), *G. J. Ward*, Lydney, England (*bottom*).

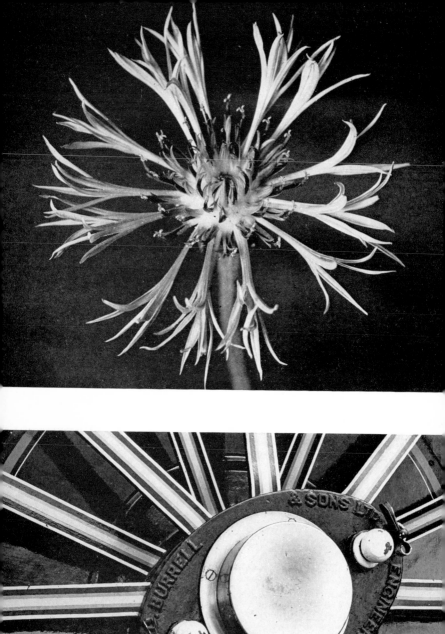

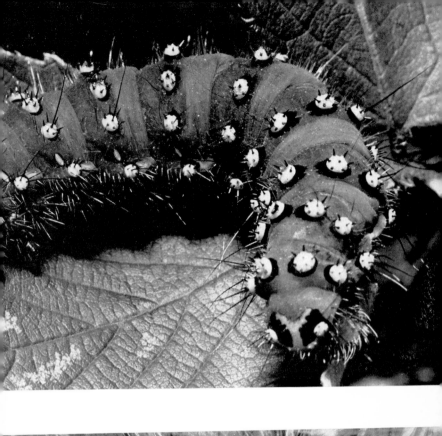

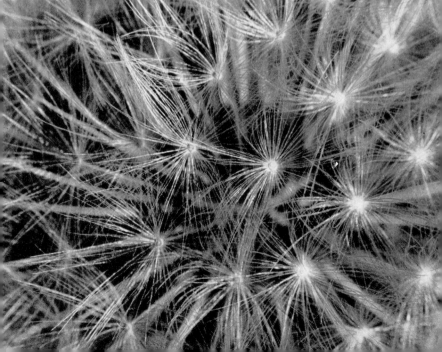

(*Above*). The giant snowdrop is not all that big but a close-up lens attached to the standard Praktica lens gives you a large image. With a black card behind the blooms and frontal flash you isolate the subject completely. Photos: *Raymond Lea*, Marlow, England.

Page 205. With extension tubes or bellows on the Praktica, you can go as close as you like. With a small flash unit also attached you can poke into the darkest corners to bring out the tiny details of plant and insect life. Photos: *G. J. Ward*, Lydney, England (*top*); *J. Henshaw*, Ilminster, England (*bottom*).

Pages 206 *and* 207. In those odd moments when you run out of inspiration for Praktica pictures, try making photograms. Simply lay your subject on a sheet of bromide paper on the enlarger baseboard and expose for maximum black in the background. Photos: *J. Henshaw*, Ilminster, England.

a 135mm telephoto lens you might well need 9–10× more exposure. The Praktica TTL meters indicate this.

The reason is simply that the telephoto lens has a shorter light path than the long-focus lens, but that you have to increase the bellows extension by just the same amount for close-ups, whether the lens is long-focus or telephoto. Thus, for 1:1, you more than double the light path and thus need more than 4× exposure increase.

Unfortunately, this fact has been linked to "pupil magnification"—a phenomenon of the telephoto lens whereby the diaphragm opening appears larger when viewed from the front than from the back. The ratio is called the pupillary factor and has been said (erroneously) to be the reason for the increased exposure required.

From that derives the fallacious argument that less exposure is needed when the telephoto lens is reversed on the camera. This theory overlooks the fact that when the telephoto lens is reversed for close-up photography, it needs extra bellows extension just as with the normal long-focus lens, which is then lacking the extension provided by its own barrel.

The real importance of pupil magnification is in the TTL meter design, but that is a different matter.

USES OF INFRA-RED MATERIAL

You may notice a small red dot, letter R or other mark on your lens or lenses to the right of the focusing mark on the depth of field scale. This is the infra-red focusing mark, necessary because normal camera lenses are corrected for visible light in the 400–700 nanometre range. Infra-red rays stretch well beyond this region and are refracted less by the normal lens, coming to a focus an appreciable distance (in terms of sharp focus) behind the focal plane.

Once you realise what this mark is, your thoughts inevitably turn to the possible uses of infra-red photography. You may have some recollection of "photography in the dark", "black light", and other such intriguing phrases. These arise out of the fact that infra-red radiation is invisible but that photographic emulsions can be made sensitive to it by the addition of special dye materials.

All modern films are, in fact, dye-sensitised to make them sensitive to the red and green content of visible light. The undyed emulsion is sensitive only to blue light. Infra-red film is treated to make it sensitive to a portion of the infra-red waveband as well as the normal red. It retains its natural blue sensitivity but has reduced sensitivity to green.

Characteristics of infra-red film

Kodak make an infra-red 35mm film that can be used in the Praktica cameras but it is not stocked by the average photographic dealer. It has a shelf life of only a few weeks or, at best, a few months in a refrigerator. It has to be specially ordered and must be used and processed as quickly as possible after purchase. If you keep it in a refrigerator, remember not to unwrap it until it has been out of the refrigerator for several hours. Otherwise, moisture in the air will condense on the cold film and cause, at least, irregular densities in the processed film.

The peculiar sensitivity of the infra-red film means that it can be used as an ordinary film, perhaps with some distortion

of tonal rendering in the green region, while for true infra-red pictures it has to be exposed through a special filter that absorbs all visible light or to a source that emits only infra-red radiation.

The true infra-red filter is opaque and Kodak's infra-red film has a speed of about 6 ASA in daylight and 12 ASA in tungsten light—with this filter in use. The speeds are increased to about 12 and 20 ASA respectively if an ordinary deep red filter is used. These are, of course, approximate speeds based on exposure meter readings. The exposure meter is not sensitive to infra-red radiation and the amount of such radiation can vary with the nature of the light.

Characteristics of infra-red radiation

Most heat-emitting substances provide infra-red radiation. The sun, tungsten lamps, flashbulbs and, to a lesser extent, electronic flash tubes are all good sources. Electric hotplates, domestic flatirons, radiant heaters and similar appliances also emit infra-red rays, but pictures made by "illumination" from these sources are likely to need some hours' exposure.

Viewing and focusing calls for special treatment. If you use a true infra-red filter over the lens, no light gets through to the screen. If you are hand-holding the camera, you need a separate optical viewfinder to frame the picture. For static scenes, however, you can put the camera on a tripod and view and focus before placing the filter over the lens.

If your lens has an infra-red focusing mark, you focus on the screen image in the normal way, note the distance opposite the normal focusing mark and turn it to the infra-red mark. If you have no infra-red mark, make a tentative mark on the $f4$ division on the right-hand side of the depth of field scale for a 50mm lens, on the $f5.6$ division for 85–100mm lenses between the $f8$ and $f11$ division for 135–150mm lenses and on the $f16$ mark for 200–300mm lenses. These marks should be reasonably accurate for most subjects at normal distances and apertures. If you intend to shoot often at full aperture or very close range, you will have to carry out experiments to ascertain the correct position for the focusing mark.

The real uses for infra-red film are in the professional field of industrial and medical photography, but any Praktica user can produce interesting results if he has an inquiring mind and a willingness to experiment.

211

The effect that infra-red film has on landscape photography is widely known. Any red filter absorbs light from a blue sky strongly. The infra-red filter absorbs it completely so that the sky is reproduced as jet black. At the other extreme, green grass and foliage are rendered as a very light tone and often as completely white because they reflect infra-red rays strongly. All other colours are similarly distorted according to their relative red and blue content. Generally, the red gets through to the film, the blue is cut off. Landscapes thus take on a dramatic, contrasty appearance and distant detail is reproduced clearly, even when there is considerable haze.

This last mentioned feature of infra-red radiation—its ability to pierce haze—is frequently misunderstood. Haze is the scattering of light by small solid particles, water droplets, etc., in the air. Only light at the blue (short-wave) end of the spectrum is significantly scattered. The red (long-wave) component—and the longer-wave infra-red—suffers very little from scatter. Consequently, the red filter, in absorbing blue light, also absorbs haze because it prevents the scattered blue light from having any effect on the film. The unscattered red light passes through the filter and reproduces the distant scene distinctly. Infra-red radiation does *not* penetrate heavy mist or fog, which consists of very much larger solid particles that affect all wavelengths.

Photographs in darkness

The "black-light" nature of infra-red radiation is its invisibility. It is possible, therefore, to "illuminate" a subject with infra-red radiation and take a photograph in total darkness. In practice, such a powerful light source would be needed for this type of photography that it is more usual to use a deep red filter instead of the true infra-red filter and make some use of the film's sensitivity to red light, too. Thus, the light is not truly invisible but it can pass unnoticed or, at least, cause no distraction.

In this case the filter has to be placed over the light source and no filter is needed on the lens. Fortunately, filters used in this way can be made of almost any material, whereas the filter over the lens has to be of optical quality. Specially coated flashbulbs are available in some countries while a filter bag made of several layers of dyed cellulose material can be obtained in the UK. It is large enough to cover a fairly sizable

INFRA RED, RELEASE LOCK, SELF-TIMER, BATTERIES

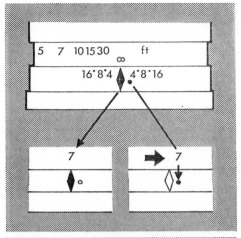

Zeiss lenses have a red mark next to the focusing mark on the depth of field indicator. This is the infra red focusing mark. You focus normally and then move the focusing ring so that the distance indicated appears opposite the infra red mark.

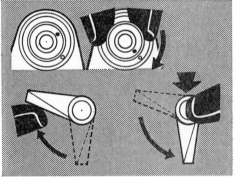

The later Prakticas have red dots on the shutter button and the rim around it. When the release button is turned so that the marks coincide, the button is locked and the shutter cannot be released. This lock has a particularly important function on the Praktica LLC (see page 75).

The Praktica VLC, LLC and LTL have self-timers. The lever on the camera front is moved up to its limit to set the timer. Release is effected by pressing the button on the timer arm.

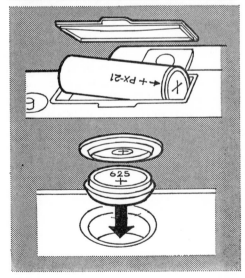

The battery of the Praktica LLC is a 4½-volt PX21 type. It is housed under a clip-on plastic cover in the camera baseplate.

The batteries for the Super TL and LTL are both mercury button types PX625 housed under a screw-in cover in the camera baseplate.

flashgun and is particularly useful with electronic flash, which does not require it to be removed after each exposure to replace the bulb.

Difficulty of predicting results

The other uses to which you might put infra-red film are largely a matter for experiment. The behaviour of infra-red rays with particular materials is never entirely predictable. They pass freely through some materials and are strongly absorbed by others. They tend to penetrate skin and show close-to-the-surface veins. When they are strongly absorbed or reflected, they might show up stains on materials or alterations to documents. Infra-red rays have been used to penetrate oil paint to demonstrate an artist's technique. They can pass through some polishes to show the natural wood beneath.

There is even an infra-red colour film, originally devised with intentionally false colour rendering to show up camouflaged areas during wartime and subsequently used to differentiate between healthy and unhealthy vegetation. This film is now sometimes used to provide striking colour renderings from otherwise relatively ordinary subjects.

Handling and processing

Infra-red film is supplied in metal cassettes of the same type as other 35mm films. It can be handled normally while loading it into or unloading it from Praktica cameras, although it might not be safe in some plastic-bodied cameras or in the older bellows types because infra-red rays can penetrate some plastics and bellows materials.

Processing, too, is normal, development time being about 10–12 min in an orthodox MQ or PQ developer (see page 236) at 20°C (68°F). You should conduct tests first, however, if you use a plastic tank to ensure that it absorbs infra-red rays or make sure that the tank is not exposed to any bright light or radiation from heated surfaces during processing. Stainless steel tanks are perfectly safe.

THREE-DIMENSIONAL
PICTURES

The Prakticas, like all normal cameras, see the subject from a single viewpoint, through the taking lens. The normal human being, on the other hand, sees everything from two viewpoints —two eyes, generally spaced about 65mm apart. The result is that the camera's view is two-dimensional, whereas human vision is three-dimensional.

The difference is very often marginal because we are so accustomed to three-dimensional vision that we tend to see many pictures as if they were three-dimensional. Indeed, many —perhaps most—pictures are deliberately arranged and lit to give the appearance of three dimensions.

Adding depth to the picture

The third dimension, in this case, is depth. The printed picture, transparency, etc., has height and breadth but it has no discernible depth. Nevertheless, by careful attention to composition, focus, lighting, etc., it is possible to give an impression of depth that is extremely realistic.

Some people feel that this is not enough and, in an attempt to add the missing dimension, they take their photographs in pairs from two viewpoints just 65mm apart. They then arrange by various means that each picture of the pair shall be viewed by the eye corresponding to the position of the lens that took the picture. Thus, each eye sees the subject from a slightly different viewpoint—the left eye seeing a fraction of the background to the left of the subject that is hidden to the right eye, and vice versa. With rounded subjects, the left eye sees a little more of the left side and the right eye a little more of the right. The result is a quite marked separation of planes, the nearer objects standing out from the background.

Small stereo images of this nature seen through a hand viewer (or direct, by those who have trained themselves to dispense with a viewer) look, to many people, like cardboard

cut-outs. The impression of depth is there, but not of round-ness or of depth within a particular object. A tree, for example, looks like a flat tree standing out quite markedly from a flat background. When the images are projected, however, and viewed through suitable spectacles, a much more genuine three-dimensional effect is obtained.

Methods of taking stereo pictures

There are various methods of taking three-dimensional photo-graphs and, for pictorial effect, the Prakticas are particularly useful cameras. The small size of the film makes projection a reasonably simple business and keeps the cost within bounds.

The simplest method, calling for no additional equipment, is to use a single camera and to move it 65mm to one side between exposures. It is easy to make a shallow tray for fixing to a tripod, the dimensions of the tray being such that the camera can be slid from one end to the other to provide the two required viewpoints 65mm apart. Alternatively, you can use the focusing slide (see page 184) designed for close-up work with the Prakticas.

The drawback of this method, of course, is that the two exposures are separated in time and the subject must therefore be completely static.

You could overcome that drawback by fastening two Prakticas together so that their lenses are 65mm apart and operating the shutters simultaneously by a double cable release. The difficulty there is that the shutters and lenses must be near-perfectly matched and that is not as simple as it might seem.

The more usual method is to use a stereo attachment in con-junction with the standard 50mm lens. The attachment con-tains a beam splitter composed of mirrors or prisms to provide two pictures from the required separate viewpoints. The two pictures are the so-called half-frame size (18×24mm) and are therefore contained on one normal 35mm frame.

Viewing methods

Once the stereo pictures are taken you have to prepare them for viewing. You can, of course, use black-and-white negative film and make prints. You must make the prints to exactly the same degree of enlargement and to include exactly the same area. It is preferable to make the prints simultaneously on a

single sheet of paper, which is easy enough if you use a stereo attachment but needs a large-format enlarger if you use the two separate exposure method.

Prints of, say, $4\frac{1}{2} \times 3$in size can be mounted about $\frac{1}{4}$in apart and viewed direct from your most comfortable viewing distance. The trick is to persuade your eyes not to converge on to the print surface. Each eye must see its own print only and, to do that, the eyes must look straight ahead and not converge. You must try to look through the prints as if you were looking at a distant scene and then bring the focus back without the convergence that normally goes with it. Most people can do this after a little practice.

It is generally more comfortable to use a viewing box or frame either supplied commercially or made up. Essentially, this type of viewer consists of a frame to hold the prints and a pair of lenses a suitable distance away through which to look at them. The box type is open-topped to provide illumination for the prints. A central "barrier" or hooding of the lenses keeps each eye on its own print.

If you produce black-and-white or colour transparencies, you need illumination from behind the stereo slides and this is usually provided, as in the normal transparency viewer, by bulb, battery and diffuser. Again, however, as with normal transparencies, the best method of viewing is by projection.

Stereo projection requires a double-lens projector and, for colour, polarising filters differently oriented on each lens. The stereo pairs provided by the attachment are placed in special stereo mounts with twin apertures. The lenses of the stereo projector have polarising screens oriented at right angles to each other and the pictures are superimposed on a special screen that does not depolarise the light. The image is viewed through polarising spectacles of which the lenses are oriented at right angles to each other in the same manner as the polarising screens in the projector. Thus, the right eye sees the image provided by the right-hand lens and the left eye sees the left-hand image. With suitable slides and efficient projection equipment the three-dimensional effect is truly startling.

Limits of stereoscopic photography

There are limits to the kind of subject you can reproduce stereoscopically. Stereoscopic vision does not extend far into the distance, as you will readily appreciate when you consider

217

that it depends on the separation between the eyes. If you hold a pencil in front of your face and view it through each eye alternately, you will notice that it appears to move sideways in relation to its background. If you view a distant lamp-post, telegraph pole, etc., in the same manner, no such movement is discernible. Thus the normal stereo attachment could not produce a picture in which that lamp-post stood out from its background.

That does not mean that distant views cannot be produced stereoscopically. They can—but you have to increase the separation between the viewpoints. That means a specially designed camera, two cameras suitably spaced or one camera moved a suitable distance between exposures. By the same methods, you can exaggerate the three-dimensional effect by shooting normal scenes from widely separated viewpoints.

The average stereo attachment works satisfactorily with subjects at about $1\frac{1}{2}$m (5ft) or more from the camera. For really close work, a special attachment is required, providing a much smaller separation, or the two-exposure method can be used, reducing the sideways movement of the camera to, say, 18mm or less.

Stereo subjects should generally be sharp in all planes because the stereo effect is barely noticeable in unsharp areas. There are exceptions, of course. Ultra close-ups of single blooms, for example, can look very effective against an unsharp background or even behind an unsharp foreground.

Foreground and background are important. In landscape shots, it is often only the foreground that provides the three-dimensional effect. In mid-distance shots a background is necessary to separate the main objects, even though detail in the background shows no plane separation in itself.

Some subjects are not particularly suited to stereoscopic treatment. The straightforward head and shoulders portrait, for example, gains nothing that could not be provided by careful posing and lighting. On the other hand, a more imaginative portrait, including some environmental detail, might well gain from the added dimension.

Rapidly moving subjects can look unnatural. In normal photography, you can blur the background by panning the camera or allow the subject to blur to a greater or lesser extent to convey an impression of movement. Such blurred effects are rarely acceptable in stereoscopy, while a racehorse, dancer,

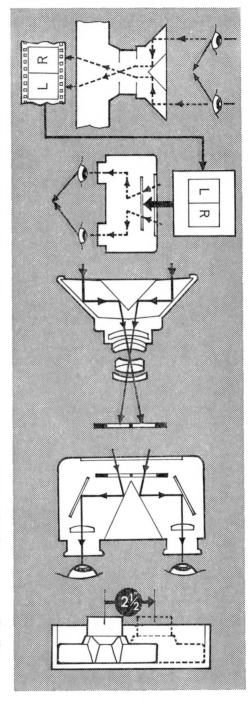

Stereo attachments vary in design but the principle is the same. Stereo vision depends on the two eyes seeing slightly different aspects of the subject, which are combined in the brain. The stereo attachment likewise records two different views on the 35 mm. frame which, when seen through a stereo viewer present the correct left and right images to the eyes. This form of attachment contains a prism system which takes two separate images from correctly separated viewpoints and presents them side by side on the film correctly oriented for subsequent viewing.

The 35 mm. frame is bound up in a standard 2 × 2 in. slide and placed behind the diffusing screen of the viewer. The eyepieces of the viewer accept mirror images of the stereo pair to present the subject to each eye as it would be seen in reality.

A single camera without attachment can take full frame stereo pairs of static subjects if it is moved sideways 2½ in. between exposures.

athlete, etc., can look distinctly odd if "frozen" in mid-action in three dimensions.

When you use stereo attachments, the angle of the taking lens (you should always use the "normal" or standard lens) is effectively halved and your viewing screen shows two side by side pictures. You will generally need to use a fairly small aperture, say $f5.6$ to $f8$ at the largest, both to obtain adequate depth of field and to prevent any tendency to vignetting.

CHOOSING AND MAINTAINING EQUIPMENT

Most people buy a camera complete with a standard lens of about 50mm focal length. That is sensible enough because the standard lens is designed to be suitable for most day-to-day photography. When used to take pictures from, say, 3–4m and more, it gives more or less the coverage and perspective effects that seem normal to human vision—provided you print from the whole or almost the whole negative. If you print only a small part of the negative, or mask down a transparency and project only part of it, the effect is the same as using a longer focus lens.

Camera and lens

If you are buying your Praktica as your first camera, it is wise indeed to follow normal practice and buy the standard lens with it. You usually have a choice of three such lenses at increasing prices. The Praktica L, for example, was originally offered at prices (in the United Kingdom) of £65 if supplied with the *f*2.8 Tessar, £75 with the *f*2 Oreston (now Pentacon) and £90 with the *f*2 Pancolor. Thus, you paid £25 more for the Pancolor than for the Tessar.

These prices are given only as an example. They do not apply outside the United Kingdom and, indeed, there are innumerable dealers in the UK who sell Prakticas at considerably lower prices. In many countries, the market is free and dealers can set their own prices. It is often claimed that such dealers offer no after-sales service and should not be patronised. That is a matter for individual consideration in the prevailing circumstances. The cameras are guaranteed by the manufacturers to the first purchaser from a trade source and the Pentacon company has reliable agents in most countries to undertake after-sales service.

However you buy your Praktica (and you may, of course, buy on the used market), get the best lens you can afford if you

intend to undertake critical work. This does not mean that the Tessar is not a very good lens, but the Pentacon and Pancolor are just that much better and the difference shows up when you make really big enlargements or enlarge only part of the negative. It may show up, too, when you shoot at larger apertures, but remember that much of the additional cost of the more expensives lenses is due to the extra stop they have.

But perhaps you have already had considerable experience of 35mm work and are switching to the Praktica from another model. In that case, you will have found out what type of photography interests you most. It may be orthodox portraiture, sport, wildlife, etc. In these particular fields, the 50mm lens is rarely used and you may feel that *your* standard lens should be of a different focal length—say about 105mm or longer. In that case you can buy the Praktica body only and select your particular lens from the enormous variety available.

Choosing the first accessories

Once you have your camera and its lens, what else do you need to take photographs? This is a question that seems to trouble many beginners in photography. The Prakticas are good cameras and many people's approach to good cameras is that they must be accompanied by a host of accessories in order to make the most of their potentialities. This, of course, is ridiculous. A Praktica body and one lens is a complete picture-taking outfit and you need no other equipment whatever to produce first-class pictures of a wide variety of subjects. There is no need to cast desperately around for filters, meters, flash-guns, etc., simply because you feel you ought to have them. First use your Praktica and find out what accessories you really need.

You may find that your main interest lies in landscape photography—taking pictures of the scenery wherever you travel and, indeed, searching out the particularly photogenic spots. Then you may need a filter or two. But take plenty of photographs first and consider what effect a filter might have had on them. You will probably know that a filter can be used to darken the blue-sky area in black-and-white pictures (see page 160). Do you need such an effect or do the skies look fine to you without a filter? Only when you are sure you prefer a result the unaided lens cannot give should you contemplate adding filters to your outfit. In colour, you need a filter for

your landscapes only if you find that your results are generally too blue. Then a u.v. or haze filter can be obtained.

Similarly, it is commonly thought that a complex camera cannot be used without an exposure meter. Again, if you have bought a Praktica without built-in meter, use it first, following the advice—in your instruction book and in the leaflet packed with the film—before deciding that you must have a meter. Most of your photography will be undertaken in normal day-light conditions and, particularly in black-and-white, it is not at all difficult to assess the exposure required, whereas the use of an exposure meter needs a reasonable understanding of just what the meter reading means (see page 64).

If you do most of your work in colour and/or expect to shoot in unusual lighting conditions, a meter may well help you, but you should always try to use it in conjunction with your own appreciation of the lighting conditions and the result you want. If you blindly accept the readings given by a meter you can be frequently misled.

Buying additional lenses

The extra item most camera users think of first is an additional lens. What should your second lens be? Naturally, the choice must depend on the type of work you intend to do.

Most people think first of a long-focus lens, perhaps because of the tendency of human beings to reach out beyond their natural capabilities. The long-focus lens often allows you to see and to photograph that which the unaided eye can see only vaguely or not at all. This is not its most useful aspect, however. Probably the most popular long-focus lens is the 135mm, which can be used on a variety of subjects. It enables you to stand back from your model for portraits or to make large close-ups from a normal shooting distance. It gives an image more than $2\frac{1}{2}$ times larger than that from the 50mm lens so that you need not approach animals too closely, for example, or you can take a relatively distant view of a build-ing, architectural feature, statue, etc., that has too many obstacles to photography in its immediate vicinity.

The 135mm is a medium long-focus lens in a range which extends from about 75mm to 180 or 200mm. Your preference may be for, say, a 75 or 100mm, because you concentrate on portraits. If your main interest lies in sport or other spectator events where you can shoot only from fairly long range you

might prefer the 180 or 200mm, but you have to be sure that you can hand-hold such a lens comfortably. There are some compact telephoto lenses (see page 58) in this range but others are uncomfortably long and not easy to hold steady.

Lenses of still longer focal length have more specialised uses and you should give their purchase very careful consideration. They tend to be bulky and are not easy to hand-hold. For best results, in fact, they must be used on a tripod or must be supported in some other way. You can cultivate a steady enough hold if you use these lenses habitually and do not need critically sharp results, but if you need the extra length only occasionally, you might do better to stick to the 135mm lens and enlarge only the part of the image required.

It is unlikely that you will need more than one long-focus lens. There is always the temptation, because so many lenses are available, to convince yourself that you need a 135mm, 200 or 300mm, 400 or 600mm and, of course, a 1000mm because that is generally the maximum available. You must be prepared, the argument runs, for every eventuality if you wish to be taken seriously as a photographer. The argument is ridiculous. You cannot carry such a battery of lenses around with you, together with all the other gadgets this approach would lead you to accumulate. If you feel that you should have the rarer items available for certain types of work, although you hardly ever expect to use them, it would be more sensible to borrow or hire them when the occasion arises.

The Praktica is not a particularly heavy camera but three lenses are as much as any normal person would like to carry with it. Preferably you should make do with two.

Your second lens might, of course, be a wide angle rather than a telephoto. The moderate wide angle (29 or 35mm) is an extremely useful lens. It is a mistake to think of it as a lens for landscape work. The wide sweep of scenery it reproduces may look impressive to the eye but generally turns out rather unsatisfactorily on film. The wide angle lens does its best work at relatively close range. You can shoot in a crowd, in narrow streets, small rooms and other confined spaces. Sometimes it is the only lens that you can use on statues, buildings, etc., in built-up areas. It is generally easier to focus (more correctly, its focusing is not so critical) because of the immense depth of field it gives at small apertures.

Depending on your type of work, you might find a 35mm

lens more useful than the standard lens. You can then, perhaps, dispense with the standard lens altogether and carry just a 35mm and a 100 or 135mm.

Thus, the following alternatives are open to you:

If your main interest lies in the people around you—at work, at play, in the street, etc.—and perhaps in buildings, monuments and similar subjects in the city, your two lenses might consist of a 35mm and a 135mm.

If you prefer orthodox portraiture, children, animals and perhaps some general landscape and scenic work, you would probably do better with a 50mm and 135mm.

If you intend to concentrate almost entirely on subjects you have to shoot from some distance, such as sport, wildlife, architectural detail, river scenes from the bank, and so on, a 100 or 135mm and 200 or 300mm would suit you better.

Finally, if you intend to concentrate entirely on extreme close-ups, 50mm and 100mm lenses used with bellows or extension tubes will cope with most subjects. The 100mm lens is useful when you want to increase your shooting distance, to make room for adequate lighting, perhaps. Or you might consider a 28–30mm lens instead of the 50mm. Many lenses of this focal length can focus as close as 15cm or less without tubes or bellows.

Converters and zooms

If you feel that you really should have a third lens, give some thought first to the acquisition of a good tele-converter (see page 60). Your 35mm and 135mm, for example, can become a 70mm (very useful for portraits) and a 270mm. It is as well to bear this in mind when choosing your original two lenses and, if you feel that you might buy a tele-converter, avoid choosing two lenses in a 1:2 ratio, such as 50mm and 100mm or 100mm and 200mm.

Naturally, you can combine your two or more lenses into one by buying a zoom lens. Modern zoom lenses are generally of good quality but they do tend to be rather expensive and it is possible that you might obtain better results with two lenses at no greater cost.

Carrying the equipment

Your outfit so far might, then, consist of your Praktica camera, an exposure meter, a filter or two, two lenses and perhaps a

tele-converter. That is plenty, if your choice has been well made, to cover practically any subject you are likely to encounter. It is also quite enough to carry around with you. There is no harm in emphasising at this stage that such an outfit is by no means necessary. You will eventually find that 75–90% of your photography is done with one lens. For most of the time, the rest of your equipment is so much dead weight.

It is also cumbersome. So, if you have indeed purchased all or most of these items, you will find a gadget bag or camera case essential. You have a choice of the shoulder-strap-carrying, leather, compartmented bag or the fitted case (see page 187). Make sure that it has room for everything and perhaps a little extra for holidays. If money is no object you can buy a smaller type for everyday use and a large bag or case for carrying on long trips away from home.

Other accessories

There are still many more items you can add to your collection of equipment (see pages 174–187). It is always useful to have a cable release in your bag. Some people would never dream of travelling anywhere without a small flashgun. The serious worker may want a bigger flash unit or a collection of lamps and reflectors. The copying stand is invaluable for some types of work, not to mention bellows, tubes, focusing slide, microscope adaptor and so on.

Equipment worship so easily becomes a fetish, however. Make sure that you really need the equipment before you buy it. If you do buy it, find out just what it can do and use it with the idea of getting the maximum value from it. If it is mechanical, it may deteriorate rapidly if left unused. This applies in particular to the Praktica camera itself. It is intended to be used. Do not worry, as so many do, about whether the shutter should be left untensioned or tensioned when the camera is out of use. Do not leave it out of use. Keep using it. Otherwise it will deteriorate—tensioned or untensioned.

Reasonable care of equipment

Your Praktica is a robust camera and it will withstand the knocks and bumps of everyday wear and tear. Nevertheless, you should take care not to subject it to unnecessarily harmful treatment or conditions. The shutter blinds of some models, for example, are rubberised fabric and it would be unwise to

leave the camera for prolonged periods in direct hot sunshine, especially if the lens is removed. Excessive heat can make the blinds tacky and cause shutter troubles.

If you put the camera down while you rest in the open air somewhere, make sure it is in the shade, cover it with your coat or put it in a bag. The ever-ready case gives useful protection on such occasions and in many other conditions. Similarly, you should never put your Praktica down in the sand while you sunbathe or wait for pictures at the seaside. Somebody will surely kick the sand up nearby and sand finds its way through anything. Once it gets into your camera you may be faced with a major overhaul operation that could cost a lot of money. It is a wise precaution to carry a plastic bag with you in sandy areas and put the camera in it when you are not using it—even if it is in an ever-ready case and a gadget bag.

Dealing with dust
Plastic bags are, in fact, invaluable accessories for any photographer. Dust is ever present, but it is best kept out of cameras and off of lenses. Gadget bags keep out the worst of it but tend to collect their own quota in time and are not cleaned out as often as they should be. Lenses can be conveniently stored in their individual bags inside the gadget bag. Lens cases are available but they add weight and are not particularly efficient at keeping dust out.

Cases, gadget bags, cameras, lenses and all other items of equipment should be dusted occasionally, but do not make a fetish of it. Soft brushes, "puffers" and lens cleaning tissues are sold for these purposes. Use them gingerly to blow and gently brush the dust from the mirror, the inside of the camera body, lens surfaces, and so on. If you take care of your camera and keep your cases and gadget bags clean, this treatment should be necessary only very occasionally. You do not need to inspect your equipment anxiously for every spot of dust every time you unload the camera. You should not dust the mirror and lens off for every exposure. You might even stir up the dust and deposit it on the film just before you expose it. Lens, mirror, viewfinder, etc., can accommodate quite a lot of dust without any noticeable effect on the image—but it needs only a few specks of dust on the film to produce ugly black spots on your prints that are not easy to remove.

227

More drastic treatment

Anything more than the removal of dust should be approached with extreme caution. The optical glass from which lenses are made is easily scratched. Mirrors are surface silvered and can also be damaged by too vigorous cleaning. Lens tissues, for example, are not intended to be wrapped around a finger and scrubbed over the lens surface. They should be folded and used rather like a brush, with no direct pressure behind the part touching the lens. They can be moistened slightly to remove smears and may be used with a mere touch of spirit such as turpentine substitute to remove fingermarks. Too much cleaning of lenses inevitably puts a fine pattern of scratches on the surface that will eventually affect the crispness and contrast of the image.

If you should be so careless (or have the misfortune) to have your lens splashed with sea water, you *have* to take more drastic action. Salt is extremely corrosive and must be removed from the camera quickly. So, unload the film, and wash off the lens surface with clean, fresh water as soon as possible. If the camera has been dropped into the sea, wash the outside completely, but keep the lens on while doing so. Dry it with a clean rag, being careful not to rub the lens surface. Then take the lens off and blot off moisture on the inside with paper tissues. When all that is done, send the camera back to the Pentacon agents or to a qualified camera repairer as soon as you can. It will need thorough cleaning, probably involving some dismantling and reassembly, and regreasing.

When you store your equipment at home, avoid undue heat or humidity. If you have a darkroom, do not store the camera, lenses or other optical equipment there unless you have a cupboard with a close-fitting door or can store each item in sealed plastic bags. The fixer you use in the darkroom is a chemical that can do considerable damage to optical glass and it is always possible that you will leave splashes of it to dry, crystallise out and cause minute particles to float around in the air.

Never dismantle it!

Camera care is really a matter of common sense. Take care of the camera as you would any item of value, but do not spend all your time protecting it and cleaning it. *Never* attempt to

dismantle any part of it, or to oil it. If any part becomes stiff, such as the lens focusing movement, take it to a qualified mechanic. These mechanisms use a special grease and any attempt on your part to add oil will probably wash out the grease and make matters far worse.

It is quite easy to dismantle the Praktica body and the lenses. It is by no means so simple to put them back together again. Lenses are commonly assembled with multi-start threads and it is only too easy to reassemble them incorrectly and to make the lens completely useless.

Similarly, the shutter mechanism is complicated and easily maladjusted. The shutter blinds of the later models are made of extremely thin metal and clumsy handling could bend them and necessitate a costly repair.

When you attach lenses, screw them in carefully and do not over-tighten. The screwing in comes to a positive stop when the rear plate of the lens meets the flange on the camera body. Over-tightening does not affect the position of the lens but can damage the threads. Make sure, too, that the lens you are attaching is designed for use on the Praktica. If the thread is even slightly stiff, it is damaged or you have the wrong type of lens. *Never* force a lens into the body thread. You may damage that thread and make it unable to accept any other lens. It may seem incredible but there have been many cases of unsuitable lenses being forced into cameras so hard that they have cut their own threads in the camera flange.

Storage and working conditions

Whether you have a permanent darkroom or store your equipment elsewhere make sure that the storage place is not damp. Chemicals, films and paper are extremely susceptible to moisture and, once they become damp, the results they provide can become quite unpredictable. The metal parts of your equipment will not take kindly to moisture either. Keep as much of your equipment as possible in plastic bags to keep out both moisture and flying chemical dust.

If you do your own processing and/or printing, wash your tank, measures, dishes, tongs, etc., immediately after use. If you leave traces of fixer in a dish and use that dish next time for the developer, the resulting prints are distinctly substandard. Dishes become stained in time and a certain amount of staining does no harm. Do not scrub the stains from plastic

229

dishes with abrasive scouring powders or pads. You destroy whatever surface there may be and the dish stains that much more quickly next time. Diluted household bleach is effective or you can use the special cleaners produced for plastic crockery, dentures, etc.

Keep your storage space or darkroom as dust-free as possible and, if you have an enlarger, cover it when it is not in use. Again, a large plastic bag gives perfect protection. An enlarger presents some fairly large surfaces for the collection of dust but the last thing you want to do is to clear that dust just before you start printing; some of it will inevitably float about in the air and settle on film, paper, cover glasses, etc., at just the wrong moment.

PROCESSING YOUR FILMS

The home processing of colour film is for enthusiasts only. It is not a difficult procedure but it is a time-consuming, rather boring activity and not totally reliable. One of the most widely used colour films, moreover, cannot be home processed. If you feel that you must have everything under your own control, there are official processing kits available and it is wise to stick to them. Various substitute formulae have been devised and are generally satisfactory, but you have to be constantly on your guard against minor changes in emulsion chemistry that the manufacturers are in no way obliged to publicise.

The processing of black-and-white films is an entirely different matter. It is simple, almost automatic when you are familiar with the behaviour of your selected films and developers and occupies very little of your time. Even if you do not make your own prints (a much more skilled operation) it is worth learning to develop your films. There will often be occasions when you want to make sure as soon as possible that you have the type of result you were seeking and that the camera functioned properly. You can then select the negatives that you want to have printed and send or take them to the processing lab without delay. It is a rather wasteful procedure to have the film developed by the lab and enprints made from every negative.

Processing your own films calls for a limited amount of special equipment. The 35mm film you use in your Praktica comes in rather unwieldy lengths: the 36-exposure film is more than 5ft long and the method we used years ago of see-sawing the film through a dish would be impracticable. It would, in fact, be even more impracticable by virtue of the fact that modern films are panchromatic. They are sensitive to light of all colours and have to be processed in total darkness.

Types of developing tank
Thus, the first requirement is a light-tight container that will hold the film and the processing solutions. Such a container is

known as a developing tank and is now in most cases a cylindrical tank with a removable lid. Inside the tank is a removable "spiral" rather like a film spool with oversize flanges. The flanges have a continuous groove from outside edge to middle or, in stainless steel models, consist of a flat spiral of steel wire. The film is pushed into the begining of the groove on the outer edge of plastic models and fed through to the middle, usually by a slight to-and-fro twisting action of the two flanges. The stainless steel spirals are rigid, one-piece constructions, and the film is first pushed in to the core (and sometimes secured there by a clip) and fed back to the outer edge of the spiral by pressing lightly on the edges of the film so that it bows enough to slip between the coils. Thus, the five-foot length of film can be accommodated in a tank measuring no more than $3\frac{1}{4}$in dia. and height and holding only about 250ml of solution.

The film has to be loaded into the tank in total darkness, but once the spiral is in the tank and the lid is replaced, all work can be carried out in normal lighting. The tank is totally light-tight but has a specially constructed opening in the lid through which liquids can be poured in or out.

Developing the film

With the film in the tank, the next step is to pour in the developer (see page 236). This calls for two more items of equipment. First, a graduated flask into which to pour the correct amount of solution. It is advisable, in fact, to buy two —one for the fixer (see page 237). Secondly, a thermometer. The developer has to be allowed to act on the film for a length of time that depends on the temperature of the solution, and special short-scale photographic thermometers are available at quite reasonable prices. The recommended temperature is generally 20°C (68°F) but it can be varied within limits if circumstances make higher or lower temperatures necessary.

Once the temperature is established, you pour the developer into the tank as quickly as possible in a steady stream and take a note of the time at which you start pouring. A watch with an easily visible seconds hand is adequate as a timer but you can use a special timer if you prefer it. As soon as the developer is in the tank, replace the small cap that now generally covers the pouring aperture and invert the tank. Hold it upside down for a second or two and then return it to the upright position.

232

FILM PROCESSING

Essential equipment for processing black-and-white film consists of no more than a developing tank, two storage bottles, measuring flask and a photographic thermometer.

The first step is to load the film into the tank in total darkness. The correct quantity of developer at the recommended temperature is then poured into the tank, noting the time or setting a timer.

The tank is inverted several times for half a minute or so to ensure even wetting of the film. Agitation by inversion for 5 or 10 seconds is repeated at one-minute intervals.

At the end of the development time the developer is poured out and the tank is filled with clean water and emptied to rinse the alkali based developer from the film. This prolongs the life of the fixer.

Fixer is poured in and the tank again agitated once or twice. The fixer is poured out after the recommended time and the tank placed under running water to wash the remaining chemicals from the film. After about half an hour's washing, the film is hung up to dry in a dust-free atmosphere.

Repeat the process for at least half a minute and then at the end of each subsequent minute invert the tank two or three times.

Importance of agitation

This procedure is known as agitation and is essential for two reasons. First, if the tank is left undisturbed, the developer quickly becomes exhausted where it does most work—in the immediate vicinity of the emulsion surface. Owing to the very closely spaced spirals of film, the used developer cannot diffuse rapidly into the fresher solution farther from the film and various unpredictable results can occur, such as uneven development and the formation of shadow-like lines between areas of different tone. Secondly, the times and temperatures recommended by manufacturers of films and developers allow for agitation in the manner described. If the solution is not agitated or is agitated in a significantly different manner, the time of development has to be adjusted to obtain the same densities of image on the film.

Fixing the image

At the end of the recommended development time, pour the developer out of the tank as rapidly as possible—either down the sink or back into the bottle for re-use (see page 236). Refill the tank with clean water, preferably but by no means essentially, at the same temperature as the developer. Invert the tank once or twice and pour the water away. Refill the tank with fixing solution (see page 237), the temperature of which should be around 16–21°C (60–70°F). Agitate initially as for development but subsequent agitation is not necessary. When fixing is complete (the instructions with the fixer will state the time required) pour the fixer back into the storage bottle for re-use.

Washing out the impurities

The film is then fully developed and is no longer sensitive to light, but it contains in the emulsion certain silver salt compounds that can deteriorate in time. These have, however, been made soluble by the fixing solution and can be washed out of the emulsion with clean water. The simplest method is to place the tank, with the lid removed, under the cold water tap and let the water run for about half an hour. Some workers

hold that this method does not promote efficient washing and, if you prefer it, you can use one of the commercial siphon or similar methods on the market or even a hypo-eliminating solution. Despite the theory, however, the under-the-tap system is unlikely to give you any trouble, especially if you empty the tank two or three times during the wash.

Similarly, there are gloomy stories about the reticulation that your film will suffer if the rinse between developer and fix is not at the same temperature as those solutions. Reticulation is, indeed, said to be caused by rapid contraction of the gelatine after expansion, but the expansion generally has to be rather more rapid than is induced by a temperature of 20°C. Reticulation, if you do run across it, can be recognised as an irregular patterning of very fine lines in a sort of mosaic form. It is often barely visible in the negative but, naturally, becomes extremely prominent on an enlarged print.

Drying and storage

When washing is complete, remove the film carefully from the spiral, and hang it up to dry in a dust-free atmosphere—or as dust-free as possible. Some prefer to accelerate drying by wiping excess moisture from the film with specially designed squeegee tongs or by passing the film between two moistened fingers. It is not advisable to force dry by using fan heaters, hair dryers, etc., which are more inclined to blow dust, fluff, etc., on to the film. When dry, the film can be cut into strips of four, five or six exposures according to the method of storage you adopt. Various envelopes, binders, and filing systems are available from photo dealers. The film should not be kept in its original length to be unrolled and rolled up again when prints are made. That will almost certainly promote scratches and abrasion marks on the negative that make the production of clean prints almost impossible.

Your 35 films must always be handled with extreme care both before and after exposure. The image has to be enlarged quite considerably to make a worthwhile print and the slightest blemish then becomes clearly visible.

The development process is thus quite simple and the equipment required is confined to the tank, a thermometer, two graduated flasks and two or three storage bottles of about 600cc capacity. You can also obtain specially designed film clips for hanging the film up to dry. There should be a clip

at top and bottom because the film will tend to curl if it is not weighted at the bottom and moisture will collect in the curled-up part.

Choosing the developer

The choice of developing solutions is wide. The major film manufacturers and various independent chemical manufacturers make several versions each. For general work, however, your choice of developer *type* can be narrowed down to the standard MQ type or the acutance or high definition type.

The standard MQ developer is one in which the developer substances are metol and hydroquinone. In practice, most so-called MQ developers are now really PQ because Phenidone (an Ilford product) has largely replaced metol. Phenidone can be used in smaller quantities, allowing the formulation of concentrated solutions, it is cleaner working, does not discolour badly with oxidation (attraction of oxygen from the air) and is less likely to attack tender skins.

The standard MQ or PQ developer (Kodak's D76 and Ilford's ID11 are the traditional types) is perfectly suitable for all general photography, giving good clean negatives with adequate contrast and acceptable grain size (i.e., the image can be enlarged appreciably before its granular structure becomes objectionally apparent).

In recent years, some workers have forsaken their old MQ formulae for newly-introduced so-called acutance developers. The reasoning behind this change is that sharpness of the image in photographic prints is largely subjective. A print can look sharper if it has distinct boundaries between adjacent tones rather than the more usual almost imperceptible blending of one tone into another. The acutance developer is designed to enhance this edge effect when used with suitable films (usually of slow or medium speed) and first-class lenses.

You can make your choice between these two types of developer. The brand you use is largely immaterial. There is little to choose between the reputable makes, but you will eventually find the one you prefer and will be sure that there is no other to beat it. Just ask your dealer for a film developer of the MQ or acutance type, whichever you prefer and he will advise you what makes are available.

A factor that might influence your choice is that some developers are supplied in powder form to be made up into

a solution and others are in concentrated solution to be heavily diluted for use. The concentrated solutions are usually of the use-once-and-throw-away type and that is undoubtedly a great convenience. You then need no developer storage bottle and have no problems about loss of energy in used developer.

Choosing the fixer

The choice of fixers is limited to two basic types—normal and rapid. The normal developer is based on sodium thiosulphate (popularly known as hypo) and fixes a film in 10 min. The rapid type is based on ammonium thiosulphate and fixes films in about 90 sec. Both usually contain a hardener to protect the emulsion against damage and are acidified to neutralise the developer immediately. It is often recommended, however, that the plain water rinse between developer and fixer be replaced by an acid stop bath (such as 2 per cent acetic acid). This arrests development immediately and extends fixer life by preventing carry-over of alkali to the fixing bath.

Development standards

The extent to which you develop your films is partly a matter of preference. If you intend to have your prints made commercially you should expose and develop entirely in accordance with the manufacturer's instructions. If you make your own prints, you may find that you prefer to work from negatives either less or more dense than those recommendations provide. Similarly, some subjects may call for non-standard treatment. A contrasty subject, for example, can sometimes be improved by a generous exposure to obtain detail in the shadows and restrained development (cut by one-third or more) to prevent the highlights blocking up.

MAKING YOUR OWN PRINTS

If you use your Praktica solely to produce colour slides, you are missing a great deal. Colour photography is by no means the purely mechanical process its detractors sometimes call it, but it does not offer the average worker the scope and control afforded by black and white. In most cases, the picture exists without the colour, which merely adds a further dimension. Sometimes, in fact, colour can add nothing at all: the picture depends entirely on form, shape and lighting.

For most workers, too, creation begins and ends in the camera. There is no opportunity to modify the effect on the film by suitable treatment in the processing or printing. Such treatment of colour slide film can be extremely expensive.

Printing equipment

Making prints from your Praktica black-and-white films inevitably means enlarging because the negative measures only 24×36mm and a print of that size is of no use to anybody. So you need a certain amount of equipment. Apart from the enlarger itself, you must have dishes in which to process the paper on which you make the prints and, preferably, a masking frame to hold the paper flat on the enlarger baseboard while you expose it to light directed through the negative. You need chemicals, too, of course—a paper developer and a fixer, which is the same as you use for the film but in a weaker solution.

Useful, but not essential, items of equipment are a timer to regulate the enlarger exposure, a focus-finder, print tongs to keep your fingers out of the solutions and a drying or glazing-and-drying press.

It is also essential, of course, that you work in a room or other area that can be made completely dark. "Completely" need not be translated too literally. Tiny chinks of light will do no harm provided they do not allow the light to fall directly on your photographic paper. You cannot work in complete

darkness so you have to illuminate the room with light that will have no effect on the paper. The usual item is a safelight, generally consisting of a box-shaped container holding a 15–25W bulb behind a safelight filter of light brown colouring. Safelights come in various sizes but the 7 × 5in size is suitable for most small darkrooms.

Enlargers and lenses

Your choice of enlarger is largely a personal matter. Most makes on the market are adequate and, generally speaking, you get what you pay for. The higher-priced models are likely to be more carefully engineered, longer lasting and better finished. The essentials are absolute parallelism between negative carrier and baseboard; sturdy, rigid column on which the lamphouse rides; smooth, securely locking movement up and down the column and positive fine-focusing lens movement that will not slip when released.

The height of the column governs the size of enlargement that can be made, although it is generally possible to swivel the lamphouse through 180° to project the image on to the floor or some other surface below workbench level. It is more convenient, however, to have a reasonable column height and large baseboard.

No matter how good the enlarger, the quality of your prints depends ultimately on the performance of the lens. Enlargers are frequently sold without a lens so that you can choose your own lens from the large selection available. There are reasonably cheap lenses of good quality, but the really high-performance lens can cost a lot more than the enlarger itself. You should pay as much as you can afford. The Praktica lenses are of high quality and it is rather wasteful to make your enlargements with a lens that cannot do justice to the quality of the camera lens. Do *not* use your camera lens for enlarging. It is designed to do a very different job and it is quite unusual for a camera lens, however good, to perform well as an enlarger lens, unless you do not ask very much of it.

The focal length of your enlarger lens should be 50mm or 2in. A lens of shorter focal length may not cover the negative completely, i.e., it may produce prints with dark corners. A lens of longer focal length needs a greater projection distance and thus limits the size of print that you can make.

Dishes, paper and chemicals

In addition to the enlarger, you need three dishes, one for the developer, the second for plain water and the third for fixer. Do not stint the solutions when you fill these dishes. You need enough to keep the print fully submerged during processing without having to hold it down all the time. Similarly, buy dishes large enough to take the largest print you expect to make and deep enough to hold a reasonable amount of solution. Dishes of only half to three-quarter inch depth are not very useful. If you expect to make a lot of very large prints (15 × 12in or 20 × 16in) and therefore buy dishes of that size you will also need to buy a set of smaller ones for when you make smaller prints, unless you are prepared to use an unnecessarily large amount of fixer and developer.

Which brand of developer and fixer you use is largely immaterial. Your dealer will supply you with a bromide paper developer (your printing paper is known as bromide paper) and you can confidently take any brand he recommends. You may prefer a concentrated liquid that you dilute for use or a packet of powders that you have to dissolve in water. The same applies to the fixer. In each case, full instructions for dilution and working strengths are contained on or in the package.

You can take your dealer's advice on printing paper, too, but you have to tell him what size you want and he will probably ask you what surface and grade. Bromide papers are made with various surface finishes (lustre, velvet stipple, matt, etc.), but you would be well advised to start with glossy paper. The sizes generally available are quarter plate ($3\frac{1}{4} \times 4\frac{1}{4}$in), half plate ($4\frac{3}{4} \times 6\frac{1}{2}$in), whole plate ($6\frac{1}{2} \times 8\frac{1}{2}$in), 8 × 10in, 10 × 12in, 12 × 15in and 16 × 20in. A useful small print size that almost fits the proportions of the 35mm negative is half of half plate, but you can, of course, print to any size you like and you will certainly want larger prints than that at least occasionally. When buying paper, remember that it is cheaper to buy the larger sizes and cut it down to the size you require.

The grade of bromide paper is the degree of contrast it provides. It is usually expressed by numbers from 0 or 1 to 5 or 6. The normal grade, which is what you should buy to start with, is No. 2 or 3, depending on make; the lower numbers give less contrast and are known as soft, while the higher numbers give higher contrast and are known as hard.

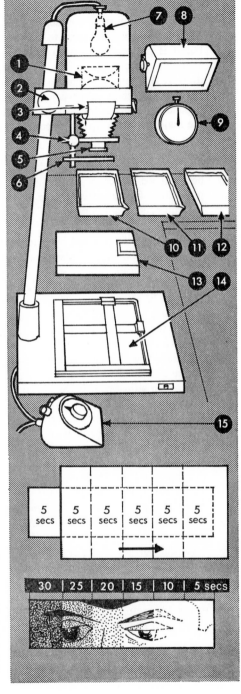

The enlarger and its darkroom accessories are as follows:

1. Condensers
2. Locking knob for housing movement
3. Negative carrier
4. Fine focusing control
5. Lens
6. Swing filter
7. Opal lamp
8. Wall-mounting safe-light
9. Clock or minute timer
10. Developer
11. Water rinse or stop bath
12. Fixer
13. Printing paper
14. Masking frame
15. Enlarger exposure timer

The best method of determining the printing exposure is to make a test strip. A reasonably sized piece of paper is given a series of exposures of different durations. After full processing, the strip is examined in white light to determine the exposure which provides the best result.

The paper must, of course, be kept in a dark place until it is used. Most workers seem to keep it in the original wrapping but it is preferable to use a "paper safe" (various types are available commercially) or a specially constructed light-tight drawer. A luxury addition to such a drawer is a switch that puts out the white light whenever the drawer is opened. That depends on your having a darkroom, of course. Otherwise, join the majority and keep the paper in its original wrapping.

Using the enlarger

We cannot deal completely with the technique of enlarging here but we can cover the main points. Enlarging entails the projection of the negative image on to photographic paper and the subsequent development of the image so formed on the paper.

The image is projected by placing the required negative in the negative carrier and inserting the carrier into its place in the enlarger head. When the white light is switched off and the enlarger lamp switched on the image is projected on to the enlarger baseboard, on which you have placed the masking frame or a white card for composition and focusing purposes.

You set your masking frame to the size of print you intend to make and raise or lower the enlarger head until the part of the image you require (you can use all or part of the negative) can be contained within the masking frame borders. This is a first rough adjustment because you then use the fine focusing adjustment on the enlarger to focus the image sharply and that has some effect on the size of the image.

You focus the image with the enlarger lens set to full aperture because it gives its brightest image and least depth of field at that setting. This is the same principle as focusing the image on the Praktica viewfinder screen (see page 86). There are various models of focus finder that provide an enlarged view of part of the projected image to facilitate accurate focusing. They are useful if the negative is rather dense or if your eyesight is not all it should be. Always focus a central portion of the image and, if your focus finder is a powerful enough magnifier, focus the grain rather than a detail of the image. If the grain is sharp, the image must be sharp. Many workers who pride themselves on their grainless enlargements are simply not focusing sharply.

So, with negative focused, paper to hand and dishes filled,

you are ready to print. First, you have to find out what exposure to give the paper, i.e., how long to leave the enlarger light switched on and at what aperture of the lens. Most enlarger lenses give their best performance at about two stops down from maximum aperture so it is best to start there. The best way to determine the exposure time required at that aperture is to produce a test strip.

Making a test strip

Making sure that the white light is switched off, cut a piece of the paper on which you intend to print to a width of about $1\frac{1}{2}$–2in. Lay it on the baseboard in such a position that it can reproduce as many different tones as possible from the negative. The idea now is to expose the paper in strips, each strip taking in as many tones as possible but receiving different exposures. This you achieve by holding an opaque card close to the strip of bromide paper and covering all except, say, a third of it as you switch the enlarger lamp on. After, say, 5 sec, move the card back to uncover another third of the paper. After a further 5 sec, move the card back again to uncover all the paper. After a final 5 sec, switch off the lamp. The result is a piece of paper with strip exposures of 5, 10, and 15 sec and, if you are lucky, one of those exposures will be right. After processing (see below) it will contain detail in each tone in which there is detail in the negative and a full black where the negative is completely empty of density, if there is such an area in the negative.

At first, you will not easily recognise the correct exposure, especially by the light of the safelight. You will tend to print too lightly and not obtain the full range of tones of which the paper is capable. This is particularly likely to be so if you base your judgment on the prints provided by the average commercial processing house. You should seize every opportunity to see prints produced by accomplished workers.

Developing the print

Apart from exposure, print quality depends on correct development. After exposing the paper you place it in the developer and leave it there for at least two minutes. The easiest way to get the print into the solution quickly is to tip the dish slightly away from you and slide the print into the solution face down-

wards as you lower the edge of the dish. The reason for inserting the paper upside down is that it tends to curl inward toward the emulsion and, as you attempt to flood the solution quickly over it, it lifts upward and floats. Do not leave the paper upside down, however. As soon as you have lowered the edge of the dish turn the paper over (preferably using print tongs) and gently prod it in each corner until it remains submerged. It can then be left until the end of development time.

Never develop the paper for less than two minutes unless you are using one of the special chlorobromide papers designed to give a warmer black tone. These are usually developed for only $1\frac{1}{2}$ min. Longer development causes them to lose their warm tone characteristics.

At the end of the development time, lift the paper from the developer and hold it up by one edge to allow excess developer to drain back into the dish. Transfer it to the water dish, submerge it and rock the dish for a few seconds. Remember to *drop* the print into the water rinse. Do not allow the developer tongs to enter the water, because the tongs you use for the fixer *do* enter this dish and it needs only minute amounts of fixer to enter the developer to ruin the quality of your prints. After rinsing, transfer the print to the fixer bath by means of another pair of tongs and make sure that it is totally submerged. At the end of the fixing time (which depends on the type of fixer), the print is finished and is no longer sensitive to light.

Thus, if the print is a test strip it can be quickly rinsed and examined at this stage. Make sure that you examine it under strong white light. A yellowish light can make the print look darker than it really is.

Washing and drying

The test strip need not be fully washed but the prints you intend to keep have to be washed in running water for at least 40 min. If you have no running water in your darkroom, place the fixed prints in a large bowl, bucket, etc., full of water and wash them all together at the end of your printing session.

As with film washing, you will find that placing the prints in a large dish and allowing the cold water tap to run into it provides adequate washing if you move the prints around occasionally and make sure that they do not stick together.

Drying after washing can be accomplished in various ways.

ENLARGING PROCEDURE

The negative to be printed is inserted in the negative carrier. The required portion of the negative image is focused on the masking frame surface by raising the head to the required level and operating the fine focusing control.

The timer is set to the exposure determined by the test strip.

Printing paper is inserted in the masking frame and the enlarger lamp switched on.

At the end of the exposure time, the lamp is switched off (if not wired to the timer) and the paper placed in the developing solution.

After the recommended time in the developer, the paper is transferred to the rinse or stop bath and then to the fixer.

Fixing is followed by thorough washing in running water and drying on a clean fluffless surface.

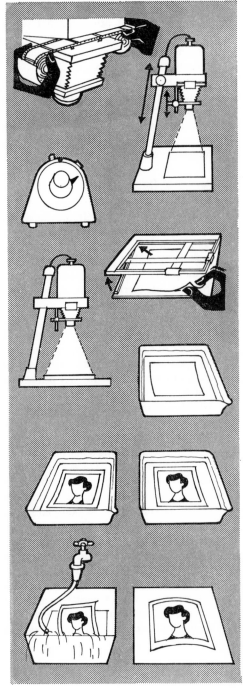

You can lay the prints out flat on fluffless towels, you can place them between sheets of photographic blotting paper, you can hang them from lines with clothes pegs or you can use a drying and glazing machine.

If you do not use a machine, the prints usually curl strongly as they dry. The curl can be removed, however, by passing the print, face upward, over the edge of a table, bending sharply downwards. Make sure that you flatten the print as it passes over the edge of the table or you may put an irremovable crease into it.

Glazing the print

Glossy papers can be glazed, either straight from the wash water or after drying. If they have been dried, soak them in clean water for at least 5 min. The glazing surface can be almost anything with a very high polish. Glazing machines use metal plates, but you can use glass, plastic, Perspex, etc. The principle is simply that when the slightly softened gelatine is pressed into perfect contact with the glazing surface it will take on its high polish.

Whatever glazing surface you use, make sure that it is perfectly clean before you start operations. It should be thoroughly washed in soap and water, detergent, washing-up liquid, etc., and as thoroughly rinsed to remove all grease, fingermarks, dust and so on. Take the wet print, drain off excess water and lower it on to the glazing plate, middle first and ends afterwards. Using a roller or flat squeegee, press the paper into contact with the plate, working from the middle outward, so that excess water is squeezed out around the edges.

If you are not using a machine, place the glazing plate where it can dry naturally. Do not apply heat. With luck the print will fall off the plate with a perfect glaze as it dries. Unfortunately, this largely *is* a matter of luck when you use glass. Glass probably gives the best glaze but prints have a stubborn tendency to stick to it. There are glazing solutions you can use to discourage this tendency but even they are not always successful. If you *do* find a sheet of glass that prints do not stick to, treat it like gold dust.

The glazing machine generally consists of a shallow, box-like structure with a curved metal top containing an electric heating element. The glazing sheet, which is flexible, is placed on top and a cloth drawn across it under tension to hold the

prints on the plate and the plate on the machine. Drying and glazing is accomplished in a few minutes.

Glazing plates, whatever they are made of, must be treated very carefully and protected against the slightest scratch or other abrasion. Unless they have a faultless surface, they cannot give a faultless glaze.

Holding back and burning in

Not all negatives are so perfect that printing becomes a simple matter of one overall exposure of the paper. That is the standard to aim at in exposing the film, of course, but it is not always attainable. Sometimes the negative is so contrasty for instance that a single exposure of the paper either blocks up the shadows to get detail into the highlights or leaves the highlights empty in order to retain detail in the shadows.

Changing to a softer grade of paper may be all that is necessary but frequently the trouble occurs only in a small highlight or shadow area. The softer grade of paper might cause a loss of brilliance in the print as a whole in such cases, so the preferred remedy is to give more or less exposure to the small unsatisfactory areas. This you do by interrupting the light beam from the enlarger lens to "hold back" the shadow areas or "burn in" the highlights.

There might, for example, be a rectangular notice board or poster within the picture area that reproduces as stark white with an exposure that brings out all the other tones satisfactorily. The remedy is to give this area extra exposure after the normal exposure is completed. The easiest way to do that is to tear a hole of similar proportions to the area to be burned in from a sheet of stiff black paper or thin card. You hold the card under the lens in such a position that only the required area receives light when you switch the enlarger lamp on. You should keep the card moving slightly during the extra exposure so that the edges of the hole are not sharply reproduced. If the surrounding area is light-toned the hole in the card has to be carefully shaped and the card kept moving only very slightly during the exposure. Otherwise, the burned in area will be surrounded by a dark "halo".

The opposite procedure is to tear a small piece of paper or card roughly to the shape of an area requiring less exposure, such as an underlit face that prints too dark. Attach the piece of card to a thin wire and hold it between lens and baseboard

to prevent light reaching the underlit area for part of the exposure time. Again keep the card and wire moving slightly to soften the edges and prevent the shadow cast by the wire affecting the print.

When either holding back or burning in keep the masking card or paper nearer the lens than the baseboard. If you take it too close to the baseboard, its edges will inevitably be reproduced too sharply.

Making colour prints

You can, of course, produce colour prints if you use colour negative film. The process is much more complicated than with black-and-white but, contrary to popular belief, it is well within the scope of the amateur. To be able to reproduce your results accurately, i.e., to produce exactly the same colours in prints from the same negative in different printing sessions, you need elaborate control mechanisms. Normally, however, you are merely concerned with obtaining a pleasing result from a particular negative and, if you wish to print the same negative at a later date, you are quite prepared to start all over again and make such modifications as the conditions then demand.

Colour printing paper has three emulsion layers, just like colour film. You expose them, either one at a time through separate red, green and blue filters or all at once through a combination of two filters selected from a magenta, cyan and yellow set. The first is the additive method, the second the subtractive or "white light" process. An ordinary enlarger is suitable for the additive process because the filters can be held below the lens. The subtractive process, however, demands a colour head on the enlarger which, in its simplest form, entails only the addition of a filter drawer—a sliding tray in which the filters are placed between the lamp and the negative.

Exposure is complicated by the fact that both density and colour have to be balanced in all three layers and slight errors of exposure or filter selection can lead to extraordinary colour effects. Making test strips can be quite a lengthy procedure.

Processing is not a simple develop-fix process. Several solutions are required and, as the paper is fully panchromatic (sensitive to light of all colours), you have to work in complete darkness. Mechanical aids of varying complexity and price are available to reduce the processing time.

PROJECTING YOUR SLIDES

If you take many colour slides you will sooner or later want to see them at their best—and that means buying a projector. You cannot appreciate 35mm slides by viewing them in the hand and, although hand or table viewers give a better impression of their quality, there is nothing to compare with the really large, brilliant picture obtained on a screen that you can comfortably view from 6ft and more.

Slide projector models

The slide projector is basically a comparatively simple instrument but there are innumerable models on the market ranging from the relatively inexpensive to the really costly. The simplest type consists of little more than a lamp, condenser, lens and slide holder in a functional but not very attractive housing. The slide holder can generally be moved from side to side and has openings for two slides so that as one is slid behind the lens, the other can be extracted and another put in its place. So, with a to and fro action of the holder, you can run rapidly through a pile of slides placed at the side of the projector.

The constant insertion and extraction of slides is a little tiresome, so improved models use a magazine taking 36 or more slides with a push-pull mechanism that places a slide in position for projection at each push and extracts it and moves the magazine forward (normally at the side of the projector) at each pull. The magazine generally has a toothed track driven by a cog in the push-pull mechanism, but the arrangements are not standard and you have to ensure that you obtain the correct magazine for your model of projector.

There are other projectors that do not use magazines but select their slides from a stack. That eliminates the necessity for loading the magazines but is no advantage to those who use the magazines as storage boxes. As the magazines are not too expensive, this is a common practice, but special, even less

expensive, transfer boxes are available into which magazines can be emptied in one motion. These boxes have no track and cannot therefore be used as magazines.

There are also projectors with circular magazines, mounted either horizontally or vertically on the projector, taking 80–120 or more slides and allowing virtually continuous operation when the magazine is mechanised. This type is probably of greater interest to the publicity industry or those who habitually prepare slide shows necessitating large numbers of slides.

The mechanics of the illumination system of the projector need not concern you unduly. All you will normally have to do with it is to change the lamp when it burns out. If you use the projector frequently and especially if you move it about a great deal the lamp may not have a very long life and you should always keep a spare available. Setting up a slide show can sometimes be a rather protracted business and it is more than a little frustrating to have the lamp blow after the first slide.

The only operation you concern yourself with, apart from slide changing, is focusing. Most projector lenses are comparatively simple assemblies with no focusing movement in the mount. Focusing is effected by moving the lens forward and backward in the projector housing, often by a coarse screw thread. Sometimes you turn the lens itself to focus; sometimes there is a separate control on the projector housing; and sometimes there is a remote control facility for both slide changing and focusing from a distance. Thus, you can sit comfortably in an armchair behind or beside the projector and operate all controls except the initial loading at just the touch of a finger.

Slide mounting

The sharpness of the image on the screen is, of course, affected by how accurately you focus it. In most projectors, the focus also depends on the type of slide. If you have mixed card-mounted, glass-mounted and other slides, the emulsion is in slightly different planes each time and you have to refocus constantly. You would be wise, therefore, to standardise your mounting method. There are many methods available. The simplest is the card mount, such as that still used by Kodak. Card mounts can be purchased, consisting of a single piece of card scored across the middle, treated with pressure-sensitive

adhesive and with apertures cut on either side of the scoring of about $23 \times 35mm$ size. The single, cut frame is placed over one of the openings and the mount folded to bring the adhesive surfaces together.

There are plastic versions, often consisting of two separate pieces that clip together and can be pulled apart for re-use. Some include very thin cover glasses to protect the slide surface. Metal types are also supplied.

Some slide enthusiasts still believe in the principle of binding each slide between two pieces of glass with a black or silver paper or foil mask. The whole sandwich is tightly bound together with special paper tape, similar to passe-partout. Theoretically, this is the safest method, because it totally protects the slide from fingermarks, scratches, abrasions, etc. In practice, it is not easy to ensure that the slides, glasses, and marks are completely dry and clean before binding. If they are not, untold trouble can develop later.

The type of mounting you use is entirely a matter for your own choice, but it is advisable to standardise your method to facilitate focusing, magazine loading, storage and general handling of slides. Card mounts are adequate in most cases but if you can afford the plastic or metal versions, they are probably preferable for long-term ease of handling.

Image brightness

The brilliance of the image you obtain from slide projection depends on various factors: lens aperture or speed, projector-to-screen distance, screen surface, and efficiency of illumination system.

The lens aperture is generally about $f2.8$ with a focal length of 85mm, giving a screen image about 2ft 6in wide at 6ft projection distance or about 4ft 6in wide at 10ft. Zoom lenses are also available to enable the size of the image to be varied without altering the screen-to-projector distance.

The efficiency of the illumination system means largely the power of the lamp. Most projectors now use low voltage (12 or 24V) lamps with wattages varying from 50 to 300 and more. A transformer is built in to the projector to enable these lamps to be operated from domestic electricity supplies. Where projection is to be carried out in small rooms for audiences of only three or four, all sitting fairly close to the screen, the 50W lamp is adequate. The 300W lamp, on the other hand, is

essential if the show is semi-public and the projector "throw" is, say, 15ft or more. For most domestic uses, however, a 100 or 150W lamp is fully satisfactory.

Types of screen

The screen can be anything from an off-white crumpled sheet, through an emulsion-painted sheet of hardboard to a super-efficient commercial screen of exceptional reflectivity. It is to be hoped that you will not use a dirty sheet. You will probably not need the highly reflective screen either because it means that the image can be viewed only within a fairly narrow angle in front of the screen. At acute angles the image brilliance is considerably reduced.

The emulsion-painted wall or sheet of hardboard is, in fact, one of the most efficient screens you can use. It has high reflective value (provided you use a really white paint and keep it clean) and can be viewed from almost any angle without loss of brilliance.

If you have no convenient wall, however, or storage space for sheets of hardboard, one of the commercial roll-up screens is your best purchase. There are various types—hanging, tripod mounted, pull up from a box, and so on. The surface is generally a beaded or lenticular type with characteristics midway between the matt surface and the directional type. The viewing angle is wide enough for most rooms to be used fully to accommodate large family audiences.

Preparing for the show

When you project slides for other people to see, it is worth taking some trouble over the procedure. There are, for example, the obvious matters of ensuring that there are enough seats and that they all command an unobstructed view of the screen. The screen must be placed at the right height for comfortable viewing and the projector at a corresponding height to avoid having to tilt it unduly and thus present a misshapen picture. If you give frequent shows, it is worth investing in a projector table of the folding variety which affords a high, secure seating for the projector and, usually, a separate shelf or tray for slide magazines, notebook, etc. The alternative of using a pile of books on the dining-room table can have disastrous consequences.

If you have to run a long cable from the power supply to the

SLIDE PROJECTION

The simple projector has a push–pull mechanism for loading one slide at a time.

Box-form magazine-loading projectors allow 36 or more slides to be loaded into the projector and shown in rapid succession either by manual operation or remote control device that may also control focusing.

Bigger slide loads are carried in the "jumbo" projectors with rotary magazines that may be horizontally or vertically mounted. These, too, often have remote control facilities.

One popular method of slide mounting consists of a clip-together plastic mount, the film being sandwiched between the two parts. Many models include cover glasses for further protection of the film.

An alternative method is to place the film in a black or silver paper mask and to sandwich it between cover glasses.

Various forms of mounting jig are available to enable the glass-sandwich slide to be permanently secured with paper binding strips.

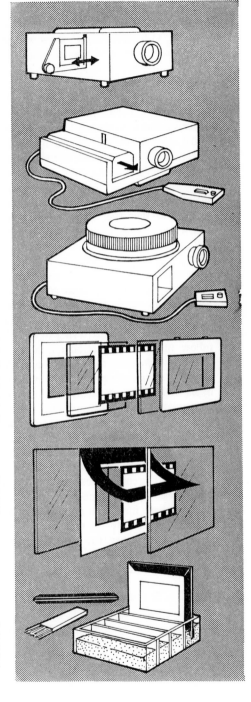

projector, make sure that it runs round the room edge as far as possible. Otherwise, somebody—probably yourself—is bound to trip over it at some stage and pull the projector off its table.

Make sure that sufficient light is available to enable you to attend to the projector and to cope with any sudden emergencies. While a slide is on the screen, the room looks quite reasonably lit, but if the lamp fails and the room light switch is not immediately to hand, you may stumble into trouble.

All these matters should be attended to before you seek the attention of your audience. If they are unavoidably in the same room while you make your preparations, persuade them to "talk among themselves" for a few minutes while you get the show ready. If you can prepare the show in a separate room, make sure that everything is in order, with the first slide focused and ready to project before you call your guests in.

Making the commentary

How you handle the actual projection depends on the type of audience, the pictures you are showing and your own character. You will inevitably say something about the pictures as they come up. In a proper presentation, that would be called the commentary. If you are trying to do the job properly, you can follow the rules of commentating but keep your remarks in character—your character. If you try the "As the sun sinks slowly in the west" approach you will probably be greeted with hoots of laughter or silently shaking shoulders—according to your relationships with your audience. On the other hand, if a shot of Johnny (whom everybody knows) paddling on the beach comes up and you say "That's Johnny paddling on the beach", you are wasting your breath and well on the way to boring your audience.

In such circumstances, you might more reasonably say "That was the first time he had seen the sea" or "We only stopped there for a few minutes on the way to Cornwall" to provide a lead-in to the next slide. It is pointless to tell your audience what they can see for themselves. Your remarks should be related to the picture or the occasion but should either add information or introduce the following picture.

Timing the show

It is never easy to decide how long to leave a picture on the screen. A single close-up with little detail rarely needs more

than 6–8 sec, whereas a group picture shown to a family audience may need a great deal longer to settle arguments about who is wearing what, where they bought it and how much it cost. Generally, however, 10–12 sec is the maximum screening time and it is better to err on the short rather than the long side.

How long should the whole show take? That is even more difficult. Ideally, no single collection of slides on one subject should take longer than about 10 min. After all, that means a minimum of 50 slides and probably nearer 70 or 80. On the other hand, it is hardly worth going through all the rigmarole of setting up and inviting an audience for a mere 10-minute show. So you should really have two collections to show at a time. With a short break between the two subjects to allow for chit-chat and adjustment to different ideas, the show would then occupy about 25 min, which is worthwhile and on the safe side of boredom.

Adding the finer touches

By the time you reach the stage, however, of showing more than 100 slides, you must be taking the matter fairly seriously and, if your audience know what to expect, they, too, are ready to view your show in a settled, appreciative and probably even critical frame of mind. At this stage, therefore, you have to bring in a little more professionalism. You have to sort the slides carefully, to make sure that the story, pattern, theme or what-have-you develops naturally and without awkward changes of direction, colour, emphasis and so on. You need to start with a fairly strong picture—perhaps one of the best you have on the subject and then develop your theme gradually. Your last picture or two should also have fairly strong appeal to avoid an anti-climatic ending with the commentator saying "Well, that's another picture of the willow warbler" or some equally uninspiring remark.

You might even consider adding sound by playing a record of suitable music as a background, fading it up and down as you make your commentary. You can develop that still further by recording both commentary and music on tape and playing back the tape during the show, leaving you nothing to do but change the slides. If you put an extension speaker on the tape recorder and place it near the screen you begin to get a really professional touch.

That is by no means the end of it, however. If your projector is a remote-control automatic model and especially if it is the "jumbo" variety with rotary slide carrier, you can buy a slide-tape synchroniser that will enable you to play back the tape and operate the projector entirely automatically. All you do is switch on and join the audience.

The slide-tape synchroniser is an elementary tape recorder that attaches to your ordinary recorder and enables you to put an electronic pulse on to the tape at each point in the commentary where you require the slide to be changed. When the taped commentary is played back, the synchronizer is similarly fitted to the recorder and connected to the projector so that the slide is changed automatically at the predetermined times.

If your projector has no remote control, you can still use the tape recorder to signal the slide change although you have to effect the change manually. You can fix metallised tape patches to the back of the recording tape so that they connect electrical contacts leading to a buzzer or light placed near the projector.

UNUSUAL SHOOTING TECHNIQUES

The suggestion that the camera cannot lie has long been discounted. The camera can be made quite an accomplished liar. We have already seen that actual viewpoint in conjunction with apparent viewpoint can distort relative sizes and distances. The long-focus lens, by selecting and magnifying a distant portion of the scene can reduce the apparent distance between objects because it reproduces them all on much the same scale.

The wide-angle lens can approach very close to an object and make it apparently much larger than a similar object a short distance behind it. Similarly, the disparity in size between similar objects can increase the apparent distance between them.

The Prakticas can use lenses with angles of view from 180° (producing a considerably distorted circular image) to a degree or two (producing, for example, a gigantic moon behind a distant church steeple that looks close by).

Using the two dimensions

Although there are stereo attachments available for the Prakticas (see page 215), the cameras are normally used to produce ordinary two-dimensional pictures. Illusions of solidity, depth, etc., are produced by lighting. When the lighting is almost totally flat, i.e., non-directional, and the air is clear, the impression of depth and space between objects at different distances from the camera can be completely lost. A diminutive figure can be pictured as standing on a car bonnet when the actual scene was a normal-sized person standing on higher ground some distance behind the car.

A very similar result could be obtained by placing a cut-out photograph of a model on the car bonnet. A photograph of a photograph can obviously be as convincing as the original photograph because it is an exact duplicate. Therefore, in the

right circumstances, a photograph can be placed within a scene and the whole set-up reproduced as if the photograph within it were the original object.

In the example of the figure standing on the car bonnet, it would be evident that there had been some sort of trickery. If, however, the inserted photograph is completely in character with the scene and is placed square to the camera to avoid distortion it can be perfectly convincing. The object photographed must be lit from the direction it is apparently to be lit from in the subsequent scene. It must be photographed at the same angle as it is to appear to be placed. By this means an elegant mirror or clock could appear on a bare wall, a valuable cigarette or snuff box on the desk, and so on.

If the inserted object is too large for a photograph of it to be placed in the scene, you can resort to montage instead. This involves photographing the scene and the object separately on the same scale or, more likely, photographing the scene on the scale of an existing photograph of the object. A print of the object is then cut out and pasted on to a print of the scene. Generally, it is advisable to make the pasted-on print on the thinnest available paper and to chamfer its edges to make them as undetectable as possible. Even then some handwork may be necessary before rephotographing the combined print. Otherwise, the edges may cast shadows.

Mechanics of double-exposure

One of the commonest methods of making the camera lie is to double-expose the film, i.e., take two pictures on the same frame. The difficulty here is that the Prakticas are specially designed to prevent double exposures. Film transport and shutter tensioning are operated by the same control—the knob on earlier models and the lever wind on the later versions. Once the shutter has been released it has to be retensioned before it can be operated again. But it cannot normally be retensioned without winding on the film. Thus, unintentional double exposures are impossible.

On earlier Prakticas (those with the older shutter speed knob that turns as the shutter is tensioned), there are two methods of retensioning the shutter without moving the film. Make the first exposure in the normal way and then, instead of operating the transport knob or lever, turn the shutter speed knob against the spring as far as it will go. After rather less than one com-

plete revolution it clicks into position at the shutter speed previously used (provided there is film in the camera: it does not work with an empty camera). The shutter is thus retensioned ready for the second exposure but the film has not moved. You can alter the shutter speed for the second exposure if you so wish. This method, however, leaves the mirror in the up position on pre-VF models. If you need to see the image, you can remove the lens and gently pull the mirror down.

The alternative method is to make the first exposure in the normal way and then depress the rewind button while operating the transport knob or lever. This disengages the sprocket drive so that the film does not move. This method is not quite as easy as it sounds, however, because you have to maintain pressure on the rewind button to prevent it from springing out again. Moreover, you feel the need for a third hand because with this method it is advisable to take up the slack in the cassette with the rewind knob and hold the knob while operating the film transport. Otherwise the film may move sufficiently to upset the expected position of the second exposure. This latter method is the only one possible with the models with all shutter speeds on the one knob.

Technique of double-exposure

The simplest effect of this kind is the so-called ghost picture. One exposure is made, say, of a normal interior with staircase. A second exposure is made on the same film with a figure on the staircase. This means that most of the scene is exposed twice and it follows that the camera must not be moved between the two exposures and that the two exposures must be at such a level that they add up to a single exposure that is correct for the general picture, i.e., the interior scene. If, for example, the interior demands an exposure of 1/15 sec at f4, the two separate exposures must be 1/30 at f4. Theoretically, equivalent unequal exposures can be given but this is only possible with time exposures of several seconds.

It is apparent that this method underexposes the inserted figure but for ghost pictures that is no drawback. The figure should be rather misty and indeterminate. Fortunately, the traditional type ghost is normally dressed in light clothing because it would be difficult to produce a dark-clothed ghost by this method. The first exposure affects the whole film area and if the area where the ghost is to appear is light in tone, a

259

heavy density is produced on the film and a subsequent exposure of a dark object cannot remove that density.

This is a basic rule of all double exposures in the camera. You cannot use a light background except by masking off the area to receive the second exposure. Masking the film inside the camera is not feasible with a 35mm camera and double exposures of this kind can only be made without complicated manoeuvring by placing a mask over the lens. This is done by constructing a tube to fit on to the front of the lens. Black paper is then pasted over the front of the tube to obscure about two-thirds of its opening. The effect is to prevent the image forming rays reaching one half of the film. After the first exposure, the tube is turned to obscure the other side of the lens and the second exposure made. This is the still version of the cine split-screen effect in which a person is seen talking to himself.

The method calls for considerable experiment to find the best distance in front of the lens for the mask (it varies with focal length and aperture). If the mask is too close, it merely acts as a diaphragm stop, reducing overall illumination of the film. If it is too far away it produces a hard line that is not easy to conceal. Again, depending on focal length, varying proportions of the lens may need to be covered to mask half of the image area. It is advisable to place the dividing line either in a dark area or to follow a natural line, such as a door or window edge. It is almost impossible to conceal if it is placed in a medium-tonal area. Generally, some handwork on a print and subsequent copying is necessary.

Where the object is merely to reproduce two or more images of the same object in isolation, it is easier to shoot them against a non-reflecting black background or to arrange the lighting in such a manner that the background receives as little light as possible. This method can be used, for example, to produce merging full face and profile shots of the same model. The lighting of the subject and arrangement of the images has to be carefully worked out so that important features do not overlap or the light tones of one image impinge awkwardly on the shadows of the other.

Double exposures can occasionally be used to give interesting X-ray effects. Commercially, for example, motor cars have been shown with their engines apparently visible through the bonnet. Unless, however, you can totally remove the bonnet

DOUBLE EXPOSURE

A split frame device can be made from a tube fitting over a lens with its end partially covered.

The first exposure is made with the front mask perfectly vertical. The shutter is retensioned without moving the film and the mask turned to cover the opposite side of the lens, again with the mask edge perfectly vertical.

An ordinary mirror, but preferably front surfaced, can be used to shoot at right angles to the camera axis.

If the mirror is at a greater angle than 45° a direct and reflected image can be combined.

A half-silvered mirror allows direct and reflected images to be superimposed.

Where the scales of reproduction are to be altered, the subjects must be at different distances from the mirror.

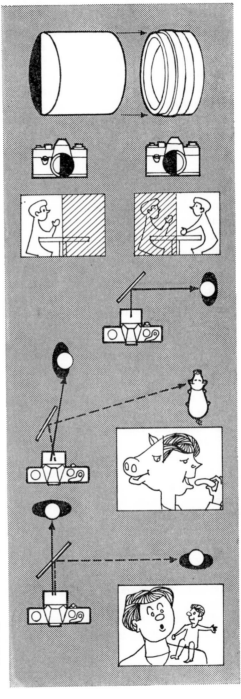

of your car and, perhaps, paint the engine parts in light colours, this effect is not for you. Similar shots are possible, however. You can take a normal shot of a light-coloured typewriter, for example, and then put a darker-toned cover or case over it and make the second exposure. If the case or cover has some slight embellishment, trade mark, name, etc., on it, so much the better. Some detail (depending on the exposure level) of the cover registers on the film but for the most part, the lighter tones of the typewriter show through clearly.

Using semi-silvered mirrors

A more sophisticated method of achieving a ghost or inserted image effect is to use a semi-silvered or two-way mirror. Such a mirror is less heavily silvered than the normal mirror and the back is not covered. The effect is that in normal lighting conditions, the mirror effect is less pronounced and half or more of the light falling on it passes through. Thus, if this type of mirror is placed at an angle in front of the camera it can pick up an image from out of the field of view of the camera lens and overlay it on the scene the camera shoots *through* the mirror. This method could be used to place the ghost on the stairs previously mentioned. The ghost figure could stand against a black background to one side of the camera and would be positioned to appear in the correct part of the picture. The scale of the inserted image naturally depends on the distance of the figure from the camera. For correct scale, the figure and the plane in which it is to appear to stand should be equidistant from the mirror. Altering that relationship distorts the relative sizes of figure and background.

The transparency of the image is also affected by the nature of the mirror. So-called semi-silvered or two-way mirrors can be made with varying proportions of reflectivity and transparency. The more light they transmit and the less they reflect, the more transparent the inserted image becomes. In fact, ordinary plate glass can be used for this type of shot.

The strength of the reflection depends, too, on how brilliantly the figure to be reflected is illuminated. The Prakticas, however, give you full control over all these variables because you can adjust them as you like and watch the effect on the image in your viewfinder.

The semi-silvered mirror can also be used to give shadowless lighting. If the mirror is placed at a 45° angle to the lens

axis, and a light source (such as a small spotlight or projector) placed at 90° so as to shine on to the mirror from exactly the same height as the camera lens, the light will travel along the lens axis and throw no shadow visible to the lens. This can be a useful method of lighting close-up subjects with a small light source.

Another feature of the semi-silvered mirror is that, in the right circumstances, it is a mirror viewed from one direction and is transparent from the other. This is a common method of concealing cameras used for security or observation purposes. The requirements are that objects in front of the mirror are reasonably well lit and that the camera or observer behind the mirror is in darkness. It is also a useful method of photographing captive animals that would be disturbed by the proximity of camera and operator. The animals are placed in a well-lit box, one side of which is the two-way mirror. The room in which the photography is carried out is in darkness or very dimly lit. The observer (and the camera) can see straight through the mirror but the animals can see only the mirror image.

Using ordinary mirrors

Ordinary mirrors have their uses in photography, too; ordinary, that is, in the sense that they are fully silvered and therefore reflect all light and transmit none. The average mirror, however, has its silvering on the back, with the result that it actually provides a double reflection—the stronger one from the rear surface, which is in contact with the silvering, and the weaker from the front. This second reflection is generally so weak as to be unnoticeable to the eye but the camera may record it quite clearly. It is therefore preferable to use front-surfaced mirrors for photographic purposes. The mirror in your Praktica is a front-surfaced type, to ensure that you see a single, sharp image through your viewfinder.

A simple use for a mirror is to enable you to shoot at right angles to the direction in which the camera is pointing. Commercial items of this type are available but it is possible to make up a box with one side open and a mirror angled at 45° inside it facing the opening. When this is attached to the lens, you can hold the camera as if shooting straight ahead in the normal way but the view you see and take is to one side of you. It takes a little practice to use such a gadget satisfactorily

because the image is reversed left to right and, if it is moving, tends to move in the opposite direction to that which you expect. This method of shooting can sometimes make it easier to light the close-up subject and can also be used with a rather larger mirror to photograph objects inaccessible to the camera.

When the mirror is placed at a 45° angle (and provided it is large enough) it completely shuts off the view in front of the lens and provides a totally reflected image. If, however, the mirror is placed at a lesser angle to the lens axis, it allows the lens to see part of the scene in front of it by shooting past the edge of the mirror. The remainder of the picture is provided by the mirror reflection. The effect can be almost anything you want it to be. If the mirror is placed below the lens, parallel to its axis, a figure can appear to be reflected in water. If it is tilted up slightly or placed to one side and turned inwards, various effects from the humorous to the horrific can be obtained.

A useful form of front-surfaced mirror is the highly-polished metal plate used on flat-bed glazing machines. This can provide normal reflections of exceptional brilliance if kept flat but can also introduce a variety of distortions if bent into single or compound curves.

Yet another photographic use of mirrors is based upon the kaleidoscope—an arrangement of mirrors in a tube which provides multiplied images in regular geometric patterns. Commercial items of this type are available to produce several images of the same object on one frame, variously distributed according to the arrangement of the mirrors.

Lighting effects and light sources

The word "photograph" could be translated as "light drawing" or something similar. Photographs are created by light, and the way in which the objects to be photographed are lit can have a considerable effect on the type of picture produced. For most photographs, we use more or less natural lighting, giving a normal likeness of the subject and a reasonably faithful reproduction of its tonal range. We can, however, fail to light the subject altogether while throwing a lot of light on to a light-toned background. That produces a silhouette. Or we can add just a little light to prominent features or to one side of the subject, perhaps, to produce a semi-silhouette. For such

pictures, the subject generally needs to be composed almost entirely of darkish tones, because it is often difficult in practice to prevent light tones picking up some spill light.

At the other extreme, we can flood the entire scene with even, soft light and produce a virtually shadowless, entirely light-toned picture. Naturally, the subject must not contain large areas of dark tone in itself.

These are the so-called high key and low key approaches, but it is the intermediate treatments that are more interesting. Back-lit subjects need not be silhouettes. The backlighting can produce rim light or halo effects around the subject but the front can still be adequately lit by reflectors, lamps or flash to produce a fully detailed picture. Sidelighting can be used to increase contrast by making shadows more pronounced and, by the same method, to emphasise detail in, for example, architecture, sculpture, statuary, etc.

Light sources themselves can form the major part of some pictures—an ornamental street lamp, perhaps, against a river back-drop; streaks produced by the lights of moving vehicles; the rising or setting sun through a long-focus lens, and so on. Sometimes, the light source can be made more interesting by special treatments such as defocusing or adding star points. The tiny lamps on a Christmas tree, for example, can be pictured so completely out of focus as to be reproduced as soft discs of light and can make interesting colour patterns. Star points can be added to lights by placing a wire mesh in front of the lens. The shape of the mesh governs the number of points. A square mesh provides four points at right angles; a five-sided mesh provides five points, and so on.

Possibilities in colour

In colour photography, the possibilities for experiment are increased by the triple emulsion make-up of the colour film. Each emulsion layer is acted upon by light of a different colour. When yellow light reaches the film, for instance, it acts on the green-sensitive and red-sensitive layers and produces magenta and cyan dyes which, in turn, reproduce the yellow when white light is passed through them. Evidently, if a red filter were placed over the lens, the green component would not reach the film and the magenta dye would not be produced. The cyan dye produced by the red component would subtract blue and green from the white light and leave only red. All other colours

would be similarly affected—the effect varying with the strength and purity of the filter colour and of the colours within the scene.

Alternatively, coloured or filtered lights can illuminate various parts of the subject, using spotlights or shaded lamps to arrange the colours as required. Double exposures can be separately filtered so that they affect different layers of the film.

Tricks need justification

These unorthodox or experimental methods of shooting can fill in the boredom gap when you can think of nothing else to photograph, but they should not generally be regarded as an end in themselves. Trickery just for the sake of trickery rarely has lasting interest and it is better to reserve these techniques for occasions when you are really trying to put across a specific point or create a particular type of meaningful picture. A composite portrait, for example, might reasonably be used to illustrate a family likeness. A colour-distorted picture can convey a mood or an impression of surroundings different from those in which the picture was taken. Star-spangled lights make a "pretty" picture if you are producing your own traditional Christmas card.

UNUSUAL
DARKROOM TECHNIQUES

Normal printing methods suffice for most photographs you are likely to take with the Praktica, but there are various less orthodox methods that can be used to advantage on occasions.

Using high-contrast paper

The simplest departure from the norm is the falsification of tonal values brought about by using the harder (or more contrasty) grades of printing paper. No printing paper is capable of reproducing accurately all the intermediate tones of a long-scale subject (i.e., a subject with many delicate changes of tone from pure white to deep black). The normal grade of paper inevitably loses many of these intermediate tones but nevertheless manages to reproduce most subjects satisfactorily. When you use a contrastier paper, however, more intermediate tones are lost and the harder the paper you use the more tones you lose. So, if you start off with a really contrasty negative you can print on the hardest grade of paper to produce a print with only a few well-spaced tones.

This technique is effective with almost any subject and has frequently been used, for example, on shots of ploughed fields or similar landscapes taken from a relatively high viewpoint. The increased contrast then tends to emphasise the pattern rather than the content of the picture.

When the purest black-and-white line is required you can use "lith" paper, which is specially designed for this type of work. It will eliminate virtually all intermediate tones at one step.

Tone separation

Printing on contrast paper is a simple form of tone separation but the technique more commonly referred to by this name involves a more complicated procedure. The aim is to com-

press the tones in a similar manner to the results given on contrast paper but to retain detail in both highlights and shadows. Thus, two negatives are used—a highlight negative and a shadow negative. These are produced from an intermediate transparency printed on medium-speed film from the original negative. The transparency is then printed twice on to slow or medium-speed film and processed in a fairly vigorous developer. The first printing is with a short exposure to register only the highlights. The second is given a longer exposure that blocks up the highlights but produces full details in medium tones and shadows.

It is possible to carry out these printing processes on 35mm film but it is preferable to print on to sheet film of the largest size your enlarger will take or of sufficient size to enable you to produce the final print by contact.

To make the final print, you first project the shadow negative to give good detail in the medium and shadow tones but pure white in the highlights. The correct exposure has to be ascertained from test strips. Similarly, you make test strips to find the exposure of the highlight negative that puts just a trace of density all over the print except in the extreme highlights. The result is to be a print with detailed highlights and shadows but a flattening of contrast in the mid-tone area caused by the overlapping exposures.

The two exposures have to be made on to the same sheet of paper in exact register. Registration is most easily achieved by making marks on the transparency from which the highlight and shadow negatives are produced. The marks should preferably be in the form of scratched outlines on two diagonal corners or a complete outline around the whole area to be reproduced. When the first negative is projected on to the paper, the guide lines can be pencilled in and the second negative can then easily be projected in register. Naturally, the scratch-marked areas have to be covered by the masking frame edges when making the print or trimmed off after processing.

If the print is made by contact, the transparency need generally be marked only on one corner and the negatives then trimmed identically to allow them to be fitted to a corner in an improvised printing frame.

The tone separation technique can be used with any subject consisting mainly of extremes of light and shade, such as strongly-lit landscapes, architecture, and even portraits.

Posterisation

Tone separation is carried still further by the posterisation technique, so called because it produces pictures resembling the wash drawing type of poster. The aim here is to simplify the tones to the extent that they become even and detailless and generally only three in number—black, white and grey.

Basically, the procedure is the same as in tone separation but there are important differences in detail. No gradation of tones is required: the steps between tones are abrupt. Thus, the film used for the intermediate positive and the separation negatives is the contrastiest obtainable—generally lith type. You expose the highlight negative to produce an even black density in the highlights and no image at all in mid tones and shadow areas. The shadow negative has a longer exposure to give an even density in both highlight and mid-tone areas and clear film in the shadow areas. It may be necessary to go through the process again to achieve sufficient contrast—producing a further positive and a second set of negatives. As in the tone separation process, the original transparency should be marked for subsequent registration purposes.

When printing the posterised negatives, the highlight negative is projected first and exposed just long enough to put an even grey density on the paper in the mid-tone and shadow areas and leave the highlight areas completely clear. This density is the mid-tone density and should be so judged on the test strip. It needs to be reasonably heavy to mark the highlights clearly but definitely grey and not verging on the black. The shadow negative is then printed just long enough to bring the shadow areas up to full black without affecting mid-tone or highlight areas. The result is a simplified three-toned representation of the original that can be very effective for a variety of subjects. It has been used successfully in portraits, statuary, scenics and many others—sometimes combined with other techniques such as solarisation.

Solarisation

The technique commonly known as solarisation should more correctly be called the Sabattier effect (although the man whose name it perpetuates actually spelt it with one "t"). True solarisation is the reversal of tones brought about by extreme overexposure. The Sabattier effect is produced by exposing

the film normally in the camera and then exposing it momentarily to unsafe light in the course of development. The actual procedure depends on the type of subject, film, developer, length of solarising exposure and so on. No precise rules can be laid down and the results can never be entirely predictable. Generally, however, the fogging or solarising exposure should be made about half-way through the developing process and developing then continued for the full time or a little longer. The exposure should be brief—generally no more than a few seconds at a foot or so from the average darkroom safelight. White light will normally be too strong unless an extremely brief exposure can be arranged.

The effect obtained by this technique may be partial or complete reversal of tones accompanied by a characteristic black line at the border between adjacent strongly contrasting tones. It is often said to be most effective with relatively simple subjects with strong lines and tones but can in fact produce pleasing results on almost any sharply-produced subject with reasonably well spaced tonal values.

Uses of paper negatives

Darkroom experimental work can often be simplified and more closely studied by using paper negatives. Solarisation effects, for example, can be obtained on paper as well as film. The principle is exactly the same: you expose the paper to unsafe light about half-way through development and then carry on developing. If you use this procedure with paper exposed to a negative, you solarise the positive image on the print. That may in itself make a picture but it is often preferable to make the first print in the normal way and then to use it to contact print a negative for the solarisation treatment. You then contact print that paper negative to produce the final solarised positive.

The result is very much the same as when solarising the original film—with the important difference that you can work by safelight and watch the process all the way.

You can do your contact printing from paper to paper after a simple rinse and blotting off provided one of the papers is a surfaced type. Damp glossy paper tends to stick to another glossy paper and to print unevenly. The advantage of printing from damp paper is that full contact is more easily assured. If you print from dry paper, you need to cover the two sheets with plate glass on which you can press quite heavily.

The essential steps in the posterization process are, first, to convert an ordinary negative into a constrasty transparency.

The second step is to make identically-sized highlight and shadow negatives of the highest possible contrast.

The third step is to print the highlight negative with a short exposure to put an even grey tone in midtone and shadow areas and then to print in exact register the shadow negative to reproduce the shadow areas as a full black.

Left: A simple printing-in example is that of adding a cloud-filled sky to an otherwise "bald" print. The image is projected on to white paper or card held an inch or two above the baseboard. Focus is on the baseboard. The skyline is pencilled in on the paper, which is then used as a template to cut masks in black paper or card.

Right: With printing paper on the baseboard, the sky mask is placed in position and the landscape exposed. The landscape is then masked while the sky negative is printed in.

If the sky area in the original negative is sufficiently dense, the sky mask may not be needed.

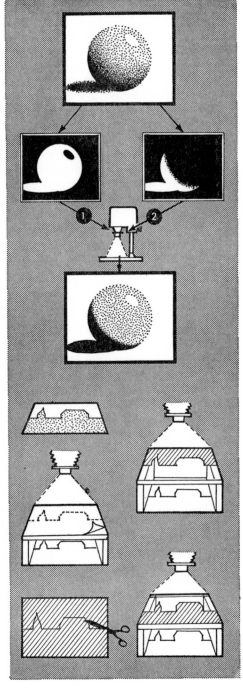

Another use of the paper negative is in making black-and-white prints from colour transparencies. If you print the transparency in the same way as an ordinary negative, you obtain a paper negative that can subsequently be contact printed to provide a reasonably good black-and-white print.

Most single weight glossy papers are suitable for paper negative work. The paper is of good quality and the base construction rarely prints through to any great extent. Naturally, definition suffers slightly where the paper structure is too coarse for fine detail, but in general the quality is surprisingly good.

The enlarger makes a useful light source for contact printing because you can leave the negative carrier in to cut off "spill" light and simply adjust the height of the head so that the light patch is of the required size. Then, when printing, you place the paper negative and a fresh sheet of bromide paper emulsion-to-emulsion on the enlarger baseboard, cover with plate glass to press the two sheets into contact and switch on the enlarger light for the required time.

Bas relief

A novel method of giving emphasis to the lines of a picture without totally destroying its tone is the bas relief technique. As its name implies, the bas relief print gives the impression that image parts stand out from or recede into the paper.

The basic procedure is to make a fairly soft transparency from a negative and then to bind both transparency and negative together slightly out of register. A print made from this combination shows the lines of the subject as more-or-less white on one side and black on the other, of a thickness varying with the degree of displacement. The relief effect also varies with the lack of registration or thickness of the lines to a certain limit. If the displacement is too great, you simply have a double image effect.

The tones of the picture virtually disappear by the cancelling out effect of positive and negative and print as an even grey. It follows that the original negative should not be so dense as to make it difficult to print through.

Combination printing

You may sometimes find that a particular photograph lacks something, or that, in a series of several shots, none contains all the elements you require.

An obvious example of the "something missing" is the landscape or architectural shot with a "bald" uninteresting sky. That is comparatively easily solved by adding clouds from another negative, especially if you have made a point of photographing interesting cloud formations in the past.

The procedure is to project the original negative on to a piece of white paper on the baseboard and mark the skyline on the paper with a sharp pencil. Intricate shapes protruding into the sky area need not be followed closely if they are dark-toned or can be placed within a white cloud area. A piece of black card is then cut to follow the pencil line on the white paper to form a mask for the lower part of the picture.

Placing your photographic paper in position, you expose it normally for the cloudless scene and then place the mask over the foreground area. Changing the negatives, you can compose your cloud formation in the sky area through the enlarger's red swing filter, which may entail altering the height of the enlarger head. If you find this difficult, you have to remove the printing paper (marking it carefully to indicate top and bottom) and put it away in darkness while you compose the clouds on your pencil-marked piece of white paper.

Exposure for the sky area has to be predetermined by tests made on paper previously exposed to the "bald" sky because that exposure may be sufficient in combination with the second exposure to put unwanted density into the clouds. If it is and you cannot obtain the required result with a shortened cloud exposure, you have to mask the sky area while exposing the scene.

It is best not to lay the masks directly on the printing paper unless your skyline is very sharply defined and the masks carefully cut. It is usually preferable to support the masks an inch or two above the paper to soften the "join" between the two exposures.

A much more complicated type of combination printing is that entailing the addition of a figure or other detail to an existing photograph. This can be done quite convincingly but it calls for skill and practice. The procedure is similar to that for adding clouds but the masks are not usually cut close to the figure. The first exposure of the general scene is made as in holding back shadow detail (see page 247) with a piece of black card held on the end of a thin wire throughout the expo-

sure to leave a white area in the print. The detail to be added is then printed through a mask into the vacant space.

The difficulty in this technique is that the surroundings of the inserted detail must closely match in tone the surroundings of the whited out area. It is usually necessary therefore to photograph the added detail in suitably matched surroundings. Naturally, the nature and direction of the lighting must also match and an additional complication of a cast shadow may be needed. That will probably have to be put in by hand. At the same time, some handwork may be necessary in the area adjoining the added detail. Skilled workers can produce remarkable results in this way but the less skilled may prefer to resort to montage methods.

Photo montage

A much easier way of adding detail to a photograph is the cut-and-paste method known as montage. The procedure is to cut the required detail from another print and paste it in the required position on the print you wish to improve.

The cutting must be very carefully done and is best carried out with an artist's trimming knife or a medical scalpel. The cut can then be made to start under the edge of the paper so as to leave it thinner at the edge. You might thin it still further by gentle glass papering so that the edges can be firmly pasted down and leave very little evidence of the join.

It is usual to rephotograph montaged prints to provide a negative from which any number of prints of the altered picture can be made. The pasted-down edges are then particularly important, because thick edges cast shadows when the copying lights are set up.

If the added detail is cut from a print in which its surroundings were entirely different from those into which it is subsequently to be placed, the cut must follow the lines of the detail. If, however, the detail can be specially photographed, the surroundings should be so arranged that an uneven trim can be made to make the join far less apparent.

Interesting colour effects are obtainable by the photomontage method because, among the special photographic papers available are many types with brilliantly-coloured bases. Combining prints from papers of different colours can produce effects limited only by the imagination of the photographer.

SEEKING A PURPOSE

You have your Praktica camera. You have read the instruction book from cover to cover. You have read all the technical details in this book. You know how the camera works. You have even loaded it with film. Now what do you do with it? Sometimes the obvious answer seems to raise enormous problems and innumerable budding photographers have found themselves totally barren of ideas after the first few exposures on friends and relations, local scenery and a series of nondescript holiday shots. Enthusiasm dies and the camera may even end up on the used market.

That must not happen to you. Certainly you must take the pictures that family and friends expect, but that is by no means the end of it. Your Praktica can help you produce pictures anywhere and at any time.

Why do people take photographs? Why do they go on taking them year after year? What do they do with them? Generally, the enthusiast goes on taking pictures because he cannot help it. That is what he wants to do. He enjoys using a camera. What he does with his pictures depends on his attitude to photography.

Apart from those who use a camera purely for their own pleasure—and there are vast numbers of them—there are those who seek recognition and those who seek money. Broadly, they are the amateurs and the would-be professionals, but there are no clear dividing lines. Some join camera clubs and submit their prints or slides to exhibitions but have no interest at all in working at the production of photographs that will sell. They want to produce *good* photographs and it is not necessarily the good photographs, in their sense of the word, that sell. Others concentrate on finding out what types of photograph publishers are willing to pay money for and bend all their efforts in that direction. Probably the majority, however, would like a foot in each camp.

Benefits of the camera club

Camera clubs and societies are many and various. The greatest criticisms they have to face from outsiders are that they are hidebound traditionalists and that they encourage the formation of self-adulatory cliques. Both are valid criticisms of the dangers that are inherent in the club way of life, but not all clubs fall prey to them and, even where there is a tendency to do so, they still have something to offer.

A common difficulty facing the beginner in photography is that he has no standards to aim at. He cannot equate his work with what he sees in magazines and books. That is *published* work by people who have had far more experience than he has —or so he thinks. He just cannot see it in the same light as the prints or slides he produces.

If he goes to a club, however, he sees the work of other people and he sees the people themselves. He may still be a little overawed because they speak the jargon so freely, whereas he is only just beginning to learn what aperture, *f*-number, depth of field and so on mean. But he can see prints and slides, not pages out of books, and he should be able to appreciate that if *they* can do it, so can he. If he has attained any sort of proficiency at all, he will see that some of the members' work does not look all that much better than his and confidence begins to grow.

What he should pay most attention to is the quality of the best work in the club. In black-and-white prints, he will see many that are bitingly sharp, that have rich black tones at one end of the scale and a full range of mid-tones to the clean highlights at the other end. If, by comparison, he finds that his prints look rather grey and lack real sharpness, he is already beginning to learn.

No Praktica owner should ever produce unsharp prints except by design. Even if his lens is one of the cheaper types that can be fitted to the Praktica, it can produce really sharp pictures if stopped down. The cheaper lenses do not always perform well at the larger apertures but very few have to be stopped down further than *f*5.6 to give very good results. So he cannot blame his lens for unsharpness.

He can blame himself for not holding the camera steady, for not focusing accurately, for using an inadequate enlarger lens or simply for making an unsharp print from a sharp nega-

tive, owing to inaccurate focusing on the enlarger baseboard. He should check over every detail of his methods to find where the fault lies.

If his prints are of poor tone and always look flat and lifeless, the problem is simpler. This is nearly always caused by bad printing technique and that is usually too much exposure on the enlarger and too little development of the print. Any correctly exposed bromide print should be able to stand at least three minutes in the developer without going too dark. If it does darken too much in that time, it was overexposed.

Lifeless prints can, however, be the result of inadequate exposure or development of the film. Some workers *can* produce excellent quality prints from very thin looking negatives, but it is wiser for the beginner to aim at obtaining a reasonably good density in his negatives, such that the print of this page, for example, can barely be seen through the heaviest density when the negative is laid on the paper.

Print quality is the most valuable thing the beginner can learn from looking at the best camera club prints. It is something in which this type of photographer excels. Not until he can produce prints approaching these in quality should the new Praktica owner think of gaining either recognition or money from his hobby.

Once he has learned to produce good sharp prints, he can turn to the question of what to photograph and what to do with the results.

If his club does, indeed, consist of hidebound traditionalists, their work may, nevertheless, appeal to him and he may well wish to emulate it. There is no reason why he should not. There is plenty of room for all types of photography and there is no particular credit due to the photographer who prefers an impressionistic rendering of a bathplug to a beautiful but uninspired picture of mountain scenery—or vice versa. The outsider looking in must sometimes wish that a little of each would rub off on the other—and, of course, sometimes it does —but that is by the way.

The ultimate for the club type photographer is the exhibition wall and there is a lot of satisfaction to be gained from making the large prints required and submitting them to open exhibitions throughout the world—and receiving them back in due course with the much-prized stickers on the back. The competition stimulates the photographer to be forever on the

lookout for camera subjects and to take great care with both camera and darkroom work.

Money-making opportunities

The club type of photography does not appeal to everybody. Only a fraction of it is saleable because so much of it really is stereotyped. So what does the photographer do who wants to make money out of his hobby? The outlets for black-and-white photography are, in fact, numerous. Colour is still in far smaller demand, especially in the 35mm size.

Saleable pictures do not have to be works of art. In fact, the market for "good" photography of this type is very limited. The essence of most saleable pictures is that they have impact—something that attracts the attention immediately. They generally have "human interest"—a much-abused term that covers almost anything that can be expected to interest the normal inquisitive person. This includes pictures of people, animals, children, accidents and disasters, sport, notable events and so on. To make the picture saleable, however, it has to be unusual, striking, humorous or possess some other quality that makes it stand out. The interest it arouses must be widespread. The very funny picture of a friend of yours in some uncharacteristic attitude is not saleable unless it is obvious to all that the attitude is uncharacteristic.

Such pictures can earn money from competitions, magazines, newspapers, books, etc. Aim for the smaller markets first. The small-circulation magazine pays less than the national newspaper but the competition is less. Newspapers have their own staff photographers and the pick of the best pictures from agencies and well-established freelances. Comparatively few magazines employ their own photographers.

Photographic competitions

Innumerable photographic competitions are held every year, with prizes ranging from the "hardly worth the trouble" to the extremely valuable. It is quite possible for the careful worker to obtain a modest additional income from these competitions, with the ever present hope that he may one day capture a really big prize.

Prints submitted for competitions should, of course, be of good quality. Although quality alone will never win a prize, it can, other things being equal, make all the difference between

winning and losing. The main requirements are, however, that the pictures are in complete accord with the aim of the competition and that they attract and hold the attention. Many competitions are run as part of an advertising campaign and their aim is to publicise a product or service. The photographer must, therefore, try to devise a unique method of showing the product in the most favourable light—and, just as important, in a suitable light. It is little use showing a glamour girl drinking a product the manufacturers wish to publicise as the ideal drink for the "outdoor man".

The rules of any competition must be read carefully for two reasons. Obviously, you must comply with any regulations regarding size of print, whether mounted or unmounted, entry fee (if any), last date for entries, and so on. You should study the rules even more closely, however, to find out what you may be giving away by entering. There have been competitions in which copyright was claimed in all prize-winning pictures. If the prizes are substantial, that may be reasonable. You may even not bother about it unduly when you have taken the picture specifically for the competition and it has no possible value elsewhere. In other circumstances you should consider the implications of such a clause very carefully.

If the rules claim rights in all *entries*, regardless of whether they win a prize or not, avoid the competition entirely. The organisers may simply be misguided or they may be seeking something for nothing. Either way, you stand to gain nothing. You should not generally be willing to surrender *any* rights in your competition entry unless the prize you win is sufficient to cover the normal cost of those rights.

Selling to magazines

It is not difficult to sell black-and-white pictures to magazines if you study the publication and the type of illustration it uses. The market is enormous and suitable pictures are not easily obtained. The run-of-the-mill types of picture used by magazines beamed at teenagers, hobbyists, motorists, gardeners, campers and caravanners, parents and so on rarely have aesthetic value. They are, or should be, good, straightforward photography of a particular subject or on a particular theme.

Study the publications that cover your particular interests and note the types of picture that appear most often. Note, too, how the subject is handled. Boats, cars, furniture and all

279

sorts of other items are often draped with pretty girls in advertisement pictures. In the hobby and technical press, it is more important to show the most important features of the product, process, construction, etc. Sufficient light to show those features is of more importance than composition or double shadows.

On the other hand, perspective may be important, too. If you photograph a car, for example, too close to the front, you will show enormous headlights, a powerful-looking bonnet and a rather long car—even if it is a Mini. You have to choose your viewpoint with care.

In the more popular type of magazine, study the usual layout so that your pictures are the right shape or can, at least, be cropped to fit. It is generally unwise to submit closely cropped pictures for editorial use unless you are certain of the space they have to fit into.

One of the biggest markets is for photographs of children. Apart from women's magazines and specialist publications aimed at parents, good pictures of children can be sold to the daily and Sunday newspapers. These are not the orthodox portrait type of picture, or the child bedaubed with ice-cream or the baby on the hearthrug. In the right season, they might be nearly as corny, but generally they need to be amusing in the widest sense, or appealing or, only too frequently nowadays, evocative of less happy emotions.

All pictures for sale to general interest magazines and newspapers should be uncluttered with extraneous detail. They must put across their story or theme clearly so that they attract and hold the attention. They do not need any special printing technique, but glossy, unglazed bromide paper is usually preferable. Surfaced papers may obliterate the finer details and can sometimes make the blockmaker's job unnecessarily difficult.

You are not likely to make a fortune from selling photographs. You are not likely even to make a living unless you take the business very seriously indeed and work extremely hard at it. The competition is keen. Apart from the large number of professionals who know exactly what is wanted and concentrate on supplying it, there are innumerable very good amateurs capable of producing first-class work. Moreover, you generally need to be at least as good a businessman and salesman as you are a photographer. A hundred people might be

capable of producing pictures of equal quality, interest, and so on. But only one of the hundred might know just where and how to sell his pictures with the minimum of effort.

Working for other people

There is always the temptation to try to make your hobby pay by doing work for other people. You may be asked to take passport photographs, pictures of children, records of parties, sporting events, etc. You should be rather careful in handling such requests. Ideally, you should not take them on at all or you should accept the job only on the understanding that you charge full commercial rates. Naturally, you cannot always do that with close friends. It is preferable then that you either charge them nothing or simply cover your costs.

Beware, particularly, of taking on wedding photography unless you are absolutely confident of your own ability. Attend the wedding and take pictures by all means, but advise the couple to employ a professional for the orthodox wedding shots. You can take less formal shots as they present themselves and may quite often come up with pleasing or amusing pictures.

Money is not everything and probably the vast majority of amateur photographers cannot be bothered to undertake the work involved in trying to make a crust out of their photography. So what else is there to do with the vast number of pictures you accumulate over the years?

This seems to worry some people to the extent that they view their piles of prints and slides from time to time and wonder whether it is all worthwhile. There are three ways out of that. You can decide that it is all a waste of time, give up and sell your equipment. Or you can decide that the enjoyment is in the taking and in the processing and that you have to keep only those that you find interesting. Throw all the others away. Or you can put some purpose into your photography by specialising in some particular subject or subjects. You can then aim at producing as complete a collection as possible of your chosen subject.

FACTS AND FIGURES

COLOUR TEMPERATURE

Approximate colour temperatures are shown for the various light sources commonly used in photography. Daylight colour films are designed to be used with light of about 6000K and will reproduce colours with reasonable accuracy in the range 5500–800K. Beyond these extremes, filters (see page 154) are necessary to prevent distortion of colour. Similarly, artificial light film is either Type A, for use in 3400K lighting or Type B, for use in 3200K lighting. At this end of the scale, there is very little latitude and a difference of 100K will have a noticeable effect on the colour rendering.

Lighting	Approx. colour temperature (K)
Light from blue sky	10000–20000
Hazy blue sky	7000–9000
Overcast sky	6000–7000
Midday sun plus blue sky	6000–8000
Mid-morning or afternoon sun	5000–6000
Electronic flash	5500–6500
Blue flashbulbs	5500
Early morning or late afternoon sun	3800–5000
Photoflood and other overrun tungsten lamps	3400
Studio lamps	3200
Household tungsten lamps over 100 W	2900
Weaker household tungsten lamps	2700

FILM SPEED CONVERSION

ASA	DIN	Relative exposure needed
800	30	1
640	29	1.3
500	28	1.6
400	27	2
320	26	2.5
250	25	3.2
200	24	4
160	23	5
125	22	6.3
100	21	8
80	20	10
64	19	13
50	18	16
40	17	20
32	16	25
25	15	32
20	14	40
16	13	50
12	12	63
10	11	80
8	10	100
6	9	125
5	8	160
4	7	200
3	6	250
2.5	5	320
2	4	400

The figures shown in the first two columns are the conversions used by film manufacturers. The third column shows exposure factors based on the 800 ASA film.

Ft/in. to metric units		Metric units to ft/in.	
$\frac{1}{8}$ in.	0.32 cm	0.5 cm	$\frac{1}{4}$ in.
$\frac{1}{4}$ in.	0.64 cm	1 cm.	$\frac{3}{8}$ in.
$\frac{1}{2}$ in.	1.27 cm	2 cm	$\frac{3}{4}$ in.
1 in.	2.54 cm	3 cm	1$\frac{1}{8}$ in.
2 in.	5.08 cm	4 cm	1$\frac{1}{2}$ in.
3 in.	7.62 cm	5 cm	2 in.
4 in.	10.2 cm	6 cm	2$\frac{3}{8}$ in.
5 in.	12.7 cm	7 cm	2$\frac{3}{4}$ in.
6 in.	15.2 cm	8 cm	3$\frac{1}{8}$ in.
7 in.	17.8 cm	9 cm	3$\frac{1}{2}$ in.
8 in.	20.3 cm	10 cm	4 in.
9 in.	22.9 cm	12 cm	4$\frac{3}{4}$ in.
10 in.	25.4 cm	15 cm	5$\frac{7}{8}$ in.
11 in.	27.9 cm	20 cm	7$\frac{7}{8}$ in.
1 ft	30.5 cm	25 cm	10 in.
2 ft	61.0 cm	30 cm	11$\frac{3}{4}$ in.
3 ft	91.4 cm	40 cm	15$\frac{3}{4}$ in.
4 ft	1.22 m	50 cm	19$\frac{3}{4}$ in.
5 ft	1.52 m	60 cm	23$\frac{5}{8}$ in.
6 ft	1.83 m	80 cm	31$\frac{1}{2}$ in.
7 ft	2.13 m	100 cm	39$\frac{1}{2}$ in.
8 ft	2.44 m	1.5 m	4 ft 11 in.
9 ft	2.74 m	2 m	6 ft 7 in.
10 ft	3.05 m	2.5 m	8 ft 3 in.
15 ft	4.57 m	3 m	9 ft 10 in.
20 ft	6.10 m	4 m	13 ft 2 in.
30 ft	9.14 m	5 m	16 ft 5 in.
40 ft	12.20 m	10 m	33 ft 0 in.
50 ft	15.24 m	15 m	49 ft 2 in.
100 ft	30.48 m	20 m	66 ft 0 in.

One metre is actually a little over 3 ft 3$\frac{1}{4}$ in. This table is calculated on 3 ft 3$\frac{1}{2}$ in. and fractions rounded off to the nearest $\frac{1}{8}$ in.

Distance ft	Reduction	Field size (ft and in.) for 20 mm lens	
20	1 : 287	21–8	× 32–11
10	1 : 143	10–9	× 17–4
6	1 : 84	6–5	× 9–8
4	1 : 55	4–2	× 6–4
3	1 : 41	3–1	× 4–8

Distance m	Reduction	Field size (cm) for 20 mm lens
6	1 : 283	660 × 990
3	1 : 141	320 × 480
2	1 : 93	210 × 315
1.5	1 : 69	160 × 240
1	1 : 45	100 × 160

Approximate scales of reproduction (reduction) and field sizes at various distance settings for 20 mm lenses. The upper table gives field sizes in feet and inches at different distance settings in feet; the lower table shows field sizes in cm at distance settings in metres.

Distance	Reduction	Field size (ft and in.) for 35 mm lens		
20 ft	1 : 165	12–5	×	19–11
10 ft	1 · 81	6–2	×	9–4
6 ft	1 : 48	2–7	×	5–6
4 ft	1 : 31	2–4	×	3–7
3 ft	1 : 23	1–9	×	2–7
2 ft	1 : 14	1–1	×	1–8
16 in.	1 : 8.8	0–8	×	1–0
12 in.	1 : 5.9	0–6	×	0–8
10 in.	1 : 4.5	0–4	×	0–6
9 in.	1 : 3.7	0–3¾	×	0–5½
8 in.	1 : 3	0–2⅝	×	0–4½

Distance m	Reduction	Field size (cm) for 35 mm lens	
5	1 : 135	310 ×	470
2	1 : 53	120 ×	180
1	1 : 25	58 ×	88
0.8	1 : 20	48 ×	72
0.6	1 : 14	32 ×	49
0.5	1 : 11	26 ×	40
0.45	1 : 10	23 ×	35
0.4	1 : 8.6	20 ×	30
0.35	1 : 7.2	17 ×	25
0.3	1 : 5.8	13 ×	20
0.25	1 : 4.4	10 ×	15
0.22	1 : 3.5	8 ×	12
0.2	1 : 2.9	7 ×	10
0.19	1 : 2.6	6 ×	9

Approximate scales of reproduction (reduction) and field sizes at various distance settings for 35 mm lenses. The upper table shows field sizes in feet and inches for distance settings in feet, the lower table field sizes in cm for distance settings in metres.

Distance	Reduction	Field size (ft and in.) for 50 mm lens		
30 ft	1 : 174	13–1	×	19–11
20 ft	1 : 115	8–8	×	13–3
10 ft	1 : 57	4–3	×	6–6
6 ft	1 : 33	3–4	×	3–10
4 ft	1 : 22	1–7	×	2–6
3 ft	1 : 15.7	1–2	×	1–10
2 ft	1 : 9.8	0–10	×	1–1
18 in.	1 : 6.8	0–6	×	0–9
15 in.	1 : 5.3	0–5	×	0–7
12 in.	1 : 3.8	0–3¾	×	0–5½

Distance m	Reduction	Field size (cm) for 50 mm lens	
10	1 : 190	438 ×	666
6	1 : 113	261 ×	397
3	1 : 56	128 ×	195
2	1 : 37	84 ×	128
1.5	1 : 27	62 ×	94
1	1 : 17.3	40 ×	60
0.8	1 : 13.5	31 ×	47
0.7	1 : 11.5	27 ×	40
0.6	1 : 9.6	22 ×	34
0.5	1 : 7.6	18 ×	27
0.45	1 : 6.7	15 ×	23
0.40	1 : 5.7	13 ×	20
0.35	1 : 4.7	11 ×	16
0.30	1 : 3.7	8 ×	13

Approximate scales of reproduction (reduction) and field sizes at various distance settings for 50 mm lenses. The upper table gives field sizes in feet and inches at various distance settings in feet, the lower table field sizes in cm. at distance settings in metres.

Distance ft	Reduction	Field size (ft and in.) for 85 mm lens		
100	1 : 359	28–0	×	41–2
50	1 : 179	13–6	×	20–6
25	1 : 88	6–8	×	10–2
15	1 : 52	3–11	×	6–0
10	1 : 34	2–7	×	3–11
8	1 : 27	2–0	×	3–1
6	1 : 19.7	1–6	×	2–3
5	1 : 16	1–3	×	1–10
4	1 : 12.4	0–11	×	1–5
3	1 : 8.7	0–8	×	1–0
2.5	1 : 6.9	0–6	×	0–9

Distance m	Reduction	Field size (m) for 85 mm lens		
30	1 : 354	8.14	×	12.4
15	1 : 176	4.05	×	6.16
10	1 : 117	2.68	×	4.08
6	1 : 69	1.59	×	2.42
4	1 : 45	1.05	×	1.59
3	1 : 34	0.77	×	1.17
2	1 : 22	0.50	×	0.76
1.5	1 : 15.7	0.36	×	0.55
1.2	1 : 12.2	0.28	×	0.43
1.0	1 : 9.8	0.22	×	0.34
0.9	1 : 8.6	0.20	×	0.30
0.8	1 : 7.4	0.17	×	0.26

Approximate scales of reproduction (reduction) and field sizes for 85 mm lenses at various distance settings. The upper table gives field sizes in feet and inches for distance settings in feet, the lower table field sizes in metres for distance settings in metres

Distance ft	Reduction	Field size (ft and in.) for 135 mm lens		
50	1 : 112	8–6	×	12–11
25	1 : 55	4–2	×	6–4
15	1 : 32	2–5	×	3–10
10	1 : 21	1–7	×	2–4
8	1 : 16.1	1–3	×	1–10
7	1 : 13.8	1–1	×	1–7
6	1 : 11.5	0–10	×	1–4
5.5	1 : 10.1	0–9	×	1–2
5	1 : 9.2	0–8	×	1–11
4.5	1 : 8	0–7	×	0–1
4	1 : 6.8	0–6	×	0–9

Distance m	Reduction	Field size (m) for 135 mm lens		
15	1 : 110	2.54	×	3.86
10	1 : 73	1.68	×	2.55
8	1 : 58	1.27	×	2.02
6	1 : 43	0.98	×	1.50
5	1 : 35	0.81	×	1.24
4	1 : 28	0.64	×	0.94
3	1 : 20	0.47	×	0.71
2.5	1 : 16 .5	0.38	×	0.58
2.0	1 : 12.8	0.29	×	0.45
1.8	1 : 11.3	0.26	×	0.39
1.6	1 : 9.7	0.22	×	0.34
1.4	1 : 8.2	0.19	×	0.29
1.2	1 : 6.7	0.15	×	0.23

Approximate scales of reproduction (reduction) and field sizes for 135 mm lenses at various distance settings. The upper table gives field sizes in feet and inches at distance settings in feet, the lower table field sizes in metres for distance settings in metres.

LENSES FOR PRAKTICA CAMERAS

Lens	Focal length	Max. aperture	No. of elements	Angle of view	Minimum focus	Diameter	Length	Weight	Filter thread	Aperture
Zeiss Flektogon	20 mm	f 4	10	93°	6in.	80 mm	57.8 mm	11.78 oz	77 mm	FAD
Prakticar Auto	24 mm	f 2.8	10	84°	15in.	65 mm	59 mm	8.46 oz	62 mm	FAD
Prakticar Electric	24 mm	f 2.8	10	84°	15in.	65 mm	59 mm	8.46 oz	62 mm	FAD
Prakticar Auto	28 mm	f 2.8	7	74°	15in.	65 mm	58 mm	8.46 oz	62 mm	FAD
Prakticar Electric	28 mm	f 2.8	7	74°	15in.	65 mm	58 mm	8.46 oz	62 mm	FAD
Pentacon Auto	29 mm	f 2.8	7	73°	10in.	57 mm	51.5 mm	8.46 oz	55 mm	FAD
Pentacon Electric	29 mm	f 2.8	7	73°	10in.	57 mm	51.5 mm	8.46 oz	55 mm	FAD
Zeiss Flektogon	35 mm	f 2.8	6	62°	6in.	67 mm	57.3 mm	6.2 oz	49 mm	FAD
*Schneider Curtagon	35 mm	f 2.8	6	64°	19.5in.	65 mm	65 mm	10.22 oz	62 mm	FAD
Prakticar Auto	35 mm	f 2.8	6	63°	19.5in.	65 mm	65 mm	10.22 oz	62 mm	FAD
Prakticar Electric	35 mm	f 2.8	6	63°	14in.	51 mm	60 mm	7.76 oz	49 mm	FAD
Pentacon Auto	50 mm	f 1.8	6	47°	14in.	66 mm	44.8 mm	7.76 oz	49 mm	FAD
Zeiss Pancolar	50 mm	f 1.8	6	46°	14in.	51 mm	44.2 mm	6.17 oz	49 mm	FAD
Zeiss Tessar	50 mm	f 2.8	4	45°	18in.	51 mm	60 mm	7.76 oz	49 mm	FAD
Pentacon Domiplan	50 mm	f 2.8	3	47°	14in.	66 mm	60 mm	7.76 oz	49 mm	FAD
Prakticar Electric	50 mm	f 1.8	6	46°	14in.	57 mm	44.8 mm	7.76 oz	49 mm	FAD
*Zeiss Pancolor	50 mm	f 1.8	6	46°	14in.	57 mm	64 mm	7.76 oz	49 mm	FAD
Pentacon Auto	100 mm	f 2.8	5	24°	3ft 6in.	57 mm	81.5 mm	11.28 oz	49 mm	FAD
Pentacon Electric	100 mm	f 2.8	5	24°	3ft 6in.	67 mm	81.5 mm	11.28 oz	49 mm	FAD
Pentacon	135 mm	f 2.8	5	18°	4ft 11in.	67 mm	93.5 mm	11.28 oz	49 mm	PD
Prakticar Auto	135 mm	f 2.8	4	18°	4ft 11in.	59 mm	91 mm	18.16 oz	55 mm	FAD
Prakticar Electric	135 mm	f 2.8	4	18°	4ft 11in.	59 mm	91 mm	14.80 oz	55 mm	FAD
Pentacon Auto	135 mm	f 2.8	5	18°	4ft 11in.	67 mm	91 mm	14.80 oz	55 mm	FAD
Pentacon Electric	135 mm	f 2.8	5	18°	4ft 11in.	67 mm	91 mm	19 oz	55 mm	FAD
Zeiss Jena S	135 mm	f 3.5	4	18°	4ft 11in.	67 mm	91 mm	19 oz	55 mm	FAD
*Schneider Tele Xenar	135 mm	f 3.5	4	18°	3ft 0in.	66 mm	135 mm	14 oz	49 mm	ASD
Zeiss Jena S	180 mm	f 2.8	5	14°	7ft 0in.	100 mm	134 mm	39.28 oz	86 mm	PD
Pentacon	200 mm	f 4	5	12°	10ft 0in.	60 mm	142 mm	21.16 oz	58 mm	FAD
Prakticar Auto	200 mm	f 3.5	6	10°	10ft 0in.	67 mm	142 mm	22.22 oz	62 mm	FAD
Prakticar Electric	200 mm	f 3.5	6	10°	10ft 0in.	67 mm	142 mm	22.22 oz	62 mm	FAD
Prakticar Auto	200 mm	f 2.8	6	10°	11ft 9in.	67 mm	155 mm	36.6 oz	72 mm	FAD
Prakticar Electric	200 mm	f 2.8	5	10°	11ft 9in.	75 mm	155 mm	36.6 oz	72 mm	FAD
Pentacon	300 mm	f 4	5	8°	12ft 0in.	75 mm	215 mm	76.9 oz	95 mm	PD
Prakticar Auto	300 mm	f 4	6	8°	13ft 8in.	100 mm	168 mm	27.2 oz	77 mm	FAD
Zeiss Jena S	300 mm	f 4	6	8°	13ft 0in.	98 mm	140 mm		86 mm	ASD
Pentacon	500 mm	f 5.6	4	5°	20ft 0in.	125 mm	450 mm	123.45 oz	118 mm	PD

*These lenses, together with the "electric" lenses have the electrical contacts required for the full-aperture metering system of the Praktica LLC and VLC.
The lenses listed are those made specifically for the Praktica cameras but many lenses with the same screw fitting are available from other manufacturers.
The Pentacon lenses are made by Meyer Optik Goerlitz, now a part of the Pentacon organisation. The Prakticar lenses are made for Carl Zeiss Jena Ltd. by Sigma of Japan.

These tables, like all depth of field tables, are intended for guidance. They are mathematically computed and therefore assume various ideal conditions as regards focal length of lens, degree of enlargement of the final print, viewing distance and so on. These ideals are seldom met in practice. For each focused distance and aperture in use, the nearest and farthest planes of acceptably sharp focus are quoted in feet and inches. Thus, with a 28 mm lens set to 2 ft 6 in. and at aperture f 16, depth of field theoretically stretches from 1 ft 9.1 in. to 4 ft 6.5 in. Such precision is obviously impracticable and it would be unwise to work right out to the limits quoted. You should check the effect carefully on your screen, remembering that the image will probably look rather sharper than it will ultimately appear on the print or transparency.

Focused distance (ft)	Depth of field (ft and in.) for 29–30 mm lenses at aperture						
	f 3.5	f 4	f 5.6	f 8	11	f 16	f 22
1.3	1–3	1–2.9	1–2·6	1–2.3	1–1.9	1–1.2	1–0.1
	1–4.2	1–4.3	1–4.7	1–5.2	1–5.9	1–7.2	1–9.2
1.4	1–4.1	1–4	1–3.7	1–3.2	1–2.8	1–2	1–1.2
	1–5.6	1–5.8	1–6.1	1–6	1–7.7	1–9.4	1–11.8
1.5	1–5.2	1–5	1–4.7	1–4.2	1–3.6	1–2.8	1–1.9
	1–7	1–7.1	1–7.6	1–8.3	1–9.4	1–11	2–.26
1.75	1–7.8	1–7.7	1–7.2	1–6.5	1–5.6	1–4.6	1–3.4
	1–10	1–11	1–11	2–5	2–2	2–5.4	2–10.9
2	1–10	1–10	1–9.6	1–8	1–7.7	1–6.2	1–4.7
	2–1.9	2–2	2–3.1	2–4	2–7.2	3–0.5	3–9.7
2.5	2–3.4	2–3.1	2–2	2–0.1	1–11	1–9.1	1–7.1
	2–9.1	2–9.7	2–11	3–2.5	3–7.2	4–6.5	6–8.4
3	2–8.3	2–7.8	2–6.4	2–4.4	2–2.4	1–11.6	1–9.2
	3–4.8	3–5.6	3–8.5	4–1.6	4–10	6–9.6	13–6.5
4	3–5.3	3–4.4	3–2.2	2–11	2–7.9	2–3.8	2–0
	4–9.5	4–11	5–5.4	6–5.6	8–5.6	17–10	∞
5	4–1.7	4–4.8	3–9	3–4.8	3–0	2–7.2	2–2.5
	6–4.1	6–7.2	7–7.7	9–9	15–5	∞	∞
6.5	5–1.1	4–11	4–6.1	4	3–6	2–10.9	2–5.2
	9–4.8	9–7	11–10	18–6	64–1	∞	∞
10	6–11	6–8	5–11	5–0	4–3.1	3–4.8	2–9
	17–11	20–3	34–10	∞	∞	∞	∞
20	10–6	9–11	8–3	6–7	5–3	4–0	3–1
	216	∞	∞	∞	∞	∞	∞
∞	21–10	19–1	13–8	9–7	7–0	4–10	3–6
	∞	∞	∞	∞	∞	∞	∞

DEPTH OF FIELD

Focused distance (ft)	Depth of field (ft and in) for 35 mm lenses at aperture							
	f 2	f 2.8	f 3.5	f 4	f 5.6	f 8	f 11	f 16
1.5	1–5.6 1–6.4	1–5.5 1–6.5	1–5.4 1–6.6	1–5.4 1–6.7	1–5.2 1–7	1–4.8 1–7.4	1–4.4 1–7.9	1–3 8 1–9
1.75	1–8 1–8.9	1–7.8 1–9	1–7.7 1–9.2	1–7.6 1–9.2	1–7.3 1–9.7	1–6.8 1–10.3	1–6.4 1–11.2	1–5.5 2–0.6
2	1–11.4 2–0.1	1–11.2 2–0.9	1–10.9 2–1.2	1–10.8 2–1.3	1–10.4 2–1.9	1–9.7 2–2.9	1–9 2–4.1	1–7.9 2–6.5
2.5	2–5 2–7.1	2–4.7 2–7.6	2–4.2 2–8	2–4.1 2–8.3	2–3.4 2–9.2	2–2.4 2–10.9	2–1.3 3–1.2	1–11.6 3–5.8
3	2–10.6 3–1.6	2–10 3–2.3	2–9.4 3–3.1	2–9.1 3–3.4	2–8.2 3–4.9	2–6.7 3–7.6	2–5.2 3–11.4	2–3 4–7.6
4	3–9.2 4–3.1	3–8.3 4–4.4	3–7.3 4–6	3–6.8 4–6.6	3–5.2 4–9.7	3–2.8 5–3.4	3–0.2 6–0.1	2–8.6 7–10.1
5	4–7.7 5–5	4–6.2 5–7.2	4–4.7 5–9.8	4–4.1 5–10.9	4–1.4 6–4.6	3–10.1 7–3	3–6.4 8–9.1	3–1.4 13–5
7	6–3.6 7–10.4	6–0.7 8–3.5	5–10 8–9	5–8.9 9	5–4.2 10–2.2	4–10.4 12–8.2	4–4.6 18–4	3–9 75
10	8–7.3 11–11	8–1.9 12–11	7–8.9 14–2	7–6.8 14–9	6–10.8 18–4	6–1.2 28–10	5–4.1 103	4–5 ∞
15	12 19–11	11–2 22–11	10–4.7 27–1	10 29–8	8–10.9 49	7–7.2 ∞	6–5.2 ∞	5–1.6 ∞
20	15 29–11	13–8 37–4	12–10 48	12 59	10–5 306	8–7.9 ∞	7–2 ∞	5–7 ∞
∞	60–4.1 ∞	42–3.7 ∞	32–11 ∞	29–7.8 ∞	21–2.5 ∞	14–10.6 ∞	10–10.3 ∞	7–6 ∞

Focused distance (ft)	Depth of field (ft and in) for 50–55 mm lenses at aperture								
	f 1.4	f 2	f 2.8	f 4	f 5.6	f 8	f 11	f 16	f 22
1.5	1–6.1 1–6.1	1–5.9 1–6.1	1–5.9 1–6.1	1–5.8 1–6.2	1–5.6 1–6.4	1–5.5 1–6.5	1–5.4 1–6.7	1–5.2 1–7	1–4.8 1–7.4
1.75	1–8.9 1–9.1	1–8.9 1–9.1	1–8.8 1–9.2	1–8.6 1–9.4	1–8.5 1–9.5	1–8.4 1–9.7	1–8.2 1–10	1–7.7 1–10.4	1–7.3 1–11
2	1–11.8 2–0.2	1–11.8 2–0.2	1–11.6 2–0.4	1–11.5 2–0.5	1–11 2	1–11 2–1	1–10.8 2–1.3	1–10.3 2–2	1–9.7 2–2.9
2.3	2–2.8 2–3.2	2–2.6 2–3.4	2–2.5 2–3.5	2–2.4 2–3.6	2–2.2 2–3.8	2–1.8 2–4.3	2–1.4 2–4.8	2–0.7 2–5.8	2 2–7
2.5	2–5.6 2–6.4	2–5.6 2–6.4	2–5.4 2–6.6	2–5.3 2–6.8	2–4.9 2–7.2	2–4.6 2–7.7	2–4 2–8.4	2–3.1 2–9.6	2–2.3 2–11.2
3	2–11.5 3–0.6	2–11.4 3–0.6	2–11.2 3–0.8	2–10.8 3–1.2	2–10.4 3–1.8	2–9.8 3–2.5	2–9 3–3.6	2–7.8 3–5.5	2–6.5 3–8
3.5	3–5.3 3–6.7	3–5.2 3–6.8	3–4.9 3–7.2	3–4.4 3–7.7	3–3.8 3–8.5	3–2.9 3–9.6	3–1.9 3–11.2	3–0.4 4–1.9	2–10.6 4–5.9
4	3–11 4–1.1	3–10.9 4–1.1	3–10.6 4–1.6	3–9.8 4–2.3	3–9.1 4–3.4	3–7.9 4–4.9	3–6.6 4–7	3–4.6 4–10.9	3–2.4 5–4.6
5	4–10.4 5–1.7	4–10.3 5–1.8	4–9.6 5–2.6	4–8.6 5–3.8	4–7.4 5–5.4	4–5.6 5–8.2	4–3.6 5–11.8	4–0.6 6–6.8	3–9.4 7–5.5
7	6–8.9 7–3.4	6–8.5 7–3.7	6–7.2 7–5.4	6–5.4 7–7.9	6–3 7–11.5	5–11.8 8–5.5	5–8 9–2.2	5–2.6 10–8	4–9.2 13–4
10	9–5.6 10–7.2	9–4.9 10	9–2.3 10–11	8–10.7 11–5	8–6.1 12–1	8 13–4	7–5.4 15–3	6–8.2 20–3	5–11.3 33–1
15	13–9 16–4	13–8 16–7	13–2 17–4	12–7 18–6	11–10 20–6	10–10 24–4	9–10 31–10	8–6.2 66	7–4.2 ∞
30	25–6 36–4	25–1 37–3	23–7 41	21–7 49	19–5 66	16–10 138	14–6 ∞	11–9 ∞	9–7.4 ∞
∞	169 ∞	151 ∞	108 ∞	75 ∞	54 ∞	38 ∞	27–8 ∞	19–1 ∞	13–11 ∞

Focused distance (ft)	Depth of field (ft and in.) for 75–85 mm lenses at aperture							
	f 2	f 2.8	4	f 5.6	f 8	f 11	f 16	f 22
2.75	2–8.8	2–8.8	2–8.6	2–8.5	2–8.3	2–8	2–7.6	2–7.1
	2–9.2	2–9.2	2–9.4	2–9.6	2–9.7	2–10.1	2–10.6	2–11.3
3	2–11.8	2–11.6	2–11.5	2–11.4	2–11	2–10.8	2–10.2	2–9.6
	3–0.2	3–0.4	3–0.5	3–0.7	3–1	3–1.3	3–2	3–2.8
3.5	3–5.6	3–5.5	3–5.4	3–5	3–4.7	3–4.2	3–3.5	3–2.6
	3–6.4	3–6.5	3–6.7	3–7	3–7.4	3–7.9	3–8.9	3–10.1
4	3–11.5	3–11.4	3–11.2	3–10.8	3–10.2	3–9.6	3–8.6	3–7.6
	4–0.5	4–0.6	4–1	4–1.3	4–1.9	4–2.6	4–4	4–5.6
5	4–11.3	4–10.9	4–10.6	4–10	4–9.1	4–8.2	4–6.6	4–4.8
	5–0.7	5–1.1	5–1.6	5–2.2	5–3.1	5–4.4	5–6.7	5–9.6
6	5–10.9	5–10.4	5–9.8	5–9	5–7.8	5–6.4	5–4.2	5–1.7
	6–1.1	6–1.6	6–2.3	6–3.2	6–4.8	6–6.7	6–10.2	7–2.9
7	6–10.4	6–9.8	6–9.8	6–7.9	6–6.2	6–4.3	6–1.3	5–10
	7–1.6	7–2.2	7–3.2	7–4.6	7–6.7	7–9.5	8–2.5	8–9.5
8	7–10	7–9.2	7–8	7–6.6	7–4.4	7–1.9	6–10.1	6–5.9
	8–2	8–3	8–4.3	8–6.1	8–9	9–0.8	9–7.9	10 5.8
10	9–8.8	9–7.6	9–5.8	9–3.5	9–0.2	8–8.4	8–2.6	7–8.5
	10–3	10–4	10–7	10–10	11–2	11–9	12–9	14–4
12	11–7	11–5	11–3	10–11	10–7	10–1	9–5	8–9
	12–4	12–7	12–10	13–2	13–10	14–8	16–4	
15	14–4	14–2	13–10	13–5	12–10	12–2	11–2	0–3
	15–7	15–11	16–4	17	18	19–6	22–8	28–1
20	18–11	18–6	17–11	17–3	16–3	15–3	13–9	12–4
	21–2	21–8	22–6	23–9	25–11	29–2	36–11	54
30	27–7	26–9	25–7	24–1	22–3	20–4	17–9	s5–5
	32–10	34–1	36–3	39–7	46	57	99	765
50	43	41	38–8	35–6	31–7	27–9	23–1	19–3
	58	62	70	84	120	257	∞	∞
∞	337	241	169	120	84	61	42	30–11
	∞	∞	∞	∞	∞	∞	∞	∞

Focused distance (ft)	Depth of field (ft and in.) for 100–105 mm lenses at aperture						
	f 2.8	f 4	f 5.6	f 8	f 11	f 16	f 22
4	3–11.6	3–11.5	3–11.3	3–10.9	3–10.6	3–10	3–9.2
	4–0.4	4–0.6	4–0.7	4–1.1	4–1.6	4–2.2	4–3.2
4.5	4–5.5	4–5.3	4–5	4–4.6	4–4.1	4–3.4	4–2.4
	4–6.5	4–6.7	4–7	4–7.4	4–8	4–9	4–10.2
5	4–11.4	4–11.2	4–10.8	4–10.2	4–9.6	4–8.6	4–10.2
	5–0.6	5–1	5–1.3	5–1.9	5–2.6	5–3.8	5–5.5
6	5–11	5–10.7	5–10.1	5–9.4	5–8.4	5–7	5–5.3
	6–1	6–1.4	6–1.9	6–2.9	6–4	6–6	6–8.5
8	7–10.2	7–9.5	7–8.5	7–7.1	7–5.4	7–2.8	6–11.8
	8–1.8	8–2.6	8–3.7	8–5.4	8–7.7	8–11.5	9–4.7
10	9–9.1	9–8	9–6.5	9–4.3	9–1.7	8–9.5	8–5
	10–3	10–4	10–6	10–8	11–0	11–7	12–4
15	14–5	14–2	13–11	13–6	13	12–4	11–7
	15–7	15–10	16–2	16–4	17–7	19–1	21–4
20	19	18–7	18–1	17–5	16–7	15–5	14–3
	21–1	21–7	22–3	23–5	25	28–4	33–8
30	27–10	26–11	25–11	24–6	22–11	20–9	18–7
	32–6	33–9	35–7	38–8	43	54	79
50	44	42	39	36–3	32–10	28–6	24–7
	57	61	68	80	104	210	∞
100	78	72	65	56	48	39	32–4
	136	162	216	432	∞	∞	∞
∞	369	258	184	129	94	64	47
	∞	∞	∞	∞	∞	∞	∞

DEPTH OF FIELD

Focused distance (ft)	Depth of field (ft and in.) for 135 mm lenses at aperture						
	f 2.8	f 4	f 5.6	f 8	f 11	f 16	f 22
5	4–11.7 5–0.3	4–11.5 5–0.5	4–11.3 5–0.7	4–11 5–1.1	4–10.7 5–1.4	4–10.1 5–2.2	4–9.4 5–3
6	5–11.5 6–0.9	5–11.3 6–0.8	5–10.9 6–1.1	5–10.4 6–1.6	5–10 6–2.2	5–9 6–3.2	5–8 6–4.6
7	6–11.4 7–0.6	6–10.9 7–1.1	6–10.4 7–1.6	6–9.8 7–2.3	6–9.1 7–3.1	6–7.8 7–4.7	6–6.4 7–6.6
8	7–11 8–1.2	7–10.6 8–1.6	7–10 8–2.2	7–9.1 8–3.1	7–8 8–4 3	7–6.5 8–6.4	7–4.6 8–9
10	9–10.7 10–1.3	9–9.6 10–2	9–8.8 10–3	9–7.3 10–5	9–5.8 10–7	9–3.1 10–10	9–0.1 11–3
12	11–9 12–2	11–8 12–3	11–7 12–5	11–5 12–7	11–2 12–10	10–11 13–4	10–6 13–10
15	14–9.1 15–3	14–6 15–5	14–4 15–8	14–1 16–0	13–9 16–5	13–3 17–2	12–9 18–2
20	19–6.7 20–5.5	19–2 20–10	18–10 21–3	18–4 21–11	17–10 22–8	17 24–3	16–1 26–4
30	28–5 31–9	28–1 32–1	27–5 33–1	26–5 34–7	25–4 36–9	23–8 41	21–11 47
50	47–4.3 53–0.6	44 56	43 59	40 64	38 72	34 92	30–9 135
100	89–7.3 113–1.6	81 130	7 147	68 186	61 276	52 ∞	44 ∞
∞	520 ∞	427 ∞	305 ∞	213 ∞	155 ∞	107 ∞	78 ∞

Focused distance (ft)	Depth of field (ft and in.) for 200 mm lenses at aperture						
	f 3.5	f 4	f 5.6	f 8	11	16	f 22
9	8–11.4 9–0.7	8–11.3 9–0.7	8–10.9 9–1.1	8–10.6 9–1.6	8–10 9–2.2	8–9.1 9–3.1	8–8 9–4.3
10	9–11.2 10	9–11 10–1	9–10.7 10–1	9–10.1 10–1	9–9.4 10–2	9–8.3 10–4	9–7 10–5
12	11–10 12–1	11–10 12–1	11–10 12–2	11–9 12–3	11–8 12–4	11–6 12–6	11–4 12–8
15	14–10 15–2	14–10 15–2	14–8 15–3	14–7 15–4	14–5 15–7	14–2 15–10	13–11 16–2
20	19–8 20–4	19–7 20–4	19–5 20–6	19–3 20–9	19 21–1	18–7 21–7	18–1 22–3
25	24–6 25–6	24–4 25–7	24–2 25–10	23–10 26–3	23–5 26–9	22–9 27–8	22–1 28–10
30	29–3 30–9	29–1 30–10	28–9 31–3	28–4 31–10	27–9 32–7	26–10 34	25–10 35–9
50	47–10 52–4	47–7 52–8	46–8 53–10	45–4 55	43–10 58	41–7 62	39–1 69
100	91 110	90 111	87 117	82 126	77 140	70 171	63 235
200	168 245	165 253	154 284	140 346	126 478	108 1310	92 ∞
∞	1071–11 ∞	938 ∞	670–2 ∞	469–4 ∞	341–6 ∞	235 ∞	171–1 ∞

Focused distance (ft)	Depth of field (ft and in.) for 300 mm lenses at aperture						
	f 4	f 5.6	f 6.3	f 8	f 11	f 16	f 22
18	17–10 / 18–1	17–10 / 18–2	17–9.7 / 18–.32	17–9 / 18–3	17–8 / 18–4	17–6 / 18–6	17–4 / 18–8
20	19–10 / 20–1	19–9 / 20–2	19–9 / 20–2	19–8 / 20–3	19–7 / 20–5	19–4 / 20–7	19–2 / 20–10
25	24–9 / 25–3	24–7 / 25–4	24–7.3 / 25–4.8	24–6 / 25–6	24–3 / 25–8	24 / 26	23–8 / 26–5
30	29–7 / 30–4	29–5 / 30–6	29–5.2 / 30–7.2	29–3 / 30–9	29 / 31	28–7 / 31–7	28–1 / 32–2
35	34–5 / 35–6	34–3 / 35–8	34–2.5 / 35–10	33–11 / 36	33–7 / 36–5	33 / 37–2	32–4 / 38–1
40	39–3 / 40–8	39 / 40–11	38–11.4 / 41–1.3	38–8 / 41–5	38–2 / 41–11	37–5 / 42–11	36–6 / 44–2
50	48–11 / 51	48–6 / 51	48–4.1 / 51	47–10 / 52	47–1 / 53	45–11 / 54	44–7 / 56
70	67 / 72	67 / 73	66 / 73	65 / 74	64 / 76	62 / 80	59 / 84
100	95 / 104	93 / 106	93 / 107	91 / 110	88 / 114	84 / 122	79 / 133
150	140 / 161	136 / 166	135 / 168	131 / 174	125 / 185	117 / 207	108 / 243
200	182 / 220	176 / 230		168 / 245	159 / 269	145 / 319	132 / 411
300			245 / 385	234 / 417	216 / 489	192 / 686	163 / ∞
500	404 / 654	376 / 746		339 / 946	303 / 1425	257 / 9098	218 / ∞
∞	2110 / ∞	1507 / ∞	1342 / ∞	1055 / ∞	767 / ∞	528 / ∞	384 / ∞

Focused distance (ft)	Depth of field (ft and in.) for 400 mm lenses at aperture				
	f 5.6	f 8	f 11	16	f 22
27	26–9 / 27–2	26–8 / 27–4	26–6 / 27–5	26–4 / 27–8	26–1 / 27–11
30	29–8 / 30–3	29–7 / 30–5	29–5 / 30–7	29–2 / 30–10	28–10 / 31–2
35	34–7 / 35–4	34–5 / 35–7	34–2 / 35–9	33–10 / 36–2	33–5 / 36–8
40	39–5 / 40–6	39–3 / 40–9	38–11 / 41–1	38–6 / 41–7	37–11 / 42–2
50	49 / 50	48 / 51	48 / 51	47 / 52	46 / 53
70	68 / 71	67 / 72	66 / 73	65 / 75	63 / 77
100	96 / 103	95 / 105	93 / 107	90 / 111	87 / 116
150	142 / 158	139 / 162	135 / 168	129 / 178	123 / 191
300	269 / 337	258 / 356	246 / 384	227 / 440	208 / 535
∞	2654 / ∞	1858 / ∞	1351 / ∞	929 / ∞	676 / ∞

DEPTH OF FIELD

Focused distance (ft)	Depth of field (ft and in.) for 500 mm lenses at aperture					
	f 4.5/f 5	f 5.6	f 8	f 11	f 16	f 22
35	34–9 35–2	34–9 35–3	34–7 35–4	34–6 35–6	34–3 35–8	34 36
40	39–8 40–3	39–8 40–4	39–6 40–5	39–4 40–8	39 40–11	38–8 41–4
50	49–7 50–5	49–5 50–6	49–2 50–9	48–11 51–1	48–6 51–7	47–11 52–2
70	69 71	69 71	68 71	68 72	67 73	65 74
100	98 101	97 102	96 103	95 104	93 106	91 109
150	145 154	144 155	142 157	140 160	136 166	132 173
520	238 262	236 265	230 272	224 282	214 300	203 324
500	456 552	447 567	427 601	405 651	373 756	341 936
∞	5209 ∞	4186 ∞	2930 ∞	2132 ∞	1466 ∞	1066 ∞

Focused distance (ft)	Depth of field (ft and in.) for 1000 mm lenses at aperture			
	f 8	f 11	f 16	f 22
100	99–2 100–9	98–11 101–1	98–5 101–7	97–10 102–2
110	109 110–11	108–8 111–4	108–1 111–11	107–4 112–9
125	123 126	123 126	122 127	121 128
150	148 151	147 152	146 153	145 155
200	196 203	195 204	193 207	191 209
250	244 255	242 257	239 261	236 265
350	339 360	335 365	329 372	323 381
600	569 633	559 646	542 670	524 701
1500	1323 1730	1267 1837	1184 2046	1097 2370
∞	11183 ∞	8108 ∞	5593 ∞	4068 ∞

RATIOS AND EXPOSURES—LARGE BELLOWS

Focal length	50mm		100mm		135mm	
Extension	RR	F	RR	F	RR	F
35	0.7	2.9	0.35	1.8	0.26	1.6
40	0.8	3.2	0.40	2.0	0.30	1.7
45	0.9	3.6	0.45	2.1	0.33	1.8
50	1.0	4.0	0.50	2.3	0.37	1.9
55	1.1	4.4	0.55	2.4	0.41	2.0
60	1.2	4.8	0.60	2.6	0.44	2.1
70	1.4	5.8	0.70	2.9	0.52	2.3
80	1.6	6.8	0.80	3.2	0.59	2.5
90	1.8	7.8	0.90	3.6	0.67	2.8
100	2.0	9.0	1.00	4.0	0.74	3.0
110	2.2	10.2	1.10	4.4	0.82	3.3
120	2.4	11.6	1.20	4.8	0.89	3.6
130	2.6	13.0	1.30	5.3	0.96	3.9
140	2.8	14.4	1.40	5.8	1.04	4.2
150	3.0	16.0	1.50	6.3	1.11	4.5
160	3.2	17.6	1.60	6.8	1.18	4.8
170	3.4	19.4	1.70	7.3	1.26	5.1
180	3.6	21.2	1.80	7.8	1.33	5.4
190	3.8	23.0	1.90	8.4	1.41	5.8
200	4.0	25.0	2.00	9.0	1.48	6.2
210	4.2	27.0	2.10	9.6	1.56	6.5
220	4.4	29.0	2.20	10.2	1.63	6.9

The reproduction ratios (RR) and exposure factors (F) apply with the lens at its infinity setting. Exposure factors are likely to be much greater if the longer-focus lenses are of telephoto construction. The TTL-metering Prakticas give accurate readings with either type of lens.

RATIOS AND EXPOSURES—SMALL BELLOWS

Focal length	35mm		50mm		100mm		135mm	
Extension	RR	F	RR	F	RR	F	RR	F
30	0.8	3.3	0.6	2.5	0.3	1.7	0.2	1.5
40	1.1	4.3	0.8	3.1	0.4	1.9	0.3	1.7
50	1.4	5.6	1.0	4.0	0.5	2.2	0.4	2.0
60	1.6	5.9	1.2	4.6	0.6	2.5	0.45	2.1
70	1.9	8.4	1.3	5.4	0.7	2.9	0.5	2.3
80	2.2	10.0	1.5	6.4	0.8	3.2	0.6	2.5
90	2.5	12.0	1.7	7.4	0.9	3.6	0.65	2.8
100	2.7	14.0	1.9	8.5	1.0	4.0	0.7	3.0
110	3.0	16.0	2.1	9.6	1.1	4.4	0.8	3.3
With special 14mm Intermediate Ring								
30	1.2	4.9	0.8	3.4	0.4	2.0	0.3	1.8
40	1.5	6.1	1.0	4.0	0.5	2.4	0.4	2.0
50	1.8	7.8	1.2	4.9	0.6	2.7	0.45	2.2
60	2.0	9.1	1.4	5.8	0.7	3.0	0.55	2.4
70	2.3	11.0	1.6	6.8	0.8	3.4	0.6	2.6
80	2.6	13.0	1.8	7.9	0.9	3.8	0.7	2.9
90	2.8	15.0	2.0	9.0	1.0	4.0	0.75	3.1
100	3.1	17.0	2.2	10.0	1.1	4.6	0.8	3.4
110	3.4	19.0	2.4	11.0	1.2	5.0	0.9	3.7

The reproduction ratios (RR) and exposure factor (F) apply with the lens at its infinity setting. Exposure factors are likely to be much greater if the longer-focus lenses are of telephoto construction. The TTL-metering.

Prakticamat

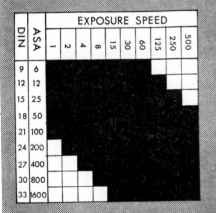

DIN	ASA	EXPOSURE SPEED										
		1	2	4	8	15	30	60	125	250	500	1000
9	6											
12	12											
15	25											
18	50											
21	100											
24	200											
27	400											
30	800											
33	1600											
36	3200											

Meter limits of the Prakticamat. For a given film speed (as shown on the left) only shutter speeds shown in the black area are usable with the meter. Thus, for speeds up to 25 ASA, all speeds are usable. At 800 ASA, only shutter speeds faster than 1/15 sec. will operate the meter.

Praktica Super TL and LTL

DIN	ASA	EXPOSURE SPEED									
		1	2	4	8	15	30	60	125	250	500
9	6										
12	12										
15	25										
18	50										
21	100										
24	200										
27	400										
30	800										
33	1600										

Meter limits of the Praktica Super TL and LTL. On the LTL, the 1/1000 sec. shutter speed can be used with films of 100 ASA and faster. All speeds can be used with the meter with films of 50 and 100 ASA. At higher and lower film speeds, some shutter speed settings will not operate the meter.

Praktica LLC and VLC

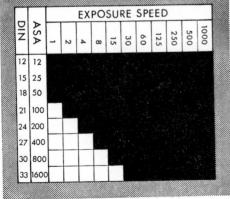

DIN	ASA	EXPOSURE SPEED										
		1	2	4	8	15	30	60	125	250	500	1000
12	12											
15	25											
18	50											
21	100											
24	200											
27	400											
30	800											
33	1600											

Meter limits of the Praktica LLC and VLC. All shutter speeds can be used with films at up to 50 ASA. With a 100 ASA film, only the 1 sec. setting fails to operate the meter.

INDEX

301

The Manuals of Photo-Technique

Focal Press

The
Focal Encyclopedia
of
Photography

2,400 articles: 1¾ million words
1,930 pages, 450 photographs, 1,750 diagrams
Revised edition in a two-volume set
Single volume Desk Edition also available

THE FOCAL ENCYCLOPEDIA is in its first fundamentally revised edition. Recent years have brought about immense advances in photographic knowledge and practice and it takes them fully into account. Its original length has expanded by close on 500 pages.

THE FOCAL ENCYCLOPEDIA covers completely the vast technology of photography and follows up all its uses for picture making. It defines terms, identifies personalities and quotes rules. It recalls past developments and records the present state of progress all over the world. It sums up scientific theory and instructs in up-to-date practice. It presents all the facts that matter, explains "why" and shows "how". It hands out advice based on first-hand knowledge, expert skill and reliable authority.

THE FOCAL ENCYCLOPEDIA is specially written in plain, readable and commonsense English. It was carefully planned and set out in alphabetical order for easy reference. You will be able to find, instantly master and put to good use, all the information you need from whatever angle you look for it.

THE FOCAL ENCYCLOPEDIA is the most used and most useful reference book on photography. A unique, up-to-date and universal source of photographic knowledge and an unfailing tool of practical help to any photographer, student of photography, professional and amateur, advanced and beginner alike.

THE FOCAL ENCYCLOPEDIA can take the place of a photographic library; and no library is complete without it.

See it at your bookseller's or photographic dealer's or write for full prospectus to Focal Press.